T0164116

EXHIBITION SCHEDULE

NANA Museum of the Arctic, Kotzebue
1 October - 17 October 1986

Deloycheet Corporation, Holy Cross
1 November - 15 November 1986

Yugtarvik Regional Museum, Bethel
29 November - 21 December 1986

Anchorage Museum of History & Art
11 January - 8 February 1987

Sheldon Museum and Cultural Center, Haines
23 February - 13 March 1987

Alaska State Museum, Juneau
26 March - 26 April 1987

Burke Museum, Seattle
14 May - 7 June 1987

University of Alaska Museum, Fairbanks
19 June - 6 September 1987

Sponsors

National Endownment for the Humanities,
a federal agency
Alaska State Council on the Arts
Skinner Foundation
in behalf of NC Machinery Co.
and Pepsi-Cola Bottling of Alaska

Organized by the

University of Alaska Museum

THE ARTISTS

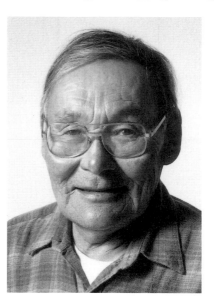

Life Histories of

NICK CHARLES, SR.
FRANCES DEMIENTIEFF
LENA SOURS
JENNIE THLUNAUT

Terry P. Dickey
PROJECT COORDINATOR

Wanda W. Chin
PROJECT DESIGNER

Suzi Jones
GUEST CURATOR AND EDITOR

BEHIND THE WORK

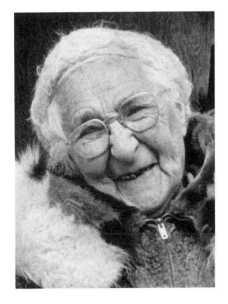
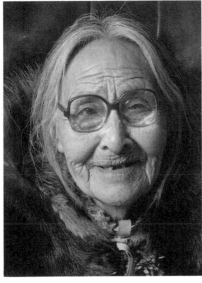

Written by

Ann Fienup-Riordan
Sophie M. Johnson
Katherine McNamara
Sharon D. Moore
Charles Smythe
Rosita Worl

UNIVERSITY OF ALASKA MUSEUM
FAIRBANKS, ALASKA
1986

Catalog Designer: Wanda W. Chin
Production: Sandy K. Frysig
 Ingrid H. Nelson
 Virginia K. Marchlinski

The exhibit and publication were made possible
through the generous support of the National Endow-
ment for the Humanities, a federal agency, the Alaska
State Council on the Arts, and the Skinner Foundation
on behalf of the N.C. Machinery Co. and Pepsi-Cola
Bottling of Alaska.

Library of Congress Cataloging in Publication Data

The Artists behind the work: life histories of Nick Charles,
Sr., Frances Demientieff, Lena Sours, and Jennie Thlunaut/
written by Ann Fienup-Riordan...[et. al.]; catalog and exhibi-
tion edited by Suzi Jones. Fairbanks: University of Alaska
Museum, 1986.

Bibliography:

1. Art, American—Alaska—Exhibitions. 2. Artists—Alaska.
3. Charles, Nick. 4. Demientieff, Frances. 5. Sours, Lena.
6. Thlunaut, Jennie. I. Fienup-Riordan, Ann. II. Jones,
Suzi. III. University of Alaska Museum. IV. National Endow-
ment for the Humanities. V. Alaska State Council on the
Arts. VI. Skinner Foundation. VII. Title.

N6530.A4A77 1986
UAF CIP
ISBN 0-931163-02-1

This catalog is available for sale through the
University of Alaska Museum Store
907 Yukon Drive
Fairbanks, Alaska 99775-1200

TABLE OF CONTENTS

LENDERS TO THE EXHIBITION

George Charles

Nick Charles, Sr.

Susan Charles

Allan and Nina Dahl

Mike Demientieff

Julie Folta

Betty Johnson

Alice Nerby

Maureen Reich

Sheldon Jackson Museum,
Sitka

Sheldon Museum and Cultural Center,
Haines

Sisters of St. Anne

Dolly Spencer

Emma G. Widmark

Rosita Worl

Yugtarvik Regional Museum,
Bethel

ACKNOWLEDGEMENTS

The University of Alaska Museum thanks the following people and institutions for their interest and support of this project.

Elizabeth Ali	Mary Hamilton
Maurine Canarsky	Austin Hammond
George Charles	Evelyn Hotch
Susan Charles	Betty Johnson
Peter Corey	Cindy Jones
Rachel Craig	Elizabeth Mayock
Nora Dauenhauer	Ethel Montgomery
Martha Demientieff	Alice Nerby
Michael and Daisy Demientieff	Maureen Reich
Julie Folta	Sister Ida

Sisters of St. Ann

Alaska State Council on the Arts

Sheldon Museum and Cultural Center, Haines

Smithsonian Institution, Office of Folklife Programs

University of Alaska, Rasmuson Library:
Program for the Preservation of Oral History
Alaska and Polar Regions Department
William Schneider, Director

P R E F A C E

The idea for this exhibition and catalog was proposed by Dr. William Schneider, Director of the Oral History Program at the University of Alaska. He had finished reviewing the final biographies of four Alaska Native artists, an oral history project entitled "The Artists Behind the Work," which was funded by the Alaska State Council on the Arts and the Skinner Foundation. He approached me with the suggestion of extending the life of the project beyond the manuscripts, making the information more public and visible. The alternative would be to place the manuscripts in archival boxes and hope researchers would someday discover this wealth of cultural information. Something more than this was deserving of the artists.

I immediately involved Wanda W. Chin, Coordinator of Exhibits and Exhibits Designer. We were intrigued with the concept from the very beginning and realized early on that this was not going to be a typically organized museum exhibition. Usually we plan exhibitions based on the strengths of available objects and add supplementary informational labels to tell the story. This project, on the other hand, would involve us searching through local museum collections, private collectors, and friends of the artists for objects and family photographs to fit the completed biographies. As it turned out, this proved to be as difficult as we had expected, especially since the majority of objects useful to this exhibit were made to be used, worn, and new ones made to replace them. They were not collected and kept as museum objects. For example, we were extremely fortunate to have found a Lena Sours' fancy parka, primarily for the reason that most anyone lucky enough to own one of her parkas was reluctant to go through a winter without it. Maureen Reich, Lena's granddaughter, loaned us a fancy parka for the exhibit, but because it showed some signs of wear, the parka was sent to the Alaska State Museum for conservation prior to being placed on exhibition. Only five objects shown in the exhibition were loaned from museum collections, the rest of the objects were obtained from individuals.

We were surprised at the large number of photographs that were sent to us showing the artists with family and friends. These pictures were extremely useful to the project, and we were able to reproduce a number of them in the exhibition and catalog. We are grateful to all the lenders for their support of this project.

After a general consensus was reached between the researchers and the Museum staff as to the feasibility of project funding and purpose, it was decided that an exhibition and catalog could be produced under the sponsorship of the University of Alaska Museum. A grant proposal was written to the National Endowment for the Humanities (NEH) with the assistance of Suzi Jones, Director of the Traditional Native Arts Program at the Alaska State Council on the Arts (ASCA). Based upon the strength of this proposal, ASCA funded the project to photo document the artists' family, friends, surroundings, and available art work. When funding from the NEH was received in early January 1986, Suzi Jones was selected as editor with grant money reimbursing ASCA for the time she spent on this project.

The NEH grant included money for the exhibition to travel to the communities where each artists live. In this way, the artists can be seen not only in the context within his or her own community but in relation to the other artists and their communities. The point to be made here is that the experience of these artists and their relationship with their families, extended families, and the whole community are not atypical. "The Artists Behind the Work" will travel to the following locations: NANA Museum of the Arctic, Kotzebue; Holy Cross Community Center; Yugtarvik Regional Museum, Bethel; Anchorage Museum of History and Art; Sheldon Museum and Cultural Center, Haines; Alaska State Museum, Juneau; University of Washington's Burke Museum, Seattle; and the University of Alaska Museum, Fairbanks.

Over the course of the project, there have been many people who have contributed their talents. Of special recognition is Wanda W. Chin who was responsible for designing the exhibition and catalog. Organizing the graphic continuity between both projects was an arduous process, especially when considering the different writing styles between the researchers, the huge volume of written material needing to be discussed, and the diversity and sizes of the objects. Andrea P. Krumhardt, who acted as project assistant, did a masterful job of organizing and following-up on the countless details associated with an exhibition and catalog of this scope. Sheila Carlson, Museum Word Processing Operator, typed the manuscripts and subsequent revisions. This project was made possible with their assistance.

I also thank Dr. Basil C. Hedrick, Museum Director, for his generous support of this project. Over the years, he has clearly shown his sincere commitment to the University of Alaska Museum for publishing materials on Alaska Native art and culture. His continued advocacy is much appreciated.

Terry P. Dickey
Coordinator: Education and Public Service
University of Alaska Museum

F O R E W O R D

"The Artists Behind the Work" features the life histories of Lena Sours, an Inupiaq skin sewer from Kotzebue; Nick Charles, a Yup'ik carver from Bethel; Frances Demientieff, a bead worker from Holy Cross; and Jennie Thlunaut, a Chilkat blanket maker from Klukwan. How simple it was two years ago to categorize these artists as carver, sewer, beader, and blanket maker. And now, how inadequate these one-word descriptions sound. The original archival collections, the life history manuscripts, and the museum exhibit of "The Artists Behind the Work" lead us to see each of these individuals within a personal and cultural context, broadening our appreciation of the role art plays in their lives.

"The Artists Behind the Work" began in 1983 as a project of the Oral History Program at the Alaska and Polar Regions Department of the Elmer Rasmuson Library, and generous support was provided by the Alaska State Council on the Arts and the Skinner Foundation. The Traditional Native Arts Panel of the State Council on the Arts assisted in choosing the artists to be honored.

The researchers were selected for their familiarity with the artist and their home communities, for their sensitivity to cultural values, and for their ability to write: Ann Fienup-Riordan, Sophie Johnson, Katherine McNamara, Sharon Moore, Charles Smythe, and Rosita Worl.

We know historically that men have been the primary subject of biographies. Anthropologist Margaret Blackman has pointed out that for Native North Americans, there have been more than three times as many life histories written about men than women and, until recently, there were more male than female ethnographers. L.L. Langness and Gelya Frank, in their survey of the literature of biography, note that the primary subjects for biographies have historically been prominent North American Indian men, chiefs and warriors, a trend which has only recently begun to change. The four life histories presented in this book address these imbalances in the literature.

An interesting facet of this project was the support that the researchers received from other community members. Sharon Moore teamed up with Sophie Johnson and Bertha Lowe to document on tape, transcribe, and write Lena Sours' life history. Ann Fienup-Riordan worked closely with members of Nick Charles' family,

particularly with his wife, Elena, and their children, George, Mary, and Susan. Katherine McNamara's close friendship with Frances Demientieff's relative Martha Demientieff, helped provide insight and perspective on family history and Athabaskan culture. Rosita Worl and Charles Smythe worked with John Marks on the recording of Jennie's life story and received support from Tlingit Elder Austin Hammond. In each of these cases, a high level of local control and involvement characterize the way the research was conducted and the final materials that were produced. For the Oral History Program, each researcher produced an archival collection of recordings and pictures and the life history manuscript. These four collections are now a permanent part of the Archives at the Elmer Rasmuson Library.

The biographies were written to give readers a feel for the development of each artist's life and a glimpse of the role of art and artist in four Native culture areas. The life history approach was chosen because it permitted us to ask people to describe the influences which shaped their lives. A good life history effectively conveys the particular shaping influences such as a grandfather, the cultural expectations of community members, or conditions growing up in a church mission. For each of the four individuals featured in this catalog, the influences are different, but their experiences are described with sufficient depth so that we can see how they developed and the significant factors in their lives.

The life history method is not a new or particularly novel approach. It is used extensively in anthropology, history, sociology, and many other disciplines where the purpose is to gain an "insider's" view of how things happened. It is a highly personal way to learn about another culture. The reader finds himself or herself immersed in the life of another person, empathizing with his/her feelings, their joys and sorrows, hopes and dreams.

The four biographies presented here exemplify the intimacy of a first-person narrative. They are based on extensive interviews and some actual tape recordings, but the intimacy in these cases comes not from a first person narration in the artist's words, but from the writer's skills in working with family and community members to collect and craft the text. The investment of these people and the craft of the writers in what became collaborative efforts ensures that we, the readers, can

immerse ourselves in culturally rich description. We can come to know the artists in some of the ways that family and community members know them. This work is in the best of the life history tradition.

The close relationship between writers and artists and the assistance of family and community members ensures that the work is collaborative and culturally relevant. But collaboration works the other way too. The four biographies bear the particular personalities of the writers, their orientations, relationships, and sensitivities. At first glance, we might wonder about the writers immersing "too much" of themselves in what is, after all, the story of someone else's life. But the irony is that, to a point, the more we know about the writers, the better we are able to evaluate their influences on the stories. This is particularly true in life histories written in the writer's, as opposed to the subject's, words. It is a question of balance. If the writer dominates the discussion, then the reader loses interest and feels robbed of the first-hand experience with the subject. If the writer provides too little background, context, and explanation, the reader may not find enough common ground to identify with the subject and his or her experiences.

"The Artists Behind the Work" biographies each have a different collaborative balance, and each offers its own perceptions. Taken as a whole, they greatly increase our knowledge of the diversity present in Alaskan history and cultural groups.

I welcome you, then, to share in the lives of four Alaska Native artists and the many people who helped to produce these biographies.

William Schneider
Director, Oral History Program
Alaska and Polar Regions Department
University of Alaska, Fairbanks

INTRODUCTION

The four life histories which make up this catalog and which have been the basis for the exhibit, "The Artists Behind the Work," have all sorts of things to offer the reader. They are fascinating stories about interesting people. They are Alaskan history up close, on an intimate and very local level during a period of tremendous change in this northern region. Based on oral history interviews, they are enlivened with the directness of first-hand experience and personal knowledge.

These biographies are also an important addition to the art history of the Native people of Alaska. They are new tools for understanding Alaska Native art. I sometimes think of them as the fisherman's sunglasses. When he wears Polaroid sunglasses, the steelhead fisherman is able to see below the surface of the water. The lenses in his glasses create an optical condition which allows his sight to penetrate the otherwise reflective glare of the river's surface. In a similar way, these life histories, in acquainting us with the artists behind the art work—presenting us with the artists' own perceptions of their work, and the perceptions of the artists' own local communities—allow those of us not on familiar terms with the artists, their communities, or their cultures to see below the surface and to penetrate the reflective glare of our own cultural upbringing. The life histories create new optical conditions; they are tools which allow us to become more perceptive students of Alaska Native art. They give us new ways of thinking about Native art and, thus, new ways of seeing Native art. New ways of seeing all art.

Each of the life histories is quite different in style, in approach, and in organization. However, when the four biographers met to talk about their experiences writing the life histories of Native artists, a number of parallel themes quickly surfaced in their conversation. These themes ranged from the concept of "the artist" to the dynamics of innovation and personal style within a cultural tradition. When it was decided to present a museum exhibit based on the life histories, these themes provided an interpretive framework. Each theme becomes a mental landmark for the viewers as the exhibit leads them through the life history of each artist. For the readers of this catalog, these themes may provide a similar function, highlighting areas of comparison, both within the lives of four very different individuals, and, more broadly, between traditional Native American art and Western art.

Before discussing these themes, I should like very briefly to introduce the artists and their biographers, to provide some background on their selection and on the kinds of experiences they bring to the life history project.

The Artists

These artists—Nicholas Charles, Sr., Frances Demientieff, Lena Sours, and Jennie Thlunaut—are individuals known both in their own communities and statewide for their art work, and they are all individuals with a depth of experience in their own traditional cultures. All are respected Elders in their own communities. In addition, they are individuals who were willing to participate in the research process and to have their life histories made public. As a group, these artists represent four different Native cultures and four different art forms: Nicholas Charles, Sr., a Nelson Islander now living in Bethel, is a Yup'ik Eskimo known for his carved and painted wood masks. Frances Demientieff is an Athabaskan bead worker and skin sewer from Holy Cross. Lena Sours is an Inupiaq Eskimo skin sewer from Kotzebue known for her fancy parkas, and Jennie Thlunaut is a Chilkat Tlingit weaver, maker of baskets and the famous Chilkat blankets.

The Biographers

The biographers were selected for this project on the basis of their professional backgrounds and their knowledge of the artist whose life was to be documented. Writing a life history is, in many ways, an intimate process, which can benefit from an already established relationship between biographer and subject. (In this situation, where all of the artists live in small, rural communities, the intrusion of a total stranger from outside the culture would have required a greatly extended period in order to carry out successfully the life history interviews). As a group, the biographers bring an interesting range of perspectives to this project. (This diversity, which is reflected in the life history manuscripts, allows us further insight into the life history approach as a methodology.) Rosita Worl, who with her associate Charles Smythe, wrote Jennie Thlunaut's life history, is a granddaughter of Jennie's and is a social anthropologist by training. Ann Fienup-Riordan, Nick Charles' biographer, is a cultural anthropologist, and though she

did not know Nick Charles personally before undertaking this project, she had done extensive fieldwork on Nelson Island and is a fluent speaker of the Yup'ik language. Sharon Moore and Sophie Johnson of the NANA Museum of the Arctic in Kotzebue, are both Inupiat and residents in the same community as Lena Sours. Katherine McNamara, a writer and historian, had lived for many years in the interior of Alaska. She knew Frances Demientieff and many members of her family, especially Martha Demientieff, and had been active in the organization of the first Elders Conference in Holy Cross in 1980.

At a planning meeting for "The Artists Behind the Work" exhibit, each of the biographers talked about her personal response to the writing of the life histories. The parallel themes which emerged seemed to offer avenues to understanding the artists' lives and their art. These themes are: 1) the concept of the artist in society; 2) the education of the artist; 3) historical and social contexts for the art; 4) cultural and spiritual contexts; and 5) individual style and expression. These became the five themes to be carried throughout the exhibit.

The Artist in Society

One of the first themes to be discussed by the biographers was the concept of the artist in the cultures and the communities of the four individuals whose lives were documented. It was clear that the Western perception of the artist as a specialist, and even as one often set apart from his society, did not fit these artists' lives. Although these individuals are recognized for their accomplishments, they are not perceived in their communities as inhabiting the niche of "the artist": Nicholas Charles is not known as the mask maker in Bethel, nor Frances Demientieff as the bead sewer in Holy Cross.

As Ann Fienup-Riordan wrote of Nick Charles, "Nicholas Charles, Sr., is a father and grandfather, a husband and provider, a leader and respected Elder of the community of Bethel. During his life he has built boats and houses, sleds and fish traps. He has carved bowls and paddles and jewelry and toys. He also makes masks."

Sharon Moore and Sophie Johnson introduce Lena Sours this way: "People outside of northwest Alaska know of Lena Sours because she makes beautiful fancy parkas for women and men. To residents of this region, she is more than a talented seamstress: Suuyuk is respected for her knowledge of traditional Inupiaq culture, her strength of character and faith in God. As an Elder, Suuyuk willingly shares her wisdom with others and is a living example of the adaptability and strength of the Inupiaq people."

Katherine McNamara writes of Frances Demientieff: "Frances Demientieff is an Athabaskan woman, a wife and widow, a mother, grand- and great-grandmother, a Catholic, a fisher, netmaker, skin sewer, bead worker, a good cook, a teacher and counselor, a comforter, a midwife, a nurse." McNamara further comments, "The work which is the reason for this writing, her beadwork and skin sewing, has for more than sixty years delighted and clothed her family and friends. Unlike artists from the mainstream of American society, she has never had to contend with anonymous collectors, or with friendly or unfriendly critics with reputations to build, or with the struggle for recognition—that is—sympathetic response—from an indifferent audience. Her reality has been of a different composition...this artist, who has lived her years in the net of kinship of her own small community."

Being an excellent carver or sewer is an element in being a good Yup'ik man or a good Athabaskan woman, because mastery of these skills is part of the role of the individual within the culture. Thus, there are strong cultural and even moral values attached to one's competence in carving, sewing, or weaving. When Nick Charles was growing up, Yup'ik men made their essential tools from all kinds of wood, and as Ann Fienup-Riordan notes, "in order to be a competent and productive member of the community, each man had to be a competent and productive carver." What sets these four Native artists apart is the level of their skills, their individual passion for beauty and commitment to excellence, and the greater investment of time and effort which they devote to their arts.

Although the four individuals featured in this exhibit are all older, and traditional roles for men and women within these cultures have changed in succeeding generations, even today a significant relationship still exists between these traditional arts and their cultural values. Katherine McNamara writes that "Frances Demientieff's work is women's work. In her society, women know themselves in a fundamental way to be the bearers of life, and their work is valued as it expresses this gift. Needlework is adornment, is protection against hard weather; it is the passing of tradition from older to younger women. It is the pleasure of making, and it is consolation."

Education of the Artist

In selecting the education of the artist as an exhibit theme, we do not mean how many years these individuals spent in school, but rather the extended learning process that occurred as each individual grew up within his/her culture. This learning process involved not only the mastery of technical skills but the gradual acquisition of the broader cultural knowledge which informs aesthetics and design, and, in some cases, the artistic process itself.

Reading his life history, we learn that Nicholas Charles grew up in the *qasgiq*, the men's house, where he

listened to stories and learned "natural history through Yup'ik eyes, along with the rules of behavior which held for animal as well as human society." He spent hours watching the older men at work, carving, "asking no questions but observing each step minutely before trying it himself." The wood chips and shavings surrounding a man's place in the qasgiq were a visible index of his energy and skills. As Nick's father was working, "Nick would handle the wood chips, as well as his father's tools when they were not in use." Nick Charles learned in a traditional setting: "Each carver worked from a personal repertoire of shapes and angles that he had learned to calculate by watching the men work of their own tools in the men's house as he was growing up." There was no explicit verbal instruction such as that which characterizes formal schooling in Western societies.

Jennie Thlunaut grew up in her father's tribal house, the Frog House in Klukwan. She received the cultural training traditional for young women in Tlingit society at that time, including an isolation period when she became a woman. Her education as a weaver came largely from her mother, but it was always in response to Jennie's own demonstrated interest in weaving that came out in her play activities. When Jennie's mother saw her playing at making baskets, at splitting roots, and later at Chilkat weaving, she then showed Jennie how it was done properly.

As a girl, Lena Sours had learned from her mother how to sew small fur items, but not parkas. When she was a young wife in reindeer camp, she tried to make a parka, working from memories of observing her mother. Her friend, Jenny Sheldon, then showed her what she had done right or wrong. Soon Lena was an accomplished parka maker, sharing her own knowledge with the wives of other reindeer herders who wished to sew. Later, Lena taught sewing at Kotzebue school for many years in the 1940s, and we learn this of her teaching methods: "Lena never scolded them when they made a mistake. She would just smile, let them rip the seams, and try again. They learned well that way...."

Both Lena Sours and Jennie Thlunaut did have a few years of attending school, and Frances Demientieff remembers well the rigorous education in the mission at Holy Cross. However, as Katherine McNamara has written about Holy Cross, "Schooling did, and does not exhaust the village education system." In the village, younger people learned from older people. McNamara cites the remarks of Athabaskan Elder Belle Deacon at an Elders Conference in Holy Cross: "She reminded them that the older people had always taught the younger ones how to be people. Women, gathering food, learned the lives of small animals and plants, weather, habitat, and proper behavior; men and boys gathered in the kashim. 'That's how people learned,' she said."

McNamara writes that, as the young people learned from the older people in the village, "what was, and is, valued in this way of life is the relation of mutuality built on shared experience, and what is identified as knowledge is, in the highest degree, recognized as the artful combination of an alert an observant spirit, physical facility, long experience, proper technique, and reflection...."

In all of the biographies, we get a strong sense of the importance of personal freedom and volition and how this is respected in the education of a person. For instance, it was Jennie Thlunaut's own interest that prompted her mother to show her how it was done properly, and in Holy Cross when young people want to learn something they go to the older people.

Other cultural values reveal themselves as we read how and what these artists learned. One is the complex concept of *luck*, which has "to do with respect owed to all beings, persons, and animals" (McNamara). This concept is crucial in traditional Athabaskan learning, but as McNamara notes, we must wonder how well it is conveyed when "Native subjects" such as sled making or fish trap making are taught in today's schools: "What the old people taught, I was told, was how to put something special into a sled, or what to use on a trap or snare to make it effective, to bring good luck. Even more important, young men were taught how to behave respectfully, so they would not offend the animals, for offending the animals would ruin their luck. People of that generation shake their heads: how can the school teach this? Good luck in the woods is not a technological matter."

The theme of *respectful behavior* is a common thread woven throughout all of the biographies. In the Nick Charles biography, Ann Fienup-Riordan deals with the concept of respect in the context of Yup'ik cosmology and the importance of vision, or sight. To cite just one example, downcast eyes are a sign of respect and of restricted vision. A Yup'ik person must learn the power of vision, when to use it, when to restrict it. As Fienup-Riordan writes, "In all social as well as ritual situations, in fact, direct eye contact was traditionally, and continues to be, considered rude for young people, whereas downcast eyes signify humility and respect. Sight is the prerogative of age, of knowledge, of power." The more we begin to understand this concept of respect, the more we will understand the attitudes necessary to the hunter, the dancer, the carver. We will begin to understand a Yup'ik world view and its manifestation in artistic expression—in story, song, dance, and in the masks.

In addition to the attitude of respect, another attitude that marks the education of these four artists is belief in hard work. Nick Charles is characterized as ambitious, innovative, energetic, always working hard to improve his family's situation. Rosita Worl and Charles Smythe

write that Jennie Thlunaut is known as one who "works steady." While many weavers took two years to finish a Chilkat blanket, Jennie, by working steady, would finish one in two months. When speaking of her own education, Jennie "expresses gratitude towards her mother for her ability to work 'steady' until her task is completed. She credits her mother for teaching her to make things properly, which includes taking initiative and working diligently until a task is completed."

In the biography of Frances Demientieff, Katherine McNamara writes of Frances that she worked "steady all the time." As a young widow with a family of five to support, she cooked, minded children, scraped seal-skins, cut wood, checked fishnets and traps, sewed, and knitted.

Sharon Moore and Sophie Johnson write that Lena Sours is characterized by members of her community as a hard worker: in the winter she is busy "sewing, sewing, sewing." Even today, when she can no longer see well enough to make parkas, when as she says, "arthritis makes me slow. Slow to push the needle....No more make parka. No more make mittens. Except Eskimo doll making and mitten harnesses made of yarn....I'm never idle. That's how we were raised. We had to sew."

Historical and Social Contexts

A third exhibit theme has to do with the historical and social contexts for the art. We have seen this to a certain extent in the discussion of the education of the artists, and more broadly, in the discussion of the concept of the artist in society. Although there is a school of thought that says we need only see the art object, that all this other information is not essential to our appreciation of art, I think these four biographies offer much evidence to the contrary, especially if we are looking at art from a culture other than our own. It seems to me that it is not any "universal aesthetic," obvious technical expertise, or similarity in motif and design that give the works by these artists their power. Rather it is the precise expression of the very local village aesthetic. What does it mean to know that the red clay used by Nick Charles to paint the rings encircling his masks comes from a place near the center of Nelson Island where it is said that Raven's daughter had her first menstruation? To learn what Holy Cross women who do beadwork mean when they talk about "Shageluk Blue," or to become acquainted with the narrative dimension of Holy Cross parka borders? And how are we to understand Lena Sours' work without a knowledge of the concept of "fancy" as it is used in "fancy parka" or "fancy muk-luks"? We will find that the more we learn of Tlingit society and clan relationships—what it means to know your relatives—the greater our appreciation for Jennie Thlunaut's weaving will be.

Each of the biographies is quite specific in detailing the connections between place and the artist's work. We learn the local sources of furs and skins, wood and roots, colorants, and even designs. We also learn the social networks through which these materials are acquired by the artist, and hence the social nature of the work. This social dimension may be further intensified once the work is completed and begins to function socially: a mask used in a dance in Bethel, a Chilkat robe displayed at a potlatch in Klukwan, beaded altar cloths adorn the local church in Holy Cross, fancy parkas worn by relatives and friends on special occasions in Kotzebue. Katherine McNamara has talked about how we might best understand Frances Demientieff's work by returning to the older notion of art, to thinking about art as "sacramental," where "works are the expression of love in the form of objects which give pleasure as they provide comfort and ease."

Knowing the social as well as the historical and cultural dimensions of the work enhances and deepens our understanding. Placing works of art in a historical context means understanding which kinds of work are done at which stages in an individual's life, and also placing the works within the history of the artistic traditions they represent. Jennie Thlunaut is regarded by many as the last of the traditional Chilkat weavers. She is a practitioner of a type of weaving that is now rare. Within the past few years, a number of younger Native women in southeast Alaska have begun to learn, but the art of Chilkat weaving is still truly an "endangered species." On the other hand, the number of Eskimo women who make fancy squirrel skin parkas is much greater and the tradition more vital, at least among women aged forty or older. When we look at the tradition of Yup'ik mask making, Ann Fienup-Riordan writes that we should see Nick Charles not as the last of a dying breed, but as a forerunner in the revitalization of an important traditional art form. In comments which have much broader implications, Katherine McNamara writes of the vitality of traditional culture in Holy Cross: "I have heard often from non-Native people that the old customs are 'dead,' or that Holy Cross people have become 'assimilated' to non-Native life and have given up their own form of relationship. As an outsider, I do not intend to try to define in such a way identity or the 'loss' of identity. What seems more important is to understand what Holy Cross people mean when they speak of their identity, without assuming one can easily know what has 'changed' or become 'different.' In matters of identity, what stays the same is at least as important; and an outsider must try to learn what 'same' means."

Being specific as possible about the historical context of traditional Native arts is important for another reason, and that is as a corrective to the tendency to present tribal art in general as if it existed in a timeless realm—"in the olden days"—as if creativity and change

were recent inventions. In fact, traditional artists are always incorporating new materials, tools, or techniques into their work, and they are doing it without violating the authenticity or cultural validity of the work. The traditional artist knows well which elements of the artistic process can be changed without affecting the cultural significance or appropriateness. Nicholas Charles' use of felt-tip markers on his masks is more likely to violate a non-Native's sense of what is traditional and Native than it will any Yup'ik person's.

Cultural and Spiritual Contexts

Chilkat blankets are often made for specific individuals, and they are worn by members of certain clans for certain ceremonial occasions. The designs on the blankets identify the wearer and establish the relationships among people present. Knowledge of how one is related to others is very important. Chilkat blankets express these relationships and intensify them through display and presentations at potlatches. As Worl and Smythe write, "Weavers were often commissioned to make Chilkat blankets to commemorate events recorded in a clan's traditions. Chilkat blankets were also given away in potlatches. Sometimes they were even cut up and distributed among the guests...." Jennie Thlunaut makes some blankets for outright sale to non-Tlingits. She is commissioned by Tlingits to make Chilkat blankets and shirts, and she has made and given away blankets and shirts to family members. "Many of these Chilkat blankets and shirts remain the property of clans. Clans also own the rights to specific crests. Jennie is always careful to ensure that she weaves only those crests on the blanket and shirts to which the Tlingit recipients of the blankets or shirts have property rights. For instance, she would never weave a Raven crest for a Tlingit who is a member of the Eagle clan" (Worl and Smythe).

In the biography of Nick Charles, Ann Fienup-Riordan presents an extended discussion of the cultural dimensions of masks and Yup'ik imagery. The story she tells of the carving of the Issiisaayuq mask by Nick Charles of the 1982 mask-dance project provides an entree to Yup'ik cosmology and to an appreciation of what Nick meant when he said the mask was the "eye of the dance." When we begin to look at the cultural context of the mask we may be surprised to learn that "for Nick, the finished mask is no more important than the wood chips from which it has been so laboriously separated. Skillfully executed in order to please and 'draw' the spirits of the game, traditionally it would have been thrown away after the performance." Fienup-Riordan points out that "today, Nick will sell his masks or give them to his children. For him, either alternative is acceptable. What is important to him is the process of making the mask and the dancing behind it."

In writing of Frances Demientieff's beadwork,

Katherine McNamara says that despite the economic importance of handiwork as a source of family and personal income, it is never viewed as a commodity. In Frances' masterpieces, the beaded altar cloths for the Catholic Church, we see the intense spirituality which may be embodied in beadwork, where "each bead is a prayer." The altar cloths make visible the fusion of Athabaskan and Christian values, especially in the central image of the loaves and fishes which is represented by a salmon and a birch bark basket filled with bread, with the flowers of Frances' world twining out along both sides.

In Lena Sours' biography, Sharon Moore and Sophie Johnson talk about the current socio-cultural realities in the northwest Arctic, and we get a glimpse of how traditional cultural values are being carefully nourished and promoted in a quite contemporary context, and how Lena Sours and other Elders play key roles in this effort. Moore and Johnson write that "since 1971 and the Settlement Act, Native regional corporations have been searching for ways to integrate their corporate and cultural responsibilities. In northwest Alaska, the NANA Regional Corporation has relied on the Elders to help ensure the continued survival of the Inupiaq people." NANA initiated the Inupiat Ilitqusiat Program—the Inupiat Spirit Movement—which has identified seventeen critical human values that have contributed to the survival of people in the Arctic. Lena Sours has been a leader in this program stressing the relevance of traditional Inupiaq values in talks to schools, with Elders, in planning "Inupiaq Days," and in meetings to deal with social problems such as alcohol. Moore and Johnson write that perhaps Lena Sours' "greatest contribution is the lesson that adapting to modern life does not require us to sacrifice our identity as Inupiat."

Style

The last exhibit theme to be explored in the exhibit is the interplay of individual and cultural aesthetics which informs the art. The life history format itself is one approach to this theme. Understanding Chilkat weaving as it developed in the life of Jennie Thlunaut, or knowing how Frances Demientieff goes about her beadwork, leads us to acknowledge the individuality that is present in even the most traditional arts. This theme is especially important in understanding art from outside a culture, where, on a superficial glance, everything may look very much alike. Tribal arts are frequently characterized as unimaginative or uncreative, not because they are so, but more often simply out of ignorance of the cultural "rules" they are operating within, and consequently, ignorance of what constitutes innovation and individual style or expression.

There are a lot of us who can recognize a "fancy" fur parka. Fewer of us, though may be able to distinguish

what Kotzebue skin sewer Dolly Spencer calls "Above the Arctic Circle Style Fancy Lady's Parka," and perhaps only residents of Kotzebue will be able to pick out a Lena Sours' parka at the fashion show during the annual Northwest Arctic Trade Fair. Nonetheless these are regional and personal styles, easily recognized by those "in the know."

As Katherine McNamara has noted in her discussion of Frances' work: "In Holy Cross, no woman had to put her name on a piece of work; everyone who saw it could tell just by looking who made it. In the Interior, women usually can tell which village a particular piece has come from and often they can name its maker. This is true for beadwork, which, across the subarctic, often is worked in floral motifs. It is true for skin clothing and decoration, such as the 'fancy' on parkas. It is true for the skin applique work which is a favorite form in Holy Cross and villages downriver." McNamara also writes that "innovations in materials and willingness to experiment are admired, within certain bounds, which are perhaps felt rather than set out."

In Chilkat weaving, blanket designs are made by the male artists for the weavers. Although one may be obliged to design a Frog crest or a Bear crest, the latitude for interpretation is substantial. For Tlingit beadwork and basket patterns, women do create their own designs, again within a range of possibilities—both technical and cultural. Recent research by Peter Corey, a specialist in Northwest Coast Indian basketry, has shown that individual weavers can be identified by the designs on a basket.

The design process for Yup'ik masks is yet a different situation. Traditionally, the shaman gave the carver the general outline for a mask to be carved which was based on the shaman's dream or vision. There were no drawings. Then, as Fienup-Riordan writes, "the carver was left on his own to conjure up the required image in his mind's eye. Some conventionalized forms were followed....However, the precise way that these representations were played out was left to the carver's imagination, and the result was a stunning variety of interpretation." Fienup-Riordan describes the mask making process today, following each step from Nick Charles' gathering wood through the actual carving and painting. She says of constructing the appendages affixed to the rings which encircle a mask: "Nick remarked that this area of the mask can be an outlet for the imagination, as well as the prerogative to carve more conventionalized body parts." Nick recalled the time he was teaching carving at the high school in Kasigluk, when a young female student had carved a mask that was a woman's face, and she then carved mukluks, mittens and other "women's things" for the appendages. Nick was quite struck by this. Nick Charles' own masks are usually bird masks. An owl mask by Nick Charles is immediately recognizable as one of his pieces. Likewise, other Yup'ik carvers, Peter Smith and Edward Kiokun, are known for their loon masks.

The exhibition and these life histories can show us the styles of only four of Alaska Native artists. More important is the goal of making us aware of the significance of personal style and how it operates within the broader traditions of the community and the culture, including contact with other cultures.

Conclusion

As you read the four life histories, you will discover other connections and other parallels in the lives of the artists. Family and kinship ties are one, and the sad but common theme of the death of children and close family members is another. Each of these artists has had to deal with the circumstances of cultural suppression, and their own lives and artwork must be viewed in light of this.

The sense of place, movement over the land, "thinking by the seasons," and the significance of Native food emerge as extremely important concepts. With the help of the artists and their families and friends we have created maps to show the places and routes to which and over which these individuals have traveled, and other maps to show the sources of the materials and designs used in their artwork. We hope these maps will convey graphically and even more directly the geography of their lives and their art, the critical reality of what is more generally called a "subsistence" way of life. Take keen pleasure in reading about the lives of these extraordinary individuals, and when next you look at Alaska Native art, consider the artists behind the work.

Suzi Jones
Guest Curator

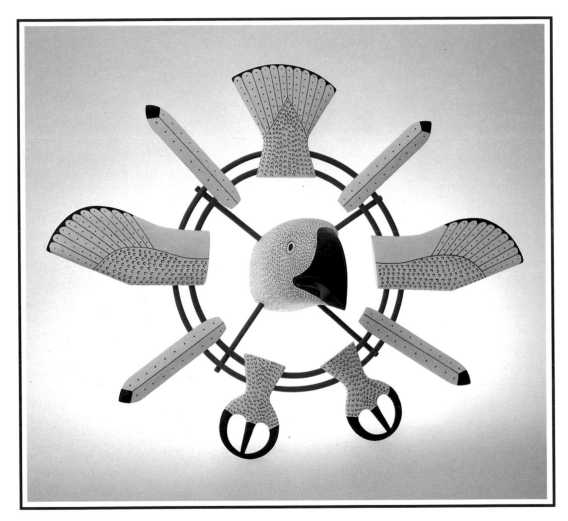

Hawk Mask by Nick Charles, 1985.

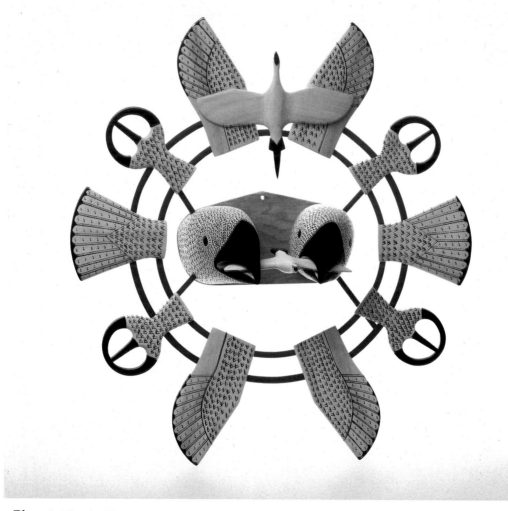

Plate 1. The double hawk mask by Nick Charles won a merit award in the 1980 Statewide Native Woodworking competition. Yugtarvik Regional Museum collection.

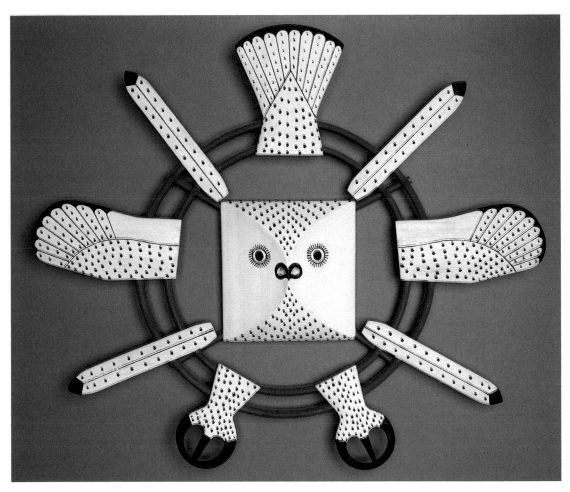

Plate 2. Owl mask by Nick Charles. The snowy owl was the shaman's watcher or guardian bird and was said to be endowed with supernatural sight.

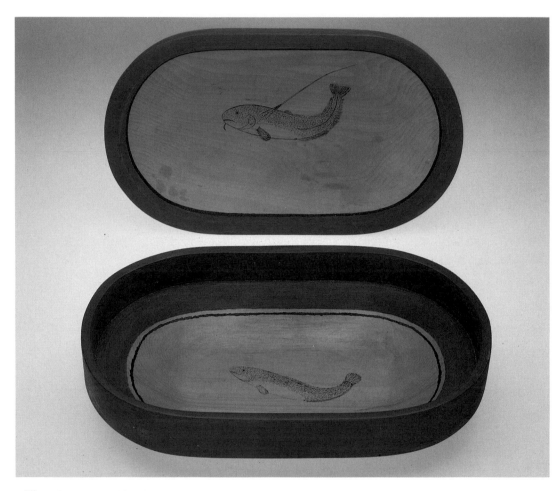

Plate 3. Bentwood bowls carved by Nick Charles. With a rim, it is a woman's bowl; without a rim, it is a man's bowl. The loche fish and bird spear design is equivalent to a family crest and is based on a legend in Nick's family. Some old people were corralling ducks and geese in the summer. One bird escaped and was followed by one of Nick Charles' grandparents. The bird fell into a dry slough where the tide was out. When the bird was speared, it turned into a loche fish.

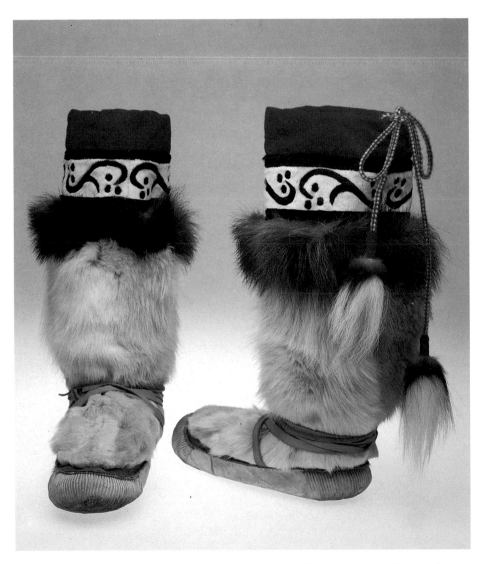

Plate 4. These fancy mukluks were made by Frances Demientieff for Alice Nerby to match the fancy parka shown on page 93. They are made of wolf, calfskin, sealskin, and wolverine.

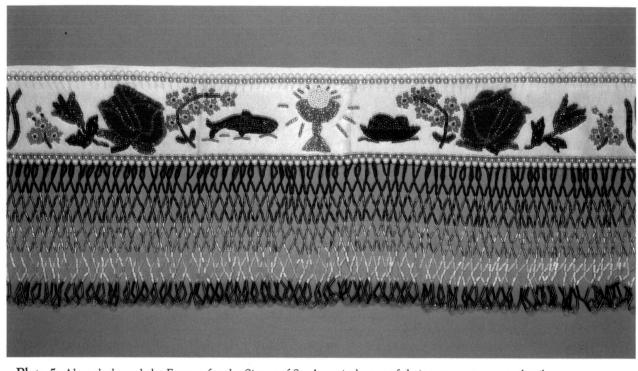

Plate 5. Altar cloth made by Frances for the Sisters of St. Anne in honor of their centenary, center detail.

Plate 7. These beaded slipper tops are examples of the floral patterns Frances likes to use. The red and yellow flowers were designed from a flowering plant received as a gift from a florist shop.

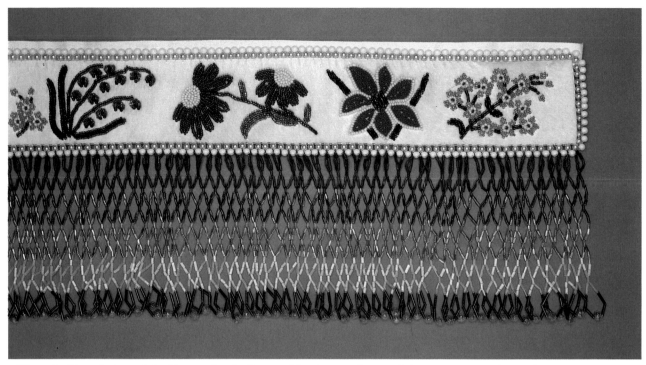

Plate 6. Altar cloth made by Frances for the Sisters of St. Anne in honor of their centenary, side detail.

Plate 8. Beaded elkskin pillow made for Frances' daughter Alice Nerby.

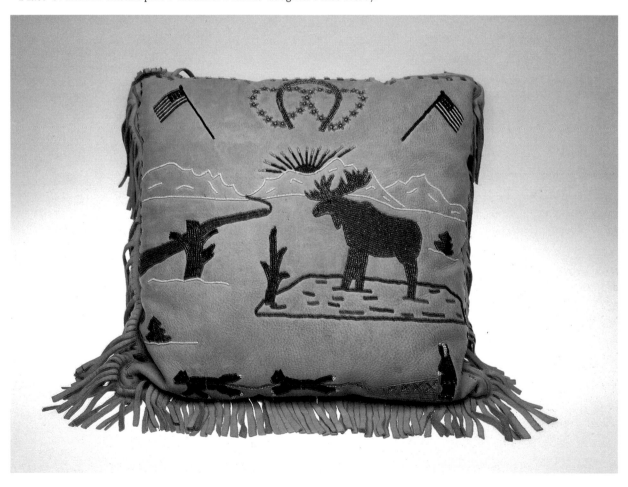

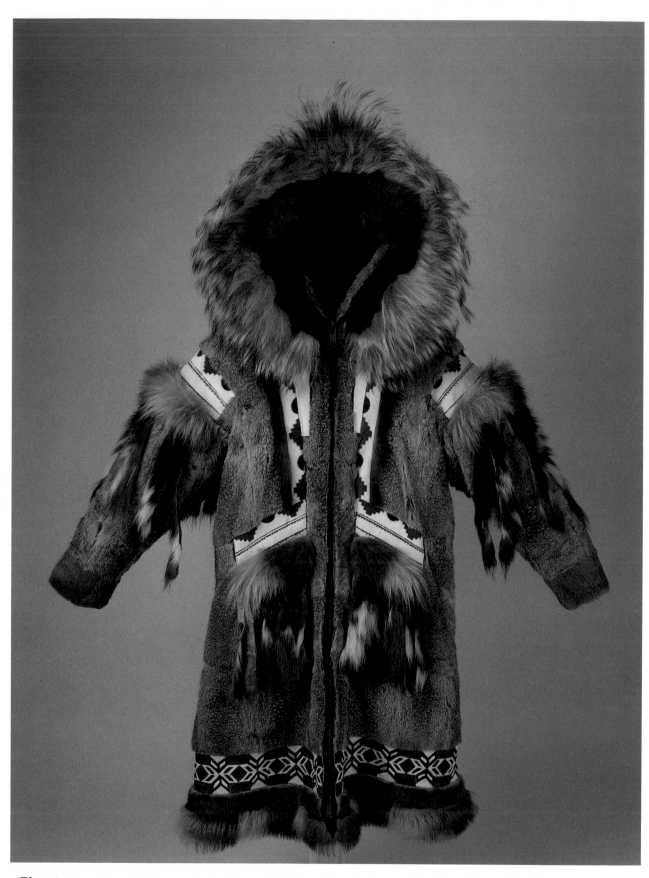

Plate 9. Front view of a fancy squirrel parka made by Lena Sours for her granddaughter Maureen Reich.

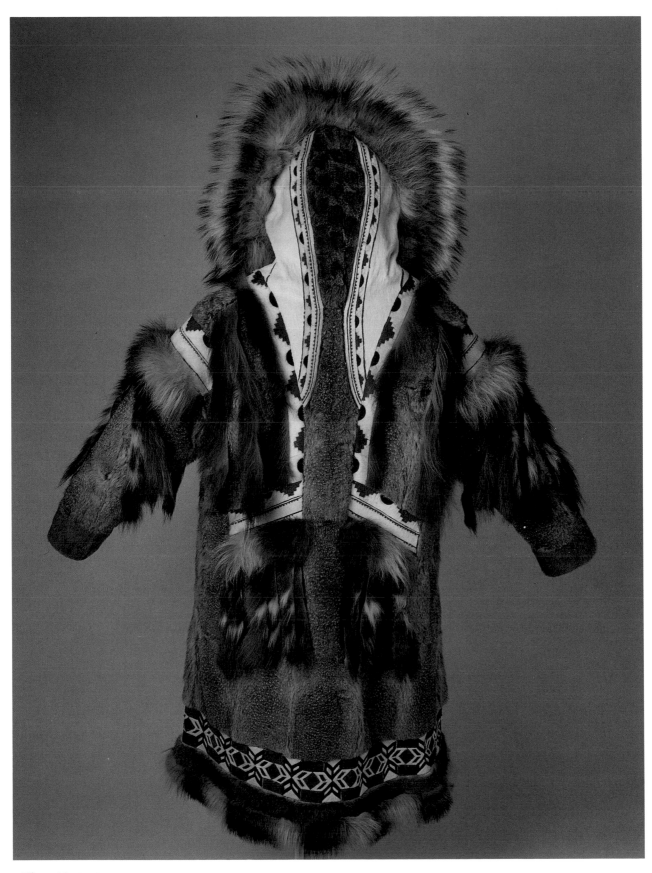

Plate 10. Back view.

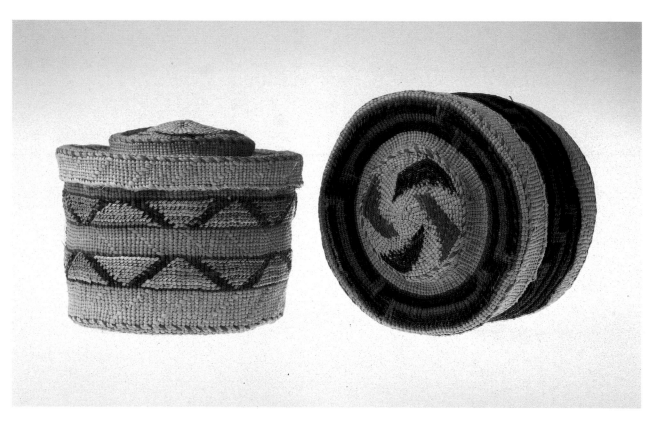

Plate 11. Spruce root baskets made by Jennie Thlunaut. The basket on the right was made for Emma Widmark. Left basket, Sheldon Museum and Cultural Center collection.

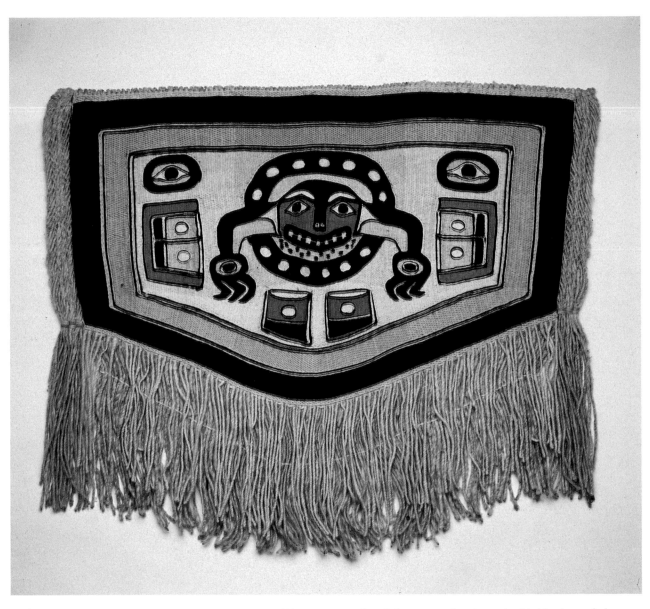

Plate 12. Small Chilkat blanket with crest design of Frog emerging from hibernation. Jennie made this blanket to help pay for one of her daughter's tuition at Sheldon Jackson College in Sitka. Sheldon Jackson Museum collection.

Plate 13. Chilkat blanket with Raven design, ca. 1968. Owned by Mary Hamilton, Fairbanks.

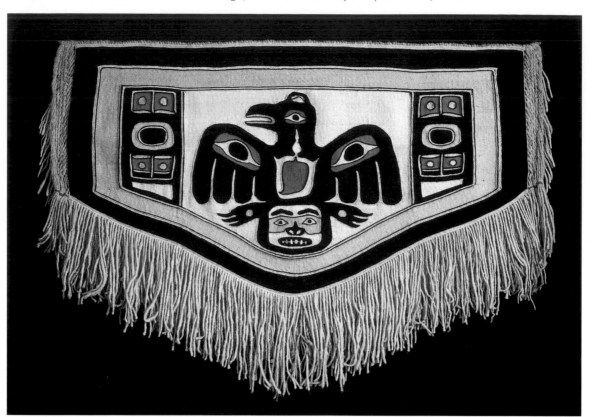

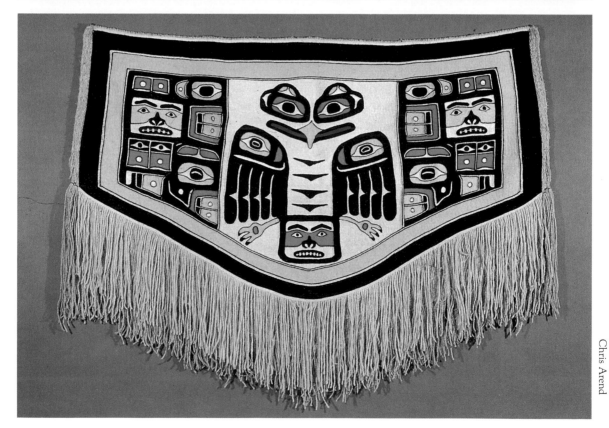

Chris Arend

Plate 14. This Eagle crest blanket was commissioned in 1964 by Rosita Worl, Jennie's granddaughter.

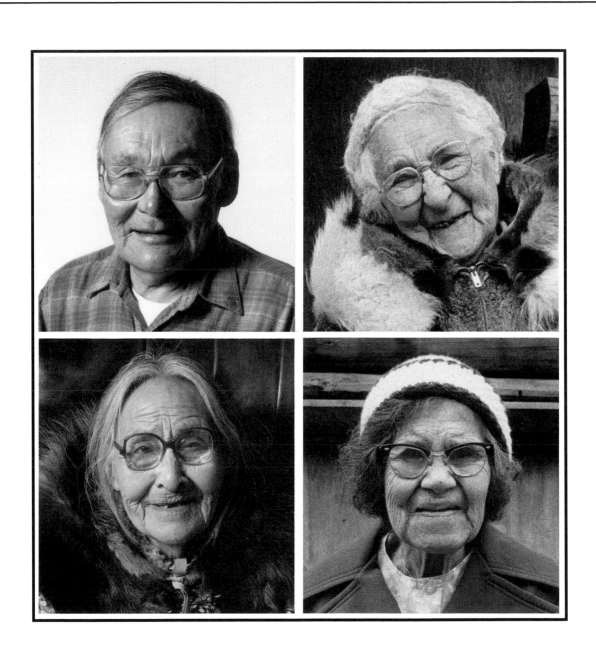

23

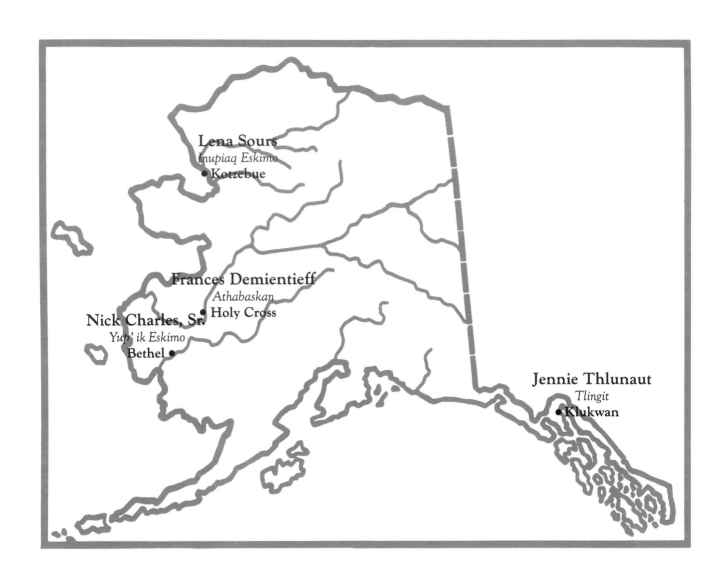

Lena Sours
Inupiaq Eskimo
● Kotzebue

Frances Demientieff
Athabaskan
● Holy Cross

Nick Charles, Sr.
Yup' ik Eskimo
Bethel ●

Jennie Thlunaut
Tlingit
● **Klukwan**

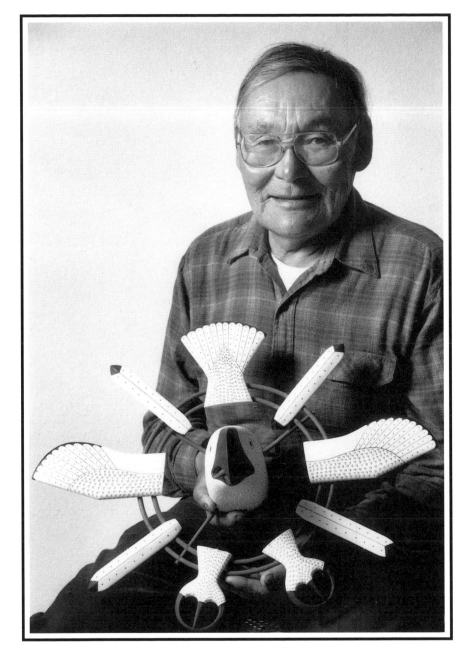

NICK CHARLES, SR.

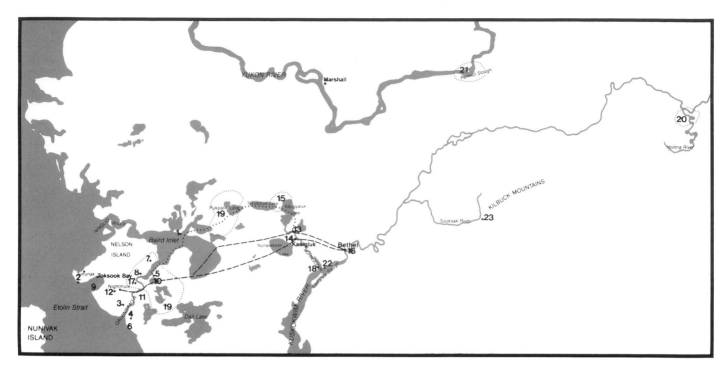

1. **Kagnasuk Lake**
 Nick's birthplace, ca. August 1910.

2. **Up'nerkillermiut**
 Nick's family's spring sealing camp.

3. **Nuturllirmiut**
 Nick's family's winter camp, ca. 1917.

4. **Arayakcaarmiut**
 A winter fishing camp during Nick's childhood.

5. **Qinaruk**
 A winter camp and fishing area.

6,7,8. **Spring hunting and fishing camps**
 during Nick's youth.

9. **Kangirrluqq Bay**
 Nick's father hunted seals from a kayak.

10. **Qinaruk Lake**
 An area for gathering seagull eggs.

11. **Qalvenraaq River**
 Nick's family summer and fall fishing area.

12. **Kassaurlut**
 Site of the traditional men's house, in which Nick grew up.

13. **Nunacuar**
 Nick's family moved here, 1929.

14. **Kasigluk**
 Nick's family relocated here, ca. 1932, and where he met Elena, ca. 1936.

15. Area where Nick worked as a reindeer herder.

16. **Bethel**
 Nick and Elena were married here, 1936, and have lived continuously since 1943.

17. **Pengurtalek**
 Nick and Elena's fall and winter home, ca. 1937-1943.

18. **Naparyarraq Slough**
 Elena's family's fish camp since mid-1940s.

19. **Fall trapping and hunting areas**

20. **Holitna River area**
 Fall moose hunting

21. **Paimiut Slough**
 One of Nick's hunting areas since 1970s.

22. **Nick and Elena's current summer fish camp.**

23. **Camp Nyac**
 Location of the annual Catholic church retreat for deacons.

-------- **Dogsled routes**
 from Qinaruk to Nightmute, Kasigluk, and Bethel. As a boy Nick Charles accompanied his father over these routes to trade furs for groceries.

........ **Route of summer boat trips**

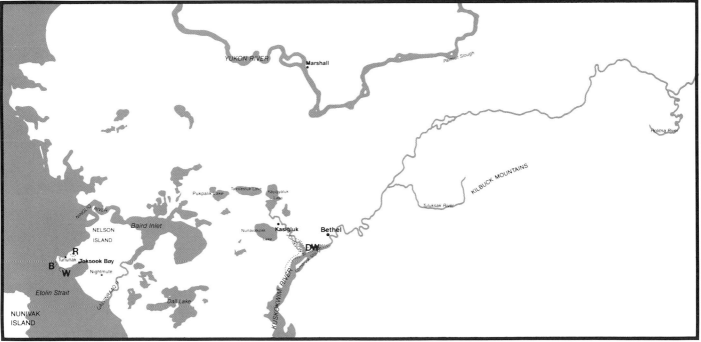

R Red clay

B Blue clay

W White clay

DW **Driftwood roots**
gathered from beaches of the Kuskokwim River
and the Johnson River.

Feathers

The feathers and quills of birds throughout the delta
were used in the making of masks and dance fans.

Page 25: **Figure 1.** Nick Charles, Sr. Bethel, 1985.

INTRODUCTION

The following pages discuss two separable although closely related concerns. The first is the clear and accurate documentation of the life and times of Nicholas Charles, Sr., the man as well as the artist. His story is presented in order to frame his work, and conversely, his work with all manner of wood is discussed in order that the reader comprehend what has been most meaningful in his life. It is perhaps a paradox that while Nick is recognized as an expert mask maker, this role is more incidental than central to his identity. This is not to say that his work is not skillfully executed, but rather that his skill has been drawn from working with wood in a multitude of other ways, just as the meaning of his work comes from a personally unique life and culturally unique perspective on life.

The second subject of the life history is the cultural significance of the mask that the carver creates. Here the mask is seen as the "eye of the dance," and vision imagery in Yup'ik iconography is discussed in some detail. This interpretive discussion stands on its own and is not the necessary appendage of a life history in a strict sense of the term. However, its inclusion represents my attempt to combine what are too often held at arm's length in biographies. It allows the manuscript as a whole to combine personal and cultural symbolism. It also allows Nick's unique story to add to what is known about cultural processes, such as the reactivation of a cultural complex. The descriptive and the analytical are never separate and mutually exclusive. On the contrary, there can be no description without an underlying cultural framework, whether implicit or explicit.

AFR

NICK CHARLES, SR.
Worker In Wood

by
Ann Fienup-Riordan

Nicholas Charles, Sr. is a father and grandfather, a husband and provider, a leader and respected elder of the community of Bethel. During his life he has built boats and houses, sleds and fish traps. He has carved bowls and paddles and jewelry and toys. He also makes masks. Beautiful, powerful masks. This is the story of his life, and the changing world in which it continues to be played out.

The World of the Carver

Nick was born on the north shore of *Nanvaruk*[1] (Baird Inlet) in August while his parents were hunting ducks at the mouth of Kaghasuk Lake. The year was around 1910, and Nelson Island, lying just off the Bering Sea coast midway between the mouths of the Yukon and Kuskokwim rivers, was still largely untouched by the amenities of Western society.[2] The Qaluyaarmiut who made it their home still moved over the breadth of the island in search of food and clothing. The places where people have since concentrated into permanent communities were only seasonally occupied. Instead of maintaining permanent residences, families and family groups engaged in a constant movement over the landscape, living in temporary camps or in the semi-subterranean sod houses built at more permanent winter villages (fig. 2).

Nick's memories of his early years are scattered. He described them with the Yup'ik base *ellange-* (to obtain awareness, to come to one's senses, to get a glimpse of reality): "It was just like I was asleep, and then I get up and then sleep." The first time he woke up to his surroundings was at *Up'nerkillermiut*, a spring camp on the north shore of Toksook Bay where people from all over the area came to hunt seals. He had on his skin boots and his parka and was going out of the house early in the morning. Then he forgot again.

Nick woke up many times in his very young years, but always in different places. In the winter, in 1917, he again caught a glimpse of the world that he could hold in his mind's eye. He was staying with his parents and sister at *Nuturllirmiut* in the flat puddle-laced tundra along the southern edge of the island. They were alone and no other families shared their camp. *Arayakcaarmiut* and *Qinaruk* are other winter camping places he remembers from his youth. All of these sites were rich enough in blackfish, needlefish, and whitefish to see the family and its dogs through the cold midwinter months when food was most difficult to find. When spring came, the family would often move northeast towards *Cakcaak* and *Urumangnak* Slough, where muskrats and loche fish were taken in abundance. Moving in the opposite direction, Nick remembers the seals his father would bring home after a day's hunting by kayak in *Kangirrluaq* Bay. Birds and bird eggs were also hunted along the low, marshy coastline. A small island in the middle of Qinaruk Lake was remembered as a haven for sea gulls and a prime gathering area for their eggs. During the summertime the family would move down to the banks of the *Qalvinraaq* River for fishing. "Fishing, fishing, all the time!" There some salmon were taken, along with tom cod, sculpin, and flounder. Later in the fall, loche fish and whitefish could be netted from the Qalvinraaq before Nick's family moved away from its banks back to the tundra camps for the winter.

During the period when Nick was growing up, most of the technology remained traditional and the food was largely harvested locally. The kayak, *angyaq* (open skin boat), and dogsled remained the chief means of travel

and transport. However, the gun had been introduced along with many other useful trade goods. A half-Russian trader living in Tununak supplied the *Qaluyaarmiut* with tea, flour, metal tools, and ammunition from a small log store. In his youth, Nick would accompany him on trading trips by skin boat south to the mouth of the Kuskokwim and north to St. Michael for supplies. While they were gone, Nick's uncle's family would track their progress in the traditional counterpart of the CB/TV. A large wooden bowl (*qantaq*) would be filled with water and covered with a paper-thin piece of dried gut. As long as the travelers remained south of Hooper Bay, the surface of the water showed black. But as they passed the mouth of the Yukon delta, their images became clearly visible and their safety established.

Acting as a lay pastor for the Russian Orthodox Church, the trader in Tununak did something towards converting the Qaluyaarmiut. His work was followed by that of the Catholic priests coming down from St. Michael. Although they visited the area in 1888 and worked briefly in Tununak in 1889, they made little progress. The Qaluyaarmiut were left virtually undisturbed until the late 1920s, when a government school was opened in Tununak and traveling priests again made Nelson Island a regular port of call.

Because of the neglect that Nelson Island experienced relative to other parts of rural Alaska, Nick was born into a world retaining both traditional contours and contents. No formal schooling was available. Instead, Nick grew up in the *qasgiq*, or traditional men's house, where he ate and slept with his father, uncles, brothers, and cousins:

> *Gee, I like that time long time ago,*
> *when I was young.*
> *Get up in the morning.*
> *My bow and arrow.*
> *Grab them all the time, everyday.*
> *Get the bird, the fish. . . .*
>
> *We got no blanket that time.*
> *Even wintertime no blanket.*
> *No mattress.*
> *Just sleep on the floor.*
> *Us boys,*
> *even men too,*
> *no sleeping bags.*
> *Use the parka.*
> *Bird skin, squirrel skin parka.*
> *Duck skin too.*
>
> *Not many white people long time ago,*
> *that time when I was young.*
> *We never see no school house. . . .*
>
> *In the early morning we get up before daylight.*
> *The women in the family give us fish in the*
> *qasgiq,*
> *Mostly ate frozen fish, needlefish, loche fish,*
> *pike fish.*

(Charles 1983:Tape 1B 95-152)

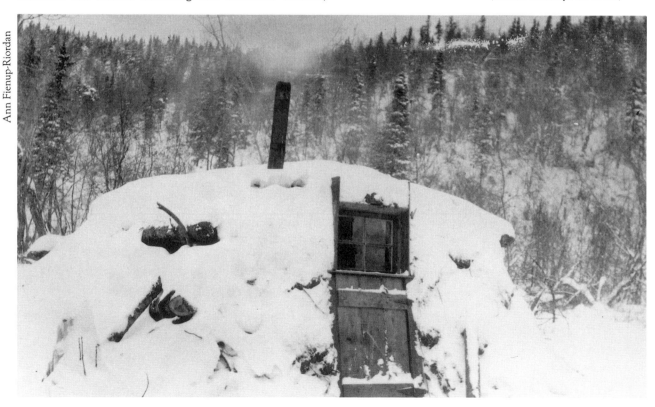

Ann Fienup-Riordan

Figure 2. This semi-subterranean sod house is similar to those used during the period of Nick Charles' childhood.

Nick remembers sleeping alongside *iluraat* (male cousins), now long dead, on the floor of the big men's house at Kassaurlut to the south of present day Nightmute. There the boys would put old mittens under their heads for a pillow. The qasgiq had no heat, but Nick remembers a sound sleep.

In the winter, the frost and ice would grow thick on the walls of the men's house. To alleviate the problem, as often as the wood supply permitted, men would remove their possessions, light a fire in the center of the room, and take a sweat bath. The heat would make them lazy, and those would be the evenings that the older men would tell stories until late at night:

> Even the birds: would be stories about
> their color.
> Because in one big community hall they're all
> gathered.
> Those birds, and they color each other, they
> paint each other. . . .
> This loon and tulukaruk (raven/crow) color
> each other.
> Crow used to be all white
> and little black spots on the back,
> and around here would be black with
> white spots.
> Loon colored crow.
> And he told him not to laugh if he'd put
> trimmings around here.
> He colored him.
> Loon has a black back and white spots,
> and a white front.
> And then he paint crow black front
> and white back
> and put little black spots. While he
> was doing that
> he told him not to laugh
> when he colored his neck,
> when he put colors, spots.
> While he was doing he laughed,
> and when he laughed he hit black,
> what he mixed.
> He colored all of him and run out!
> While he was on the door,
> crow take ashes on his head where
> he was black.

(Charles 1983:Tape IB 544-609)

Listening to stories like this one, telling of a time when the worlds of men and animals were not so far removed from each other, Nick learned natural history through Yup'ik eyes, along with the rules of behavior which held for animal as well as human society. He was also absorbing images which he would realize in his own time in wood and paint, white clay and ashes.

But first he needed the skills that would enable him to shape the wood. These he would learn from his father as well as the other men in the men's house. After an evening of stories, Nick would wake to a slow morning chant sung by the older men in the men's house. Then he would watch them work, asking no questions but observing each step minutely before trying it himself:

> I learned from my dad.
> The only way the men worked was on
> the wood.
> Making fishtraps, splitting wood,
> making sleds, making kayaks.
> Even the houses were wooden.
> All from driftwood

(Charles 1983:Tape 1B 242-291)

Indeed, traditionally, all Qaluyaarmiut, and in fact all Yup'ik men worked in wood, bone, and ivory in order to manufacture the tools needed to exploit the natural abundance of their environment and turn its resources to their advantage. Women, on the other hand, were responsible for sewing and mending the skin and fur clothing needed to keep the family warm and for weaving the grass mats and *issratet* (woven grass pack baskets) for household use and food storage. Men also worked with skin or grass as called for in their wood working, using sinew for haftings and bits of fur and feathers for mask decorations. However, they excelled in carving. Along with the above, they made bentwood bowls for serving food (plate 3), dippers and ladles, bird spears and paddles, arrows, bows, fish traps, and a plethora of essential hunting tools. All of these tools were shaped from wood, and in order to be a competent and productive member of the community, each man had to be a competent and productive carver as well.

It is paradoxical that this fundamental skill was practiced on a material not native to the region. The tundra coastline is treeless, except for stands of scrub willow and alder. The spruce and cottonwood that were so essential for carving were salvaged from the shoreline as driftwood. Boys learned early which pieces were usable for making tools, and which would be relegated to fuel for the steam bath.

The wood must be soft and light but not too dry. Stumps were especially good, particularly the roots that had grown underground. Good wood for carving is harder to find these days, as regional growth and expansion since the first part of the twentieth century have eaten away the previously abundant stores of the delta coastline. Now Nick must keep a sharp eye out for good wood whenever he travels by boat up or down the Kuskokwim in order to meet his needs.

The tool kit that Nick watched his father use was a simple but effective one, including a *kepun* (metal-edged adze) and a *mellgaraq*, a small knife with a curved blade—often referred to as a crooked knife (fig. 4). Simple wedges and wooden mauls were also used to split the wood. A hand drill was employed, as well as various

granular stones, obtained from local stone outcrops, to shape tools, to polish, and to sharpen. Some chisels and burin-like implements were also used, as were two pointed sticks fastened together to incise or mark true circles. Later, as trade goods became more readily available, Nick remembers the addition of a small hand saw, pocket knife, and metal file to this basic kit. He has since added several grades of sandpaper to his father's original repertoire, along with power tools, including a small electric chain saw and an electric drill. However, the adze and crooked knife remain his principal carving tools, and he could easily carve a mask or a bowl without making use of any of the modern accessories.

To acquire the skill to create strong and well balanced hunting equipment and household goods using only an adze and a crooked knife is no small accomplishment and required hours of patient observation and practice. Men lived in a world carpeted with wood chips. In fact, the quality and quantity of the shavings surrounding each man's place in the qasgiq were a visible mark of his energy and skill. Nick remembers sitting by his father as he worked on the wood ribs that would frame a new kayak. He would handle the woods chips, as well as his father's tools when they were not in use. The crooked knife, a combination cutting edge, gauge, and plane, requires perfect control to be effective. Nick would grasp

it in the palm of his hand, with his thumb folded in on the blade, and the handle resting against his thigh. He would hold the knife flush with the wood, as a sharp extension of his finger which then rubbed the wood's surface, shaving chips away in its path (fig. 5). If Nick made the angle too great or the pressure too strong, the knife would notch the wood or cut his finger. Like the potter's hand, he must move his tool evenly and easily or the cut would break the symmetry and throw the whole piece off center. Nick practiced long and hard to achieve this precision. His first carvings were small fish traps made from willow wood scraps he found on the men's house floor. He comments that many of the young men he tries to teach in mask-making workshops today do not have the skill necessary to carve a simple sled runner. How can they hope to move from wood to mask without anything in between?

Nick's father worked without measuring tape or ruler, and his son does the same. Measurement was traditionally all by sight, using body parts as standards for the individualized equipment each man required. For instance, the thin wooden splints which formed the body of the traditional funnel-shaped blackfish trap were normally measured from the extremity of the carver's left elbow to the end of the right hand, the right arm being extended (see also Barnum 1896:47 ff.). Models were

Figure 3. Nick Charles has not made many birch bark baskets, but its unique design represents innovation and craftsmanship.

Figure 4. The *kepun* (adze) and *mellgaraq* (crooked knife) are Nick Charles' primary carving tools. Nick made an *ulag* (a woman's knife) for his wife Elena.

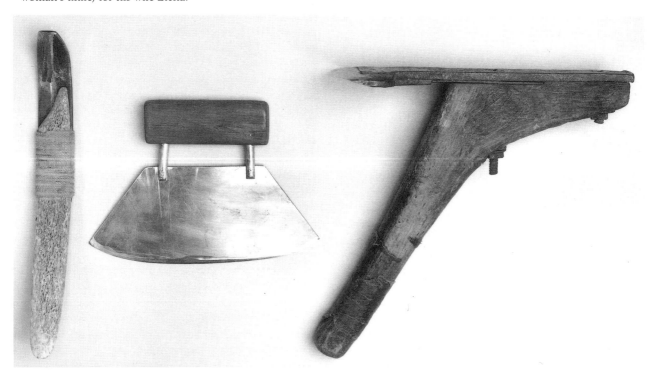

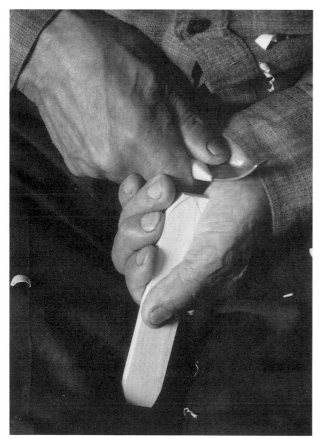

Figure 5. Nick Charles using the *mellagaraq* (crooked knife) to carve a feather for a bird mask.

never used, and no written instructions or diagrams were available. Each carver worked from a personal repertoire of shapes and angles that he had learned to calculate by watching the men work on their own tools in the men's house as he was growing up.

When Nick was growing up, all men were practiced carvers, just as all women were accomplished, if not expert, seamstresses. However, already the traditional arts and skills were on the decline. Although Nick watched his father building a kayak, he never built one himself. In his youth he used bows and arrows made for him by other older men. By the time he was a hunter and provider in his own right, the gun was the primary weapon he used in stalking birds and game. Even use of the wooden fish trap was growing less frequent. Also, although Nick watched some of the older men carving dolls and masks, these were few and far between. Even this work was grinding to a halt as Nick grew to manhood. For mask making was tied to the traditional dances in which they were used, and these were under attack by missionaries and teachers even before Nick was born.

Traditionally, although all men were carvers, only some made masks. *Agayuli(luteng)* (masked dances performed to the accompaniment of songs of supplication)[3] were discouraged by the Catholic missionaries, as were the traditional *Elriq* (Memorial Feast for the Dead) and *Nakaciuq* (Bladder Ceremony). The ambivalence that the priests' negative attitude generated did not, how-

ever, result in the immediate disappearance of these traditional ceremonies. The last Bladder Ceremony was held in Tununak in the mid-1940s, accompanied by the display of inflated bladders along with a performance by shamans who were said to fly through the room, out the solid wall of the men's house, and in again through the gut skylight. Also, although major memorial feasts drawing *allanret* (strangers or visitors) from all over the region and involving the distribution of tremendous quantities of goods were no longer held, a less elaborate version was preserved, one which Nick remembers watching as a child.

Although *kassiyut* (traditional ceremonial dances) were on the decline, including those which employed performances by masked dancers, traditional dancing as such was alive and well on Nelson Island during Nick's young years. Although he never danced himself, Nick remembers watching these dances during the long winters and learning and singing the songs that accompanied them. These he still remembers. First there were the short, slow songs that accompanied the dances that occurred just before freeze-up in the fall. Known as *Ingulaq*, these dances drew guests from the surrounding villages. Often they would involve the rebuilding of the qasgiq or men's house. Its contents would be removed,

the floor repaired, and the benches replaced. New grass mats were brought to hang in the doorway, as well as a new gut covering for the central skylight. Working together, the repairs would be done quickly. After the work, everyone would gather in the evening in the refurbished men's house for the Ingulaq. Gifts, including both food and equipment such as traps and fish netting, would be presented to the visitors.

After freeze-up, another dance distribution was held, called *Kevgaq*. This was the Nelson Island equivalent of the traditional Messenger Feast, or Inviting-in Feast as it is sometimes called. It involved a series of performances in two or more communities in which the guests at the first feast subsequently played the part of hosts at a similar distribution held not long after.

Following the Kevgaq, Nick remembers taking part in *Intrukar(aq*)*[4], a third dance distribution involving its own distinctive song style and feasting configuration. According to Nick, Intrukar(aq*) was the direct descendant of the traditional masked dances that the missionaries suppressed. As with the two preceding dance distribution, Intrukar(aq*) involved an invitation to friends and relatives residing in different villages, and the exchange of gifts and food.

Nick's youth was thus spent on Nelson Island, moving

Figure 6. Nick and Elena are to right rear, Nunapichuk, 1942. Also pictured are (L to R): Mrs. Tinker, Mrs. Nichols (Elena's mother), George P. Charles (Nick and Elena's son), Olive Nichols, and Mrs. W. Albrite.

over its natural contours during the spring and summer, while learning the skills and social dictates of its human inhabitants in the men's house during the winter. However, in 1928 Nick's grandfather died at the family's winter camp. One of Nick's father's sisters had already moved with other relatives north along the coast toward St. Michael years before, settling permanently at Stebbins. Another paternal uncle had settled in Tununak and a maternal uncle had moved down the coast toward Quinhagak. The family was scattered, and the death of Nick's grandfather broke an important tie with the island. Nick's father and mother also decided to leave Nelson Island. In the spring, they went by angyaq (skin boat) east across Nanvaruk. When they reached the far side, they paddled and portaged toward the Johnson River portage. Altogether the trip took only two days and brought them to *Nunacuar*, one of the tundra villages and home of the Akulmiut who were in many ways as isolated and traditional as their coastal neighbors. There Nick lived with his parents and brothers and sisters during the winter, traveling back to Nelson Island to hunt and fish along the Qalvinraaq River during the summer. Each fall they would return to Nunacuar, eventually moving with the other residents to the new village site of Kasigluk (*Kassigluq*) when Nunacuar was deserted because of continued flooding.

As a young man, Nick thrived on this movement. Traveling with his uncle he had already seen and experienced more than other boys his age. Now, living closer to Bethel, the commercial hub of the region, Nick began to actively seek out ways to supplement the family income and take advantage of the modern conveniences increasingly available if one had the interest and energy to pursue them. While his family was at Kasigluk, Nick worked as a reindeer herder off and on for several winters. In the summer he took a job on one of the river steamers hauling freight up the Kuskokwim. Nick remembers this as hard work. Not only must wood be split and the engines constantly stoked, but unloading was often up a steep, soggy bank.

In 1936, Nick was back in Kasigluk for the winter. There Nick was getting to know a young woman named Elena. Yet Nick's parents had other plans for him:

My father let me get married to another
 woman.
I didn't marry, you know.
I didn't touch her.
It was one year.
Then I got my wife, Elena.

(Charles 1983:Tape 2 A 235-261)

Charles Family

Figure 7. Nick and Elena Charles with children George and Mary, ca. 1945.

Elena was eighteen at the time and had already turned down a number of suitors. She did not turn down Nick. The couple was married and stayed in Kasigluk for the rest of the winter, and together for the rest of their lives.

Not long after Nick and Elena married, Nick's family returned to Nelson Island, moving back to Qinaruk. Nick and Elena went with them. Later they moved across the Qalvinraaq River to *Pengurtalek*. In the summertime they would visit the Kuskokwim and Elena's parents who remained behind. They would sail south along the coast from Nelson Island in a large skin boat, and Elena can still recall the welcome smell of willows as they entered the river's mouth. But each winter they would return to Nelson Island. There their first son was born in 1938. Two years later Elena had another child, a baby girl. They were named George and Margaret. With the added burden of young children, and missing both the help and companionship of her mother and sisters, Elena grew homesick and wanted to return to Kasigluk. However, they remained on Nelson Island where Nick knew the land and could make a living for his family.

In 1941, while they were staying at the fall camp of Pengurtalek along the Qalvinraaq, a measles epidemic swept the coastal settlements. Although the tundra villages, including Kasigluk, were spared, Nelson Island was not, and Nick and Elena lost both of their children.

Nick also lost his older sister in the same epidemic. However, they stayed on Nelson Island until 1942, when their second son, George, was born. Elena remembers with bitterness the death of her eldest children and the attention her in-laws showered on their third child. Two years later they left Nelson Island for good, this time moving to Bethel where Nick began to ply old skills as well as learn new ones in order to support what, from this point on, would be a steadily growing family.

During their early years in Bethel, Nick left reindeer herding and freighting behind and began again to work in wood. One of his first jobs was at the sawmill, where he took his pay in rough cut lumber. This he used to build a small house, 16' by 16', in the summer of 1943. It had a small wood stove made out of an oil drum. This Nick soon traded up for a coal-burning stove, which was quickly replaced by an oil stove as soon as they were available in Bethel.

During the following winter Nick began work in Bethel in earnest as a carpenter. He had many of the necessary skills already. What he lacked he picked up by watching the men he worked with, including Jessie Oscar, his partner and close friend for many years. Nick's brothers Dan and Ben were also in Bethel by this time, and together the three brothers created a formidable team of craftsmen. The Charles brothers were compe-

Figure 8. Skiff built by Nick.

tent and skilled, and their services were in demand. Many of the buildings Nick and his brothers worked on still stand. Nick helped build the old Swansons Store, as well as working on the airport and Bureau of Indian Affairs site. Although he had never been to school or received formal education, he could interpret the diagrams on building plans and produce the desired result. He also practiced his craft on cabinetry and became well known as a competent and skilled finish carpenter (figs. 8,9).

Although Nick kept busy with carpentry during the winter, he did not completely relinquish his mobile ways. In the spring he was off goose hunting for days at a time. In the summer he and Elena would go down the Kuskokwim to Elena's family's fish camp on *Naparyarraq* Slough, just off the Johnson River. During the first few years, Nick stayed at camp with Elena and the children, along with Elena's mother and her married brothers and sister.

However, soon he was staying at camp only as long as it took to catch enough fish to satisfy Elena and the needs she projected for the coming winter, after which he was off to Nushagak for commercial fishing.[5] Although Nick fished at Nushagak for over fifteen years, he was not fishing continuously during the time when men were accumulating the points requisite for the permits issued under the limited entry system instituted in 1972.[6] Locked out of the lucrative Bristol Bay fishery, he returned to the Kuskokwim, where he fished actively until the summer of 1983. Although Nick continues to go to fish camp as always to harvest salmon for use by his family, he has given his permit over to his son, Frank, and is letting the younger generation have its turn.

During his early years in Bethel, along with the annual move to summer fish camp, Nick was also actively engaged in trapping during the late summer and fall. He and Elena would move with the children out to fall camp, sometimes north of the tundra villages in the vicinity of Pukpalik Lake and other times west in the flat country between the tundra villages and Nelson Island. He also continued to hunt around Baird Inlet and the Kailik River area. There Nick would trap muskrat, otter, fox, and mink. Elena recalls that he took lots of furs but sold them cheap. However, everything else was cheap, too. Twenty dollars was considered big money, and fifty cents an hour a reasonable wage.

Trapping, fishing, and building were not Nick's only sources of income. He was also busy carving during the fall at camp and on into the winter when the family had moved back into Bethel. Nick made these early carvings to sell to Army personnel stationed at the White Alice Early Warning Station in Bethel. During the early 1950s he worked in both wood and ivory. The carvings were often not signed and today are as scattered as the men who paid for them. Nick's children wonder what their dad carved in those early days. They never saw this early work, as most of it was sold before they were born. By the time they became aware of things, Nick was too busy supporting a family to carve. The first carving that they saw was the jewelry their father made for the girls as they began to grow into young womanhood, and the checkers, skates, and speed boats he carved to entertain his sons and himself.

By the time the children were old enough to go to school, Nick and Elena began to spend more time in Bethel and less time out at camp. However, whether or not they were trapping, they would still go downriver to summer fish camp and upriver in the fall to the Holitna in order to get their annual moose. Like the salmon they smoked in the summer and the birds they hunted in the spring, moose meat was an essential part of their food supply and necessary to maintain their growing family.

All together, Nick and Elena have had seventeen children, seven of whom are alive today. One they gave away to Elena's sister, who had lost her fifteen-year-old son in a boating accident. Now the young man knows his natural parents and often visits them. When Elena's brother died just before Elena's baby was born, she took on the job of raising three of his children. Because of Nick's and Elena's choice to settle in Bethel, all of the children were able to attend public school there. All went on to high school, the older ones at Wrangell, the younger ones at Bethel. All but the youngest boys have gone to college, married, and now have jobs, homes, and children of their own.

Figure 9. Nick Charles standing in front of the house he built for his family. Ca. 1959.

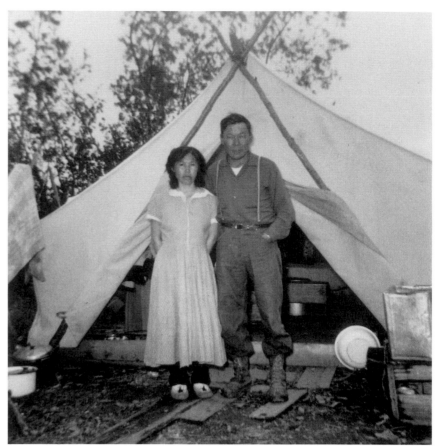

Figure 10. Nick and Elena Charles at their summer fish camp across from Bethel, early 1950s.

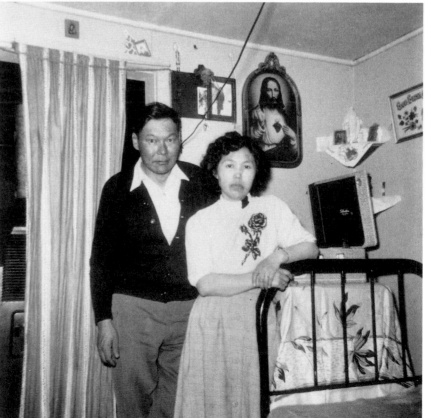

Figure 11. Nick and Elena Charles at home in Bethel, 1950s.

In describing their father, Nick's children touch on the same qualities: ambition, innovation, energy, and a wry sense of humor. Nick was ambitious in that he always wanted the best for his family and has worked hard to give it to them. In the process, he has never been reticent to try a new and creative means toward that end. From the first, he was interested in learning what he could from the missionaries and traders he began to see in his youth. Settling in Bethel, he was among the first to try oil heat, and years later, one of the first to invest in a truck. He will try anything at least once and try it first. He is a leader. For example, he has been a deacon of the Catholic church since the mid-1970s. The story goes that his work for the church originated in a friendly challenge. He had complained at the rectory that they were not doing things right, and they invited him in to begin to work for the changes he wanted. He accepted the invitation and has been an active force in the Bethel religious community ever since.

On a more mundane but equally revealing level, the fish camp that Nick built for his wife and family, when their previous site across the slough began to sink and flood, is both traditionally efficient and imaginative. The cabin that he built for Elena proved too dark for her to work in. As the roof was low, leaving no room for a window on the wall, Nick cut out a large skylight, which brings light into the whole building. Also, in front of the cabin, he dug a square hole in the tundra that, covered with plywood, serves as an efficient icebox. This underground storage cache, along with the steam house and covered fish racks, are not unique to the Charles family camp and add to the comfort and efficiency of the many Kuskokwim fish camps.

Nick's children also recall the tremendous capacity of their parents to give support to them as well as to others. Not only was their family expanding through the continual addition of children, but living in Bethel, they constantly hosted friends and relatives passing through. Their household provided a secure place to stay in an increasingly unstable community. Nick and Elena were able and willing to provide hospitality to a constant flow of visitors, maintaining the traditional pattern of a leader's generosity to strangers. They are rightfully proud of this accomplishment and as a result are rich in friends and relatives. They continue to harvest in abundance, putting up much more than they will use themselves, in order that they have enough to give away.

Because of the energy and effort they put into providing for others, they command respect and are hosted in their turn wherever they go in the delta region, and, travelers still, they go everywhere. For example, in the fall of 1982, Nick went to Mekoryuk on Nunivak Island to hunt reindeer and came home three days later with two fully dressed carcasses. In the spring of 1983, Elena went to Newtok, to the north of Nelson Island, for egg hunting, staying with friends and helping with their herring harvest in return. Each August for a number of years Nick and Elena have attended the annual Catholic retreat for deacons and their wives at Camp Nyac, upriver on the Kuskokwim. Their participation in the Bethel dance group has also taken them traveling to villages such as Kotlik and St. Mary's within the last years, as well as to Kasigluk for a mask-making workshop. Further afield, in recent years they have visited married daughters in Palmer, Alaska and Tacoma, Washington. Most impressive is their trip to Rome in 1978 with a group of Catholic deacons from all over the United States, where they constituted the entire Alaskan contingent. As their children say, if it were possible for their dad to travel to the moon, he would probably go check it.

A measure of Nick and Elena's continuing energy is the annual fall moose hunt which they still go on together. Getting to their camp on the Holitna is a two-day trip upriver from Bethel. In the fall of 1982, the couple was particularly lucky. Nick shot a moose which they dressed out even before they reached camp. They packed only half of it for themselves, giving the other half to two young men who as yet had not taken anything. The boys were from Eek, downriver from Bethel, and were related by marriage to Elena's sister. When Nick and Elena reached camp they took another moose, along with six three-foot-long pike. Now they had all they needed and more. After packing their catch, they decided to spend the night at camp before returning to Bethel. However, in the morning they were delayed by a bear, which Nick shot and added to his already full boat. Traveling back was a slow trip. The Eek boys kept in view as a safety measure for both parties, and Elena never left Nick's side, sitting by the motor, alert and ready to take over if Nick needed help.

How many times had they sat together like that in the boat, moving slowly and steadily forward? Almost fifty years ago when Elena was eighteen they began their travels together, running between Kasigluk and Nelson Island with a nine-dog team. They were young and lively that time, and so they remain, age notwithstanding. Elena admits it has been a long time: "That's why I'm not scared of him!" It is hard to imagine them moving in separate directions, as together they are such a formidable team. They have raised children together and are now parents to a huge extended family, most of whom are in Bethel, but with relatives all over the region, including Quinhagak, Nelson Island, Kipnuk, Kasigluk, and Eek.

It is in the context of this life and this family that Nick has, since the late 1970s, begun to carve again. It was actually Elena who preceded him as an artist in her own right. Since the children have grown, she has worked for many years teaching arts and crafts, first at Bethel Re-

gional High School, and later at the Kuskokwim Community College in Bethel. She is a basket maker, working in both birch bark and grass. She also sews skins, knits, and crochets. For years she has been selling her handiwork, including some of the fish she stores and even *akutaq* (Yup'ik ice cream) made from the salmonberries she gathers every summer. Like Nick, perhaps even more so, she was left on her own to acquire these skills. While she was growing up in Kasigluk, her mother and father wanted a modern life for her and never encouraged her to learn the traditional skills. Through practice, Elena learned on her own.

With Elena actively making and selling crafts, and having sold his carving earlier when he was younger, Nick turned easily to carving when he retired from carpentry and had more time on his hands. During the spring, Nick was still busy building and repairing boats for fishing, a task he had always done. The summer was still spent at fish camp and the fall hunting for moose. Winter and early spring, however, were left for carving.

Ideas had been accumulating for years, and, as Nick likes to say, to make them real he began to fill his free time with wood chips. He shaped wood into handles for the traditional *uluaq* (women's knife) (fig. 4). He made *ipuutet* (ladles), *yaaruitet* (story knives) (fig. 12)[7], and kayak paddles painted with traditional family markings. He even tried his hand at making the delicately curved bentwood hunting hat, traditionally used under a gut rain parka to capture air to sustain the paddler when he was either capsized or a wave momentarily engulfed him. He has also made the traditional ice pick and bird spear. Then he began to carve masks.

As carving is one among many parts of his life, so mask making is one among many occupations Nick applies himself to within carving. Presently it dominates, but even now not to the exclusion of other articles. As with every object that Nick makes, each mask is unique, although similar motifs can be seen in many of them.

The piece for which Nick has achieved the most recognition is the double-headed hawk mask that he entered in the 1980 statewide Native woodwork competition (plate 1). The mask won a merit award in the category of traditional woodwork and was subsequently reproduced on posters that are still on display all over the state. After the competition, Nick was told by one buyer that if he would produce twelve more just

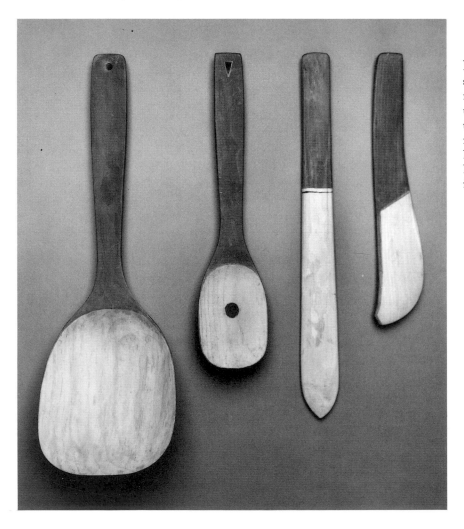

Figure 12. Wooden ladles, a girls' story knife, and a boys' snow beater made by Nick Charles. Yup'ik girls used story knives to draw stories in the mud or snow. Today, girls are more apt to use their mother's table knives. Boys used snow beaters to knock the snow off their mukluks before they came indoors.

like the first one, a profitable market would be guaranteed. Nick declined, preferring to make masks on his own initiative and his own timetable rather than in response to a specific request.

Masks that Nick has done more recently also involve bird images, although no one is constructed in precisely the same manner as another. These include an owl mask, a gull's head mask, and a raven mask. Some are rimmed with the traditional *ellanguat* (lit. pretend or model cosmos), the wood rings sometimes put around a mask to represent the traditional multi-tiered universe. Others are square, coming out to a central point representing the hooked beak of an eagle or hawk. No one species dominates, although birds in general, as creatures of the air and capable of rapid movement between worlds are an important element in traditional Yup'ik cosmology and predominate in Nick's work.

After filling his fish racks with salmon in June of 1983, Nick took advantage of the lull in a busy season to continue his carving while still at fish camp. Picking up wood gathered in previous seasons, he began roughing out the beak of a bird, as well as the face of a hawk, using only his old adze and crooked knife. His grandson Christopher hovered around the stump on which Nick was working. Chris watched his grandfather with some of the same interest that must have fired Nick as a boy. Chris' middle name is Nicholas. Once when Nick was splitting a log he found a wood worm inside. He took it out and rubbed it in Christopher's palm in order that he, too, might become a good carver. His grandfather had done the same to Nick when he was a boy, that he might learn and carve. He taught Nick all his skills as well as the gift of learning how to learn. Nick picked up many more skills as he grew and aged, leaving some behind yet reviving some that his father thought dead. These he is passing on to his children and grandchildren. Only time will tell whether Christopher will carve a mask. But if he does, it will, like his grandfather's masks, be uniquely his, yet speak his heritage.

The Mask Making Process

When Nick begins to carve a mask, he works within a tradition far older than he is. Once it was thought dying, if not dead. Mask making, like the traditional dance ceremonials within which it was a focal ingredient, was discouraged by the missionaries who proselytized in the Yukon-Kuskokwim region during the late 1800s and early 1900s. When Nick was growing up, masks were not being made on Nelson Island.[8] However, in recent years dance has been revived and mask making has seen a comparable revival. Certainly much of the overt symbolism has been stripped away. However, carvers use the same basic techniques, materials, and tools on the delta today as they did in the past to create masks for ornamental display as well as for use in dance

performances. Rather than the last of a dying breed, Nick is, true to character, a forerunner in what is hoped will continue to be the revitalization of an important traditional art form.

When Nick starts to carve a mask, he begins, much as his father did, by hunting for the right piece of wood. During the summer trip into *Lomarvik* Slough across the Kuskokwim from their fish camp, Nick and Elena might harvest a choice driftwood root washed up on the shore, along with half a dozen ducks and a sack of *quagcit* (sour dock; *Rumex arcticus*). Nick prefers using the root of a spruce or cottonwood tree. One good root can be the material out of which many masks are formed. The wood must be soft and light in order that the knife shape it easily and the dancer wear it comfortably. However, if Nick uses wood that is overly dry or rotten, the piece will split and the mask will be ruined.

After Nick has harvested the wood, he can begin the preliminary shaping. For this job Nick uses his metal-edged adze (kepun), a tool given him by an older man living in Tununak on Nelson Island. A Nunivak Islander originally made the tool. It was later found on Nelson Island, and from there given to its previous owner who eventually passed it on to Nick. Nick's sister's husband Sipary Cuukvak gave Nick his crooked knife (mellgaraq). Cuukvak presently lives in Nightmute on Nelson Island and is a skillful ivory carver in his own right. Although Nick's sister died in the early 1940s, the relationship was kept alive through Elena, who is Cuukvak's niece. Both tools are deep brown with age. However, both have years of use still in them.

Using this simple tool kit, along with a pocket knife, small plane, and eventually a piece of sandpaper, Nick accomplishes the transformation from wood to mask. Once wood and tools are brought together, Nick will begin by roughing out a rectangular block of wood. Sitting on the floor, he holds the wood between his thighs, with his legs spread out before him. Nick can also do the roughing out from a kneeling position. Then, holding the wood with his left hand and the adze with his right, Nick turns the block clockwise four turns, giving it a new face at each turn. He will vary the dimension of the block depending on the size of the piece of wood and the intended shape of the mask. The rough wood rectangle often seems small when compared to a finished mask. However, with the addition of bentwood rings and appendages during later stages in the maskmaking process, it will gradually grow in size and stature.

After Nick has formed a narrow rectangle, he quickly and deftly cuts away its edges, again using the adze or, occasionally, a small metal-edged saw. Then, rotating the roughly-edged rectangle, he uses the adze to trim away the angles and to begin to shape the oval or circular form of the mask's face (fig. 13).

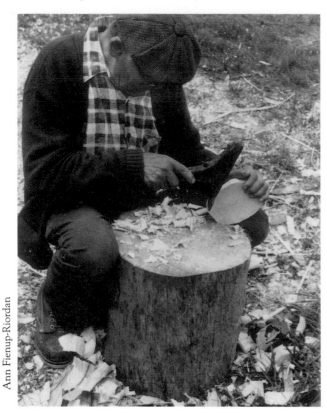

Ann Fienup-Riordan

After Nick gives the face of the mask its basic shape, he places the flat oval on the floor, or on another piece of wood, and uses the adze to transform the flat wood face into a curved one. Then he turns the mask over and roughly hollows out the back of the face with the adze. If the mask is to be worn by a performer, it must be light enough to wear and open enough to breathe through. Finally, he roughly planes the face and gives the edges the desired curve.

After Nick has completed the basic roughing out, he exchanges the adze for the smaller, hand-held crooked knife. In the hands of an expert, this simple tool moves as smoothly over the wood face as water, seeming to wash off the rough crust covering the finished form below. Nick sometimes sings a soft *"aha ha hanga yurarahah"* as he works. The image of the emerging form is clear in his mind's eye, and there is nothing haphazard in his strokes. As he works, he cradles the rounded form to his chest. One hand pulls the crooked knife toward him, while the other alternates between holding the form close and holding and turning it at a distance so that Nick can judge its progress. Watching a novice tackle the same task can give the viewer an idea of the skill it takes to make the job appear so effortless. Hunkered over his wood, the would-be carver will squeeze the crooked knife, trying to force it into the wood at an angle instead of skimming over its surface. The result is a cut in his thumb and drops of blood staining the wooden face.

After Nick has carved the features of the mask's face, he will scour the entire surface of the mask with sandpaper in order to achieve a more finished look. Nick only uses fine and extra fine grades of sandpaper, as the precise cuts he made with the crooked knife have left little to be done. After he has completed the sanding, he will use the crooked knife to cut into the curved beak of a bird form or the backside of the mouth of a human face. He makes these cuts in order to open up either a breathing hole for the performer who might wear the mask, or an orifice in which he will later attach a carved fish or animal. Finally, he will cut eye holes in the face, giving the mask sight.

If the mask is meant to be worn, along with the breathing and eye holes, Nick must also auger small holes in the back of the mask into which he can insert two thin posts. The dancer will grip these posts in his teeth in order to hold the mask up to his face while dancing. The projections enabled the traditional performer to manipulate the mask and perform tricks and transformations in front of the audience in the steamy interior of the traditional men's house. For this, as well as other reasons, the underside of the mask was never open to public view. This traditional characteristic of the use of masks makes it all the more appropriate that today we view them head on, hanging on a wall. If the wall masks on display have been deprived of their motion and their sight, at least they continue to show us their proper face.

Along with the tusk-like projections extending out from the underside of the mask, Nick will rim the face of the mask with four or more three- to four-inch pieces of wood whittled down to the diameter of a lead pencil. Nick attaches these wooden pegs as supports for the ring or rings that will eventually circle the mask. He cuts the pegs from a thin rod of wood held against his leg for support. He whittles the rod down to the desired thickness by holding a thin piece of driftwood in his left hand against his outstretched left arm and pulling his crooked knife toward his chest. Carvers traditionally applied this same technique in making kayak ribs or the slats of a fish trap. Today, Nick sharpens the number two pencil he uses to mark his masks by pulling a crooked knife in the same direction.

After Nick has whittled the wood to the desired thickness, he planes it by pushing the knife out and away while holding the wood firmly between his knees. Finally, he cuts it into equal lengths, using neither ruler nor tape measure. Rather, he cuts the first piece from memory, measuring each succeeding piece against it to give it the same length. He then inserts these pieces into holes that he has drilled equidistant from each other around the circumference of the mask's face. To insert a

peg, he puts it in the hole and pounds it gently with a smooth stone. After he has completed the mask and painted all the pieces, Nick might eventually reinforce the pegs with wood glue.

After Nick has completed and temporarily inserted the posts, he will measure the first wooden ring against the mask and bend it to the proper diameter. Like the rod from which the posts were cut, the wooden ring is a long strip of wood that Nick has thinned with the help of the crooked knife. Traditionally the strip of spruce would have been steamed to make it pliable. However, today Nick moistens the strip under running water and gently bends it by working the wood through his mouth. As Nick grips the wet wood in his teeth, he exerts pressure on both sides of the thin strip. Finally, when he has closed the circle, he will use strong string to bind the two ends together. After this closure is made, Nick runs the string across to the opposite side of the ring, back to a point just below the bound connection, and then across to the opposite side. He then hangs the bound ring on a peg to dry. Nick will leave the cross-binding in place until the wood sets. Then he will cut it away, leaving only a single tight knot connecting the two ends of the closed circle.

After the rings have dried, Nick attaches them to the face of the mask. First, he lays the ring against the post closest to the base of the mask. Holding it firmly in place, he then binds the ring to this post using strong black thread. Formerly, Nick would have used fine sinew string. To attach the ring, Nick first loops the thread around the post and ring. Then he brings the end of the thread through this loop, leaving a neat closure. Holding the loose ends together, Nick winds the thread around the juncture several times. Finally, he brings the tail of the string up and between the post and ring. He pulls it tight and the binding is completed. After the initial bind is made, Nick holds the ringed mask at a distance away from his body and eyeballs the fit. He then attaches the ring to a post at the top of the mask in the same manner as the first. After making these two attachments, Nick ties the remaining posts and completes the connection.

Having tied the ring to the posts, Nick then attaches the appendages. He has formed these small carvings from scraps of wood which he holds cradled tight in his hand while he moves the blade of the crooked knife in towards the base of his thumb. He makes them in many shapes and sizes. Most of Nick's masks have appendages that are stylized representations of the parts of animals, added to complete the spirit of the body of the mask. These stylized parts include the tail of a bird, its wings, and its feet, all appended to the ring surrounding the central head. Nick also sometimes carves the head as an appendage fastened to the top of the mask, and not as the central figure.

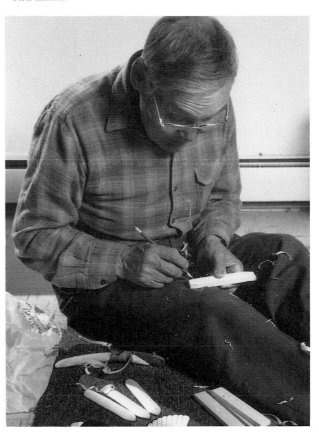

Figure 14. Nick works on feather appendages for several bird masks.

On some masks, the appendages are small models representing whole objects, such as animals or hunting implements. Nick remarked that this area of the mask can be an outlet for the imagination, as well as the prerogative to carve more conventionalized body parts. He was particularly struck with a mask made by a young woman who was his student at a carving workshop he held in Kasigluk in the spring of 1983. She carved the face of a woman, complete with downturned mouth, to which she attached small carved mukluks, mittens, and other "women's things."

From six to twelve parts surround the face of each mask. Not only do they add detail to the mask, but they also add motion. This is because Nick attaches each piece to the tip of a bird or duck feather, the base of which he inserts into the outer ring encircling the mask. Unlike the wooden posts Nick uses to attach the ring, these feather posts are flexible, and allow the appendages to bob up and down, emphasizing the movement of the dancer and the drum. Nick prefers to use the tail feathers of the *aarraangiiq* (oldsquaw duck; *Clangula hyemalis*) but also uses quill feathers of other birds such as the *metraq* (common eider; *Somateria mollissima*), *kukumyaraq* (common scoter; *Oidemia nigra*) and *anipaq* (snowy owl; *Nyctea scandiaca*). Elena also uses owl feathers for making dance fans.

After Nick has carved all of the parts of the mask, he is ready to paint and assemble the finished piece. Nick continues to use four simple colors derived from materials available in the coastal environment. These colors were traditionally used to help the mask work as a unit and to accentuate specific areas within it. The base color, *urasqaq*, is a flat white, derived from white clay, which Nick mixes with water and applies by hand. Nick often uses this clay coat to cover the mask before he adds other colors. Over the white clay base he then applies designs in blue, red, and black. *Kassiiyuaq* is the name for the blue color, probably derived from vivianite (Ray 1981:20), and used to decorate kayak paddles and hunting equipment, as well as masks. *Uiteraq* is the name of the red color derived from iron oxide found in both clay and alder bark. The color is the same as that of the red paint Elena uses to dye the tanned side of the wolverine strips that decorate her fancy dress parkas. Red paint was often traditionally mixed with nose blood in order to ensure the color's permanence. Sitting in the men's house painting his mask, the carver would prick the inside of his nose, mixing the drops of blood with the clay. Other paints, especially red, were also mixed with seal oil to make them darker and more durable. The traditional carver derived the black used to paint masks by mixing charcoal or ashes with oil and water. Nick employs India ink or felt-tip marker as a contemporary replacement.

Nelson Island was traditionally the source of white clay, the blue vivianite, and a bright red clay (goethite [Ray 1981:20]) used in decorating carvings done all over the delta. Carvers from other areas acquired these materials through trade or as a gift from Qaluyaarmiut friends and relatives. Nelson Island continues to be the source of these three materials. Nick, in fact, returns periodically to Nelson Island to stock up on colorants. The general location of these deposits is known, although people say they only reveal themselves to seekers worthy of the find. Even more elusive is the location of a pool of wet white clay located near the center of the island. The location of this pool, which is covered by a slate slab and accompanied by a bone spoon, is an old and well kept secret.

Carvers gather the blue colorant along the base of the rocky cliffs to the west of Tununak along the coast. As the deposits are located high out of reach, a gunshot blast is used to dislodge them. At low tide one can walk out on the mud flats just below Toksook Bay, where streaks of white clay reveal scattered caches of kaolin just below the surface. Traveling further afield, up the Qalvinraaq to the mouth of the Cakcaak Slough, men can harvest the orange clay (*kaiguq*) traditionally used in making seal oil lamps and cooking pots. The red clay so coveted by carvers is found in a remote spot in the center of Nelson Island where Raven's daughter was said to have had her first menstruation:

> *Then Crow's daughter went above Tununak, on this side of Englullugaq, to make story pictures . . . Also, when she was ready for her menses, she hid it on the top of a mountain . . . very red! Something else. This is where people get red coloring from, in the place where she had her menses. Lots of red coloring, very red. The name of the place where she had her menses is called Qilengpak.*

<div style="text-align:right">(Fienup-Riordan 1983:248;
see also Himmelheber 1953:101; Ray 1981:20)</div>

To paint the finished mask, Nick rubs the mask's face with a mixture of white clay and water. He applies the paint with the palm of his hand. To ensure even and complete drying, he then gently rotates the mask over the flame of a Coleman stove. After the paint dries, he will again rub the face in order to dust off excess paint.

After the initial coat of white paint has dried, Nick will rub the posts and rings surrounding the face of the mask with red clay, chunks of which he has mixed with water in order to produce a thick paste. This mixing is also done by hand, with lumps broken up through slow and careful stirring. A cloth is often used in applying the color to the mask. After Nick has applied the red paint, he lets it dry and then rubs away the excess as he did from the mask's face. In the completion of the prediction mask that Nick made in the fall of 1982, he finished the face of the mask by drawing a chin tattoo and moustache on the face with a black marker. Using a stick dipped in black paint, he then drew the designs on the sides of the boat that perched over the shaman's head.

Having painted the mask and applied the face designs, Nick is ready to apply its attachments. He had already given them a coat of white clay and detailed many with the same black paint (or marker) that he used to paint the mask itself. Now he presses the blunted tips of the feathers of an ocean bird or owl into their bases, and the basal ends of the feathers through the evenly spaced holes he has drilled in the ring. After he has properly fitted the feathers and their attachments, he removes them from their slots. Traditionally he would have dipped them into glue made from nose blood rubbed until it turned white. Today he dips them in store-bought wood glue and reinserts them in place.

Nick follows this same sequence of painting with white, detailing with red and black, and finally attaching appendages seemingly floating on feather supports in the construction of the *apallircsuun*, or driftwood dance wand, that he carves to accompany the motions of a masked dance. With the completion of the ringed mask and the tufted baton, the carver's work is done, the dance is equipped, and the performance can begin.

The Mask: The Eye of the Dance[9]

This section discusses the system of symbols and meanings surrounding the work of Nick Charles. As related above, in 1983 Nick was the focus of interviews concerning his life and work. In the process, he gave valuable information on the traditional significance of his craft, as well as testimony to its continued power to evoke a complex system of symbols and meanings. These meanings, in turn, connect both traditional and contemporary masks and masked dances to both past and present aspects of Yup'ik ideology and culture. These include the broad themes of birth and rebirth and a dynamic reproductive cycling between the worlds of the living and the dead (Fienup-Riordan 1983). Vision imagery, epitomized in the motif of the ringed center, is also evident as a means of both depicting and effecting this movement.[10]

The Loss of Vision

Less than one hundred years ago, the mask (*kegginaquq*, fr. *kegginaq* 'face, blade of knife' + *-quq* 'one that is like'; hence "thing that is like a face") was a central element in traditional dance performances. At the same time, masked dances were a central element in the Yup'ik representation to themselves of their world, both spiritual and material. The Eskimo world included a plethora of animals and spirits appearing in a multitude of forms. Carved wooden masks were an attempt to visualize and dramatize this complex reality, and ultimately to participate within it.

Part of a rich ceremonial tradition, the masked dances of the western Alaskan Yup'ik involved the transformation of their human participants into the animal and/or spirit represented by the mask. Some masks were made and worn by the *angulkuq* or shaman and might enable him to journey to the spirit world. There, according to one Nelson Island elder, he would dance for the spirits of the game, telling them of the good treatment they would receive should they continue to allow themselves to be taken. Other masks were not made by the shaman nor were they worn by him, although they often represented spirits which had appeared to him in real life or in a vision.

In a dream, the spirit of the shaman might leave his body and journey into the spirit world. He would communicate the images that he brought back from these spiritual travels to the carver, who would, in turn, apply his unique creative style in order to interpret that vision. There were no drawings. Often only the general outlines of the transformation mask were given by the shaman to the carver, who was left on his own to conjure up the required image in his mind's eye. Some conventionalized forms were followed. Fish or sea mammals might be clutched in the wooden beak of a bird in order to represent the abundance promised by the spirit of the mask.

Or a human face might emerge from one corner of the mask, representative of the animal's spiritual counterpart. However, the precise way that these representations were played out was left to the carver's imagination, and the result was a stunning variety of interpretation.

During their first years in the delta region in the late 1800s, Moravian and Catholic missionaries alike viewed with grave misgiving these masked dances along with other embodiments of traditional Yup'ik cosmology represented through the carver's art. These included the effigy memorials and carved funeral posts set up to mark grave sites, as well as the carved dolls feasted and dressed during annual dance ceremonies. Overwhelmed by the pagan implications of these traditional representations and the ceremonial cycle in which they were a part, the missionaries did their best to discourage their use. Recreational dancing survived in the areas missionized by the Catholics, but along the coast south of Nelson Island and along the Kuskokwim River where Moravian influence prevailed, dance performances, masked or otherwise, were completely suppressed.

A metaphor for this period of cultural suppression can be found in a traditional tale told by Maggie Lind of Bethel, relating how Crane got his blue eyes. According to Maggie's story, once while berry picking, Crane took out his eyes and set them on a nearby mound to watch for danger. Yet while he was bending over the tundra, someone stole them, and Crane then replaced them with blueberries: "That's what happened to the masks. Someone stole their eyes. Eyes were no longer needed to see with" (Flintoff 1983). Traditional forms remained, although functionally transformed. Masks continued to be carved, but as wall decorations and not as face coverings. The eyes of the mask were no longer essential and were rendered as painted marks rather than carved holes. Although the masks were still made, they were functionally blind.

The Rebirth of Masked Dancing

In the 1970s, some of the older Native residents of Bethel, many of whom had moved in from Catholic areas, including Nelson Island, formed a traditional dance group. Key dancers included Lucy Arnakin; Nick's wife, Elena; Nick's brothers, Ben and Dan Charles; Joe Chief, Jr; Lucy Jacob; Mary Neck; Louise Nick; Minnie Frances; and Annie Chief. Nick rarely danced, but did drum and sing for the dancers, along with dance leader Dick Andrews. Through the performances of this group, as well as other dance groups from the coastal villages, dancing began to reemerge as a significant event on the delta. Until recently it remained a relatively self-contained activity, drawing audiences, but few new participants. However, the fall of 1982 marked an important step toward a more dynamic relationship be-

tween audience and performer, and Nick and Elena Charles have both been active in moving events in that direction.

The first important event, and one organized specifically to address the issue of transmission of traditional carving skills, was a mask-making workshop, and the subsequent performance of masked dances, in Bethel. Funded by the Alaska State Council on the Arts, the workshop gave carvers and performers an opportunity to interact and begin to resurrect a dying art form. Dick Andrews, like the traditional shaman, along with the other Bethel dancers, gave general directions as to what masks should be made to Nick, as well as two other Bethel carvers Kay Hendrickson and John Kusauyaq (known as Uncle John) both originally from Nunivak Island (fig. 15). Like the traditional shaman, the members of the Bethel dance group also continually checked on the carvers' progress at the Kuskokwim Community College workshop, as though it were the men's house where they were readying for a traditional ceremonial feast. When the masks were completed, the dancers gathered again for a rehearsal performance. Just as traditionally neither the powerful shaman nor the skilled

carver necessarily wore the creation, it was the talented young dancer, Joe Chief, Jr., who wore the prediction mask that Nick had constructed (fig. 16).

Like many traditional masks constructed under the direction of a shaman, the mask that Nick carved during the workshop tells of a specific shamanic vision. It represented his interpretation of a well-known event in the oral history of the delta region. The face of the mask, instead of depicting an animal's spirit, represented the spirit of the shaman Issiisaayuq. This shaman lived before the first Kass'aq (white person) came to the region. He lived at Aproka, at the mouth of the Eek River. It was there that he had a vision in which he saw a boat approaching, a boat that would bring the first white men to the area.

> Long ago there was a shaman named Issiisaayuq who directed his people to carve a mask depicting a freightship. This was unfamiliar to the people, but they followed his instruction even so. On the forehead of the mask was a boat with three masts. The center mast had a platform with a man in it. On the deck of the ship was a caribou. The following summer a ship, exactly

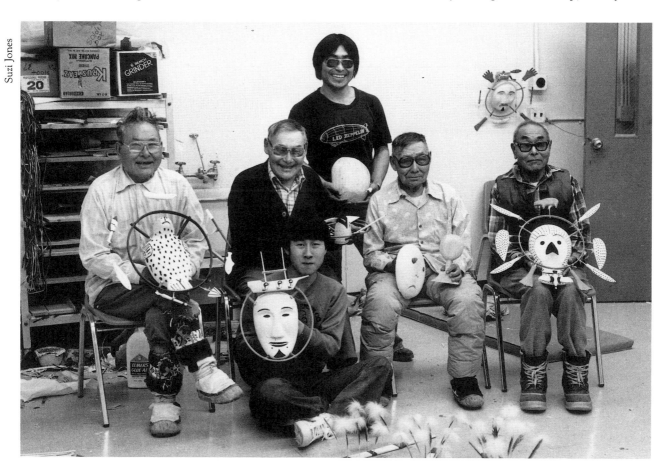

Suzi Jones

Figure 15. Participants in the 1982 mask-making workshop in Bethel during which the carvers made dance masks commissioned by the Bethel Native Dancers. (L to R) Kay Hendrickson with seal mask, Nicholas Charles, Sr., Joe Friday, and Uncle John with owl mask. The two young men are unidentified apprentices. Feathered dance wands are on the floor.

like the carving, arrived from the sea. On the sides of the ship were images of half human faces. When it arrived at the mouth of the Kuskokwim River the people warned each other not to desire or want the goods from the boat because they would come to no good. One day one of the men came to the boat, he noticed that the eyes on the faces were turning towards the sea. The ship sailed away and all the trade goods the people acquired disappeared. Issiisaayuq's daughter cried for a necklace that she saw on the boat. Since she would not stop crying for the necklace, Issiisaayuq instructed his wife to spread a skin outside. When she did so, it began to hail. The hail that landed on the ground melted but the hail that landed on the skin did not. They brought these into the qasgiq and made a necklace for the daughter. The ornament did not last for long and the following summer a real freightship arrived as prophesied by Issiisaayuq.

(Ali and Active 1982)

This is the story behind the tattooed figure Nick carved. It is perhaps significant that this mask, foretelling the

Figure 17. The Issiisaayuq mask made by Nick Charles during the 1982 workshop.

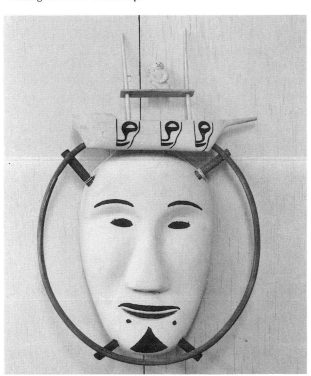

Suzi Jones

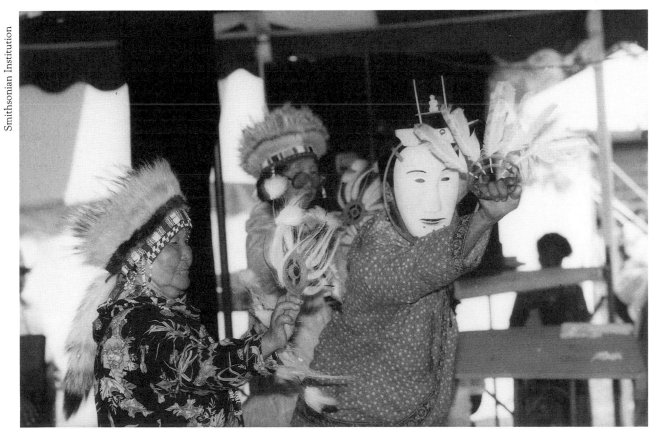

Smithsonian Institution

Figure 16. Joe Chief, Jr., performing in the Issiisaayuq mask at the Festival of American Folklife, 1984.

first contact between Yup'ik and Western culture, should be worn at the first masked dance performed for both Yup'ik and Kass'aq since the missionaries' successful suppression of Yup'ik ceremonial dancing.

For the performance, Nick represented the human face and large-eyed half-faces that had appeared on the sides of the visionary freightship in abstract form on the sides of the model ship perched on Issiisaayuq's head. During the performance, as in the shaman's vision, the eyes moved from side to side, encompassing all in their powerful gaze. As Nick said, "This mask is the eye of the dance." It is the vision of this vision that he set out to capture in wood.

The Eyes of Awareness

The eyes of the mask, however, are more than a metaphor for sight. The circle and dot motif, so common in Yup'ik iconography, is specifically designated *ellam iinga* (lit. the eye of awareness) in Central Yup'ik (fig. 18). As in the word for the wooden hoop surrounding the mask (*ellanguaq*), the term is derived from *ella-* (translated variously as outdoors, weather, world, universe, awareness, plus *-m* singular possessive, + *ii* eye). However, *ella* appears to be personified here, and was seen as a being in contexts other than that of a human or animal face (Morrow, personal communication).

The nucleated circle has, in the literature, been designated as a joint mark and, as such, part of a skeletal motif. Alternately, it has been labeled a stylized woman's breast which might then be substituted for a woman's face (Ray 1981:25; Himmelheber 1953:62). The sexual and skeletal motifs may well be part of its significance. However, it was not merely that the nucleated circle marked the joints, but rather that joints were marked with circular eyes in various ritual contexts. According to Phyllis Morrow:

The circle and dot motif is often seen on the "joints" of carved supernatural beasts. This placement is suggestive of a number of customs that involve marking, cutting, or binding joints, all of which relate to boundaries or a change of state or passage from one "plane" to another. At puberty, for example, a young woman's wrists were tattooed with dots. Red string around an infant's wrists protected it from harm. Strings were also tied around joints to prevent diseases from progressing past these points.[11] E.W. Nelson describes how a hunter sometimes cut the joints of an animal to prevent its spirit from reanimating the body. In one case, I have heard, the same thing was done to the body of an evil shaman.[12]

The connection of these customs with shamanism may be clearer when you recall that dismemberment and skeletal rearticulation was an essential part of a shaman's initiation, one that was repeated each time he journeyed to the other world(s) (see Mircea Eliade, Shamanism: Archaic Techniques of Ecstasy). Circles-and-dots placed at the joints thus recall the ability to pass from one world to another, perhaps representing the holes through which the passage was effected. The ability to see into other worlds was also characteristic of the shaman. Thus, it is particularly appropriate that the circle-and-dot, both an eye and a hole, equates physical and spiritual movement between worlds.[13]

(Personal communication)

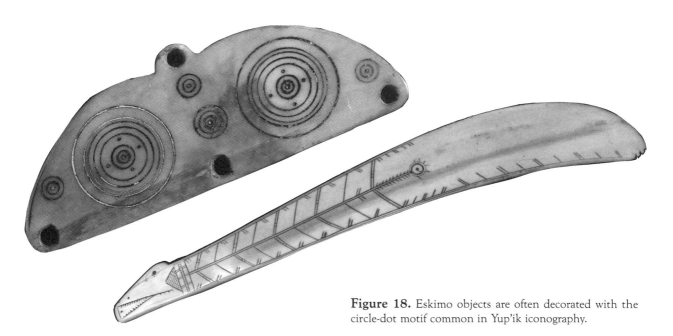

Figure 18. Eskimo objects are often decorated with the circle-dot motif common in Yup'ik iconography.

Examples connecting the circle and dot motif with spiritual vision and transformation abound in the Yup'ik ethnographic data, once the significance of these facts becomes visible. Also, not only did eyes mark joints but joints were, on occasion, explicitly given as the home of spirits with eyes.[14] Nick Charles' owl mask (plate 2) represents one incarnation of this theme. The mask depicts a shaman's watcher or guardian bird, a snowy owl. According to the oral tradition of the Nelson Island area, this bird was originally endowed with supernatural sight and protective powers by being covered with feathers, each of which was marked with a circular eye belonging to one of the shaman's spiritual protectors (Paul John 1977).[15]

Ritual dismemberment and shamanistic marking are also perhaps comparable to the circular tattoos applied in some cases to the wrists and elbows of young men at the time of their first kill of certain species.[16] In both the shaman's eyed joints and the puberty tattoo, the circle and dot design connotes enhanced vision effected through spiritual and social transformation. In fact, transformed characters are, in the oral tradition, signaled by, among other things, black circles around their eyes.[17] One Chefornak hunter recalled his mother circling his eyes with soot when, at age nine, he returned to the village after killing his first bearded seal. Finally,

pubescent girls on the Yukon delta are still advised to encircle a single salmonberry blossom with a hair of their head, which they then tie to a nearby grass plant. This is done in order that the blossom not blow away and ultimately that the year's salmonberry harvest, as well as the young woman's own future social and biological productivity, be ensured.

In some contexts, the encircling ring has been interpreted as signifying completeness and imparting spiritual wholeness (Fitzhugh and Kaplan 1982:202). The implication is that the completed circle stabilizes and establishes the spiritual integrity of the artifact to which it is attached. More accurately, for the Yup'ik, as can be seen from the above, the circle and dot is a concrete metaphor for and means to achieve a dynamic movement between worlds, be it spiritual cycling, supernatural vision, or social transformation.

In dance fans that Nick Charles carved for his wife, Elena (fig. 19), the vision imagery of this motif has been retained. With her own eyes cast down during the performance, Elena even now speaks of the fan's eye as seeing for her while she dances. Her lowered eyes and restricted sight are marks of respect typical of all the dancers. They are comparable to the lowered eyes of the novice, or the young host or hostess, and traditionally the covered head of the young woman during puberty

Figure 19. Dance fans carved by Nick for Elena with the imagery of the circle-dot motif.

restrictions. As Elena gives the dance blindly, however, it is received by the full gaze of the audience.

In all social as well as ritual situations, in fact, direct eye contact was traditionally, and continues to be, considered rude for young people, whereas downcast eyes signify humility and respect. Sight is the prerogative of age, of knowledge, of power. For example, the powerful man in the moon has a bright face, and people fear to look at him and must look downwards (Nelson 1899:430). Conversely, the mythical hero Apanuugpak was said to have been able to see his enemy from afar, while to them he was invisible (Fienup-Riordan 1983:242-3). Powerful images and hunting fetishes, some in fact marked with the circle and dot motif, were supposed to watch for game and, by clairvoyant powers, sight it at a great distance (Nelson 1899:436). Finally, the powerful shades of the dead were traditionally said to hear and see nothing at first. However, by the time they reached the grave they had attained clairvoyance (Nelson 1899:425).

A particularly eloquent and explicit example of the relationship between socially restricted sight and powerful supernatural vision is contained in the Nelson Island traditional tale of the boy who lived and traveled with the seals for one year in order to gain extraordinary hunting knowledge and power:

> . . . And his host [the bearded seal] said to him,
> "Watch him [the good hunter], watch his eyes,
> see what good vision he has.
> When his eyes see us, see how strong his
> vision is.
> When he sights us, our whole being will quake,
> and this is from his powerful gaze.
> When you go back to your village, the women.
> Some will see them, not looking sideways, but
> looking directly at their eyes.
> The ones who live like that, looking like that,
> looking at the eye of women,
> their vision will become less strong.
> When you look at women your vision will
> lose its power.
> But the ones that don't look at people, at
> the the center of the face,
> The ones who use their sight sparingly,
> As when you have little food, and use it
> little by little.
> So, too, your vision, you must be stingy
> with your vision,
> using it little by little, conserving it always.
> These, then, when they start to go hunting,
> and use their eyes only for looking
> at their quarry,
> Their eyes truly then are strong.
>
> (Paul John 1977)

Nick Charles remembers well the admonishment given him in his youth never to look into the eyes of women. However, as can be seen, this was more than a matter of etiquette circumscribing his manner of vision within the human world. Rather, restricted human sight is profoundly significant—it frames a man's future relationship with the seals and other animals on whose good opinion, as a hunter, he would depend.[18]

Just as sight in the proper context is coincident with power, lack of sight is equivalent to the ultimate infirmity biologically, socially, or spiritually. For example, in the famous dart incident, a village virtually destroys itself and war begins as a result of the accidental blinding of a young boy by his playmate. Paul John of Nelson Island tells of a cruel hunter who, upon finally recognizing his defeat, covers his eyes with his hands and is subsequently killed by an arrow from his opponent's bow. John Henry of Scammon Bay recalls the story of a stingy hunter who saw game, but refused to talk of what he saw to his fellow villagers. However, suspecting his treachery, they followed him, and seeing his eye peeking over a rock, they pulled him forth and killed him. Afterward the site became known as Iillkiavik (lit. place of the eye).

In the above, lack of sight is directly related to starvation and death. Conversely, a period of severe famine in the coastal area was said to have been alleviated by the supernatural vision of a single young girl, who journeyed out from her village in search of food. On miraculously sighting a woven pack basket full of blackfish, she raised her arm and made a circular motion in the air to "liken the fish to the sky" (possibly referring to the circular concept of the different levels of the universe). She did this in order that the fish would remain visible, and edible, for her starving family. In another account, a mythical doll (in fact the inventor/originator of masks) comes to life, completely circles the edge of the world, and then the village of his new human parents. Only then does he enter the village and make himself visible to its inhabitants (Nelson 1899:497-99).

Finally, the direction as well as the act of encircling was significant, in certain contexts producing visibility, in others invisibility.[19] For example, the presence of a ghost could be banished if a person ran out of the doorway and circled the house in the direction of the sun's course. In the event of a human death, a ritual "erasing" was traditionally performed whereby the outside of the house was circled counterclockwise and rubbed all around with a whetstone in order to close the entrances and make them invisible, and therefore impenetrable, to the spirits of the dead (Paul John 1977).

The Ringed Center

The image of Issiisaayuq in the prediction mask by Nick Charles is, then, in a way, a reflective statement on the significance of all hooped masks, as eyes into a world

or worlds beyond the mundane. Traditionally, the face was the visual means of representing and embodying for human audiences an other world reality. At the same time it was the means of vision into this world by that other reality. The mask is, literally and figuratively, a ringed center. As such, it is a condensed image of the traditional Yup'ik universe as well as the cosmological system that defined it. The ringed center is an often repeated image and is obvious in an abundance of contexts once the concept of vision and spiritual transformation which it embodies is revealed.

First of all, the mask itself is structurally a ringed center. In Nick's work, as in that of other contemporary and traditional carvers from Nunivak Island and along the Kuskokwim River, the face of the mask is often framed in multiple wooden rings called ellanguat (fr. ella- translated variously as cosmos, weather, world, universe, consciousness, and awareness, + (ng)uaq 'pretend,' hence pretend or toy or model cosmos). These concentric rings represent the different levels of the universe, which was traditionally said to contain five upper worlds and the earth (Ray 1967:66). This same heavenly symbolism was repeated in ceremonial activity in which the masked dancer was a key participant. For example, multiple rings, also called ellanguat, and decorated with bits of down and feathers, were lowered and raised from the inside of the men's house roof during the traditional Doll Festival and were said to represent the retreat and approach of the heavens, complete with snow and stars (Nelson 1899:496; Ray 1967:67; Charles 1983).

The men's house (qasgiq) in which the dance was performed in Nick's youth was also an image of the universe, whose center was likened to the heavens and whose central skylight provided exit from this world to another level of reality. For instance, during the closing performances of the traditional Bladder Feast, the shaman would climb out through the skylight in order to enter the sea, visit the seal spirits in their underwater home, and request their return. These spirits, in turn, could view the attention of the would-be hunters by watching the condition of the central smoke hole in their underwater abode. If hunters were giving them proper thought and care, the smoke hole would appear clear. If not, the hole would be covered with snow and nothing would be visible, in which case the seals would not emerge from their underwater world or allow themselves to be hunted. It was this vision that Nick sought to maintain as a young man as he carefully cleared ice from skylights and water holes alike.

In addition to serving as a passage permitting movement and communication between the world of the hunter and the hunted, the central qasgiq smoke hole was also a passageway between the world of the living and the dead. For example, in the event of a human death, the body of the deceased was pulled through the smoke hole, after first being placed in each of its four corners. By this action the deceased, on the way from the world of the living to the dead, gradually exchanged the mortal sight that it lost at death for the supernatural clairvoyance of the spirit world (Nelson 1899:425).[20]

The image of the ringed center recurs again and again in Nick's work, and always with the connotation of vision, if not movement, between worlds. In fact, the qasgiq or men's house in which Nick grew to manhood was itself the spiritual and social window of the community, surrounded by individual enat, or women's houses. It was in these enat that his mother and sisters prepared food and clothing and cared for the younger children. The reproductive capacity of the women's house was explicit. In certain contexts, its interior was likened to the womb from which children would be produced and, concurrently, the spirits of the dead reborn in human form, reentering the world of the living.

Physical birth, female productivity, and seasonal rebirth as symbolized by exit from the traditional women's house is the counterpart of the spiritual rebirth and vision of an other worldly reality accomplished in the qasgiq (men's house). Just as most masks were carved in the qasgiq, most masked dances and communal events were performed there.[21] It was largely, although not exclusively, in the qasgiq that visions of the supernatural were realized in material and dramatic form. Nick's sisters might carve a transitory representation of daily events in the earth with their story knives, but the elegantly carved knife itself, as well as the symbolic designs upon it, were made in the men's house by their father or their uncles.

However, the social interpretation of human sexual differences was not framed as an opposition, but as a circle, both encompassed and encompassing. Traditional village structure involved this same endless circle. For example, although the sexual distinction was extreme in the division of social space into separate men's and women's houses in the larger winter villages, many of the camps that Nick knew in his early years consisted of a single dwelling. However, according to Nick, the differentiation between summer and winter entrances was all that was required to realize the cosmological design.

In various ritual contexts, the oppositional relationship between the sexes was explicitly played upon. For example, there was gender ambiguity when Nick's aunt dressed as a man in a formal serving ritual. Likewise, there was gender fusion when the shaman in touch with the spirits of the animals was confined in the qasgiq like a woman in childbirth or menstrual seclusion. Note also in this context the mixed sexual imagery on the mask of Issiisaayuq, including both male labrets and a female chin tattoo.

The social interpretation of human sexual differences is also visible in the separation of men and women on

the dance floor during a contemporary masked performance. Kneeling on the floor facing the drummers and singers, Joe Chief, Jr. begins to play out the stylized motions that tell the story behind the mask that Nick has carved. His quick staccato motions are accompanied by the graceful movements of Elena and the women dancers standing in a semi-circle behind him. Together, dancers and drummers form a circle reminiscent of the ring (ellanguaq) encircling the mask. This image is, according to several Nelson Island women, taken further by the decorative belts worn around the waist of the women as well as the beaded wolverine crowns encircling the heads of the dancers and covering the studiously cast-down eyes of the performers.

The image of the encircling ring can also be seen in the rounded dance fans, fringed in both fur and feathers, held in the hands of the dancers, both men and women. These fans are reminiscent of the mask worn by the central dancer. In fact, traditional and some contemporary dance fans often have faces (see Nelson 1899:412 ff.). Women's dance fans made and used on the Yukon delta today by carvers such as Emmonak's William Trader still have faces, both animal and human. The open work design of the fans held by the men on Nelson Island was also explicitly compared by Nick to the pierced hand found as an appendage on many traditional dance masks. The hole in the hand's center, like the opening in the dance fan, is, by Nick's account, a symbolic passage through which the spirits of fish and game come to view their treatment by men and, if they find it acceptable, repopulate the world. Thus the dancers, both male and female, holding dance fans and arms extended in the motions of the dance, are like gigantic transformation masks, complete with animal/spirit faces to which the wooden pierced hands are appended.

Given this perspective, one may reasonably contrast the efficacy of the mask's supernatural sight to the lowered gaze of the human performers who dance in order that they truly "see," and that the spirits see them. According to Nick, the traditional application of a white clay base and colored finger spots to the bladders inflated for a Bladder Feast was likewise an attempt to promote spiritual vision on the part of the souls of the seals. The painting of the wooden masks, as well as the painting of the body of the dancer, had a similar effect, allowing the dancer to become visible to the spirit world and in fact to embody the spirit at the same time that his human identity was hidden from the world of men.

The image of the ringed center, implying both vision and movement between worlds, is mapped not only in village structure and in the structure of the dance performance, mask, and fans, but on the structure of the world at large. When Nick was a boy, he was taught that the earth was an island space (or hole) surrounded by water. The coast was the rim of the world as it was known. Venturing from it was a hunter's task, and while Nick was gone in search of specific species, Elena, his wife, must remain relatively motionless inside the house on the land lest the game animals that her husband pursued be scared away. Yet when, at fall camp, she heard her husband returning, Elena would quickly exit, climb to the roof of the sod house and, humming her own accompaniment, dance.

Not only is the land the female domain, but it is, under certain circumstances, equivalent to her body. This equation is given vivid recognition in the advice given a man should he meet a female ghost. He is admonished to touch her between the legs. One man who had done this was said to have disappeared. When he awoke his arm was deep in the ice. He pulled it out and the ice closed after him. In this case, the world (specifically the sea or watery world) is equivalent to a female body, a sexually potent one, and one that does not hesitate to contain its opposite. Even the smoke hole, likened to a hole in the ice in various ritual contexts, recalls the child's head emerging, as the hole with no ice (cikuilquq) is metaphorically, if not symbolically, the fontanelle, the soft spot on a baby's skull. Finally, the word for ceiling (qilak) is synonymous with sky or heaven. So, metaphorically, as the child's head emerges from the mother, man emerges from woman, and heaven from earth. Making a house, like making a child, or for that matter a ringed mask, was in a very real sense culturally equivalent to remaking the world.

As human biological processes (birthing, seeing, dying) were literally built into the structure of the house, the world in which the house existed, and the mask which represented this entire cosmological design, so were the processes of both animal and human spiritual transformation. In the specification of the significance of entry and exit from the human habitation, the tusked entryway of the men's house should be recalled. During the dance performances that Nick and Elena watched when they were young, dancers often emerged from behind a screen or through a tunnel that several Nelson Islanders specifically likened to the mouth of an animal as it opens into the men's house. Here, the vision of the spirit world came, literally and figuratively, out of the animal's body. [22]

The Yup'ik universe, both social and metaphysical, was traditionally depicted as subject to constant alternation, yet ultimate unity in the repetition of the reproductive and productive cycles. It is, ultimately, both the alterations and the unity that Nick's masks, and the masked dances of the Bethel dance group, dramatize. Traditionally each mask was unique, and the product of an individual vision and experience. Each was produced as part of a performance and then discarded, as new visions and new masks would replace it in succeeding

years. However, continuity in the use of the hooped mask today provides a key material metaphor for the system of cosmological reproduction by which and through which the Yup'ik viewed and continue to view the universe. The same image of supernatural sight that dominates Nick's masks was found in the rounded lamp and the ringed bowl, the hole in the kayak float board and the decorative geometry or traditional ivory earrings, the qasgiq surrounded by enat, the central gut skylight opening from the qasgiq, and the ellanguaq suspended from its ceiling for a dance performance. The world was bound, the circle closed. Yet within it was the passageway leading from one world to the next. Rimmed by the ellanguaq, and transformed by paint and feathers, the eyes of the mask, themselves often ringed, look beyond this world into another.

Conclusion: Rebirth and Revision

The mask of Issiisaayuq hangs on a wall and stares straight ahead, like a photograph, motion frozen in time. We can view it in terms of form and technique and when judged by this standard it wins high marks for complexity and imagination. Or we might see it in its full context, as the focus of a complex of beliefs, and in fact, a material metaphor as well as the means for the spiritual vision of the Yup'ik Eskimos. Yet for Nick, the finished mask is no more important than the wood chips from which it has been so laboriously separated. Skillfully executed in order to please and "draw" the spirits of the game, traditionally it would have been thrown away after the performance.

Today, Nick will sell his masks or give them to his children. For him either alternative is acceptable. What is important to him is the process of making the mask and dancing behind it. This is brought home by the circle of rotting masks found recently at the mouth of the Yukon delta by a group of villagers from Sheldon's Point out on a berry picking expedition, and subsequently taken back to the village and sold to the Anchorage Museum of History and Art. They were all that

James H. Barker

Figure 20. Nick and Elena Charles receiving gifts during a dance festival at Toksook Bay, 1983.

was left to attest to an event long since done. The fact that the masks were left to rot does not say they were valueless, but rather that the belief that created them was timeless. The ring of rotted faces is yet another image of the Yup'ik belief that all that is born will die, and all that dies will be born again.

This fundamental belief in a continuity in the essentials of life was reinforced by another important event in which Nick and Elena participated in the fall of 1982. The village of St. Marys sent out word that they were hosting a festival of Yup'ik dancers (Yupiit Yuraryarait) on the second weekend in October. Dancers came from Chevak, Emmonak, Pilot Station, Toksook Bay, Kotlik, Stebbins, Tununak, and St. Marys. Guests came from even farther afield, including members of the Bethel dance group. The event included dancing, bingo, and a potluck dinner. No formal gift exchanges were made, but many informal ones attended the hosting of the visitors by the residents of St. Marys. The event was a great success. The question in 1983 was not whether or not to repeat the dance, but where to hold it. St. Marys knows that the hosting duties should be shared among participating villages. Residents of Toksook Bay, including some of Nick's relatives, made it clear that if St. Marys did not host this fall's dance, they would like to. In any event, there probably will be a repeat performance of last fall's intervillage get together, and more than likely Nick and Elena will be there (fig. 20)[23].

This highly innovative exchange is another indication of the ways in which more traditional skills and events are being put to the service of new social configurations. The revitalization of the traditional multi-village exchange dance provided a valuable opportunity for friendships and bonds of kinship to be reaffirmed and revitalized through exhanges of food and gifts of seal oil. Yet the new multi-village dances do more than give Nick and his friends an opportunity to renew their acquaintance. Perhaps more important, the vitality and popularity of these events serves as a partial antidote for the fractured relationship between generations. During these intervillage dances, the elderly experts came together both on stage and off with their juniors. Although they definitely dominate the dance floor, a view of the audience intent on the performance reveals the next generation of dancers readying to take their rightful place when their turn comes. Watching them watch, one begins to believe that the gap between the generations previously exposed might not be as wide as it first appeared.

Traditionally, men and women danced to the steady rhythm of the hooped drum, said to represent the beating of the spirits and, alternately, the lively movements of the spirits of men and game over the thin surface of the earth. Certainly today the drum continues to be the heartbeat of the dance, as Nick beats out songs of hunt-

ing adventures and misadventures as well as plane trips and basketball matches (fig. 21). If Nick's mask is the eye and his drumbeat the pulse, the dance as a whole represents—in fact is—Yup'ik life at its fullest and Nick's life at its best.

Today, Nick and Elena are teaching carving and dancing, and ultimately proper living and learning, to students all over the region. Their carving workshops and dance performances take much of their energy and allow little time for the production of masks for sale. This turn of events is welcomed by both artists, as it begins to place mask making and dancing back in the context of community activity where they belong. Nick made few masks last winter. Yet through his efforts in delta villages such as Kasigluk and Kwethluk, young people who had never seen their parents dance are once again learning and performing some of the stories and songs of their fathers' fathers before them. Masked dancing traditionally involved a spiritual rebirth, where all that had been torn apart physically, metaphysically, seasonally, and socially was brought together. It also involved a renewed vision of and movement between the spiritual worlds and the everyday world of men. The ringed mask, its eyes open and all seeing, was a central element in this dramatic recreation by the Yup'ik of themselves. Although many of its specific meanings have been lost or replaced, the rebirth of masked dancing on the delta underscores an essential continuity.

Figure 21. Nick Charles singing and drumming for the Bethel Native Dancers at the Smithsonian's Festival of American Folklife, 1984.

Smithsonian Institution

ENDNOTES

1. All Yup'ik terms are given in the standard orthography (Reed et al. 1977) and are italicized when they first occur. These may vary from the place names given in missionary or conventionalized map transcription. All standardized spellings have been checked through reference to Jacobson (1984) or, in the case of place names, with the help of Native speakers James Berlin and Oscar Alexie of Bethel.

2. Nelson Island is located off the west coast of Alaska, midway between the mouths of the Yukon and Kuskokwim Rivers. A 1,000 foot rise in the center of the island (the remains of prehistoric volcanic activity) sets this area off from the surrounding alluvial flats which characterize the coastal region of the Yukon-Kuskokwim delta. The treeless expanse is riddled with slow moving sloughs and streams which provide a rich summer breeding habitat for numerous species of fish and waterfowl. The adjacent coastal waters of the Bering Sea are no less productive of sea mammals, especially the bearded seal, and fish species such as herring, salmon, and halibut. The Yukon and Kuskokwim Rivers provide equally rich environments and are visited annually by major salmon runs. Bethel, the modern transportation and service center for the region, is located 100 miles up the Kuskokwim from the Bering Sea coast, just below the point at which the subarctic tundra gives way to progressively thicker and taller stands of alder and spruce.

3. Agayuli(luteng) were actually songs of supplication performed during the traditional ceremony known as Kelek (Morrow 1984:136). Here Nick uses the term to refer to the entire ceremonial complex. He also gives the word its ancient meaning, still found on St. Lawrence Island, and in Nunivak agayu- (mask). Elsewhere in the Yup'ik area the word has, in the twentieth century, been more commonly used to mean praying or worshipping, a logical extension given the term's original meaning.

4. According to Jacobson (1984:178) this term refers to the small gift, usually food, brought to get into a dance or feast. The term was subsequently adopted as "etrushka" by non-Native commentators to refer to the feast itself. Nick Charles was using the term in the second sense.

5. Nushagak is part of the lucrative Bristol Bay commercial salmon fishery, in which boat owners could net between $15,000 and $40,000 during a summer season in the late 1970s. Crew members made considerably less. This can be compared to the much less lucrative Kuskokwim salmon fishery, averaging less than $1,000 per permit holder during the same period. The one big advantage that the commercial fishermen of the Kuskokwim have over those who go to Bristol Bay is that they are able to exploit the salmon as a subsistence resource simultaneous with taking advantage of the commercial fishery. As the commercial periods are interspersed with periods open for subsistence exploitation, a family that has moved downriver to fish camp can alternate between commercial and subsistence fishing throughout the summer, using the same equipment for both endeavors.

6. The limited entry system, enacted in 1972, is based on a complicated point system that awarded permission to harvest in the Bristol Bay fishery based on involvement in the fishery prior to 1973. Many long-time fishermen in the area who had not fished during three consecutive years just prior to 1973 were denied permits under this system and therefore prevented from full participation in the fishery in the future.

7. Carved and incised ivory knives were traditionally, and still are, used by Yup'ik girls to draw story designs in mud or wet sand as they tell each other stories. As the story is related, the orator draws stylized designs with the tip of her knife that recount the events of the tale. If an ivory knife is not available, a child may use a wooden stick or metal butter knife.

8. Although mask making declined on Nelson Island and along the Kuskokwim drainage, masks were made continuously on Nunivak Island, where there was no missionary until the late 1930s. Even after the coming of the missionaries, Nunivak carvers made masks for sale regularly in the 1940s and 1950s, although they did not make them for local use in dances (Lantis, pers. comm.). Mask making also continued in other parts of the region such as the lower Yukon delta and the Kuskokwim, as discussed and illustrated by Himmelheber (1953).

9. For an extended consideration of the themes introduced in this section, the reader is referred to an article bearing this title scheduled for publication in Arctic Anthropology in the spring of 1987.

10. The full and successful development of this theme would not have been possible without conversations with Phyllis Morrow of Bethel. Her contributions were inspirational in the beginning and substantial in comments and additions to the paper in progress. Although I take full responsibility for errors and over-generalizations that may be contained in the following pages, her detailed ethnographic input remains indispensable to the full development of the theme.

11. Nelson Islanders, at least through the 1940s, in certain circumstances tied a string joining the wrist of a child and a door or house post. One young man recalled this treatment. He attributed it to the fact that his elder siblings had all died in infancy, and that his parents were taking extra precautions to ensure his survival.

12. In 1889, Edith Kilbuck noted the manner of disposal of a female shaman suspected of killing several children: her own husband clubbed her to death, severed all her joints, and burned her with oil.

13. Although historical connections are beyond the scope of the present article, we must at least note the fact that joint-markings are not a unique feature of Yup'ik iconography. As early as 1897, Boas recognized the special function of the eye as a joint-mark in the art of the Northwest Coast. In Schuster's article on joint marks (1951:17), Boas is quoted as saying: "An examination . . . will show that in most cases it [the eye] is used to indicate a joint. Shoulder, elbow, hand, hips, knees, feet, the points of attachment of fins, tails, and so forth, are always indicated by eyes."
On the distribution of the nucleated circle as such, see also Smith and Spier (1927).
Finally, given the connection between shamanism and vision imagery for the Yup'ik area, it is interesting to note that eyes have also been found in the palms of carved wooden hands used by Tlingit shamans.

14. Here Thalbitzer's observation, although not specifically referring to the Yup'ik conceptual system, has a special significance: "According to Eskimo notions, in every part of the human body (particularly in every joint, as for instance, in every finger joint) there resides a little soul." (Extracts from his "The Heathen Priests of East Greenland" in Verhand lungen des XVI Amerekanisten-Kongresses, Wien 1908, p. 447-464; in Kroeber and Waterman, 1931:430 f; cited by Weyer 1932:291).

15. In a number of contexts, the snowy owl (anipaq) was associated with acute powers of observation. For example, traditionally warriors pretended to be owls. Anipaunguarvik (Owl Village, lit. a place to be like an owl) was located at a point on the Kashunak River where warriors traditionally watched for the approach of their adversaries during the Bow and Arrow War period.

16. This practice of ritual sacrification has also been observed among Siberian Yup'ik. Bogaras (1904:408) notes that "the man who gave the last stroke, if this happens to be his first whale or bear, has the skin near all his joints pierced with the tattooing-needle, leaving a simple but indelible mark."
According to Collins, as cited in Schuster (1951:17), among the Eskimos of St. Lawrence Island in the Bering Sea "men are tattooed on wrists, elbows, shoulder-joints, back of neck, middle of back, hips, knees, and ankles with one prick in commemoration of some event—killing a whale, polar bear, mukluk (bearded seal), or being a pallbearer." Moore (1923:345) asserts that these tattoos consisted of "two small dots near together at each shoulder, wrist, and elbow, the cervico-dorsal and lumbo-sacral areas, and at the knee and ankle." Bogaras (1904:256) records that among the maritime Chukchee of northeast Siberia tattooed joint marks once served as a tally of homicides.
Finally, Schuster concludes (1951:18):
"These tattooing customs, when aligned with the custom of applying eye-shaped markings to the joints in the decorative arts of adjacent areas to the south . . . strongly suggest that the single dot, as used in such tattooing, is itself the rudiment of an eye motif. The simple one-dot tattooing of the joints among the Bering Strait Eskimo and the Chukchee might very well be the survival of a primitive practice underlying the artistic tradition of joint marking in areas farther, and perhaps even much farther, to the south of the American continent. On the other hand, . . . such tattooing of the joints shows a surprising similarity to tattooing practices prevailing among certain peoples in the South Pacific."

17. Dark circles also appear as goggles on Bering Sea Eskimo 19th century objects. The goggles identify beings as supernatural, are puns for masking, and refer to the state of transformation (Susan Kaplan, pers. comm.).

18. Parenthetically, note here the comprehensive symbolic significance of the admonition that a novice attend to a teacher or an elder with downcast eyes as a sign of respect. This simple action has confused and confounded innumerable bush educators and convinced them that their Yup'ik students were either bashful or stupid or both. In fact, downcast eyes are an eloquent expression of the relationship between socially restricted sight and powerful vision, all of which we unwittingly undercut when we help Yup'ik children in school to overcome their apparent shyness.

19. Other instances of culturally appropriate and inappropriate directionality are also apparent in Yup'ik daily life. For example, when making akutaq (a traditional mixture of berries, snow, and oil) one must always move one's hand around the inside of the bowl in a clockwise direction. Likewise, when braiding herring, grass should begin to be crossed right over left, and when a dancer begins a performance she or he will always start on the right side. However, the precise significance of these rules, as well as their connection with traditional encircling actions, is at this point unclear.

20. Morrow notes that although both smoke hole and ice hole were rectangular rather than round, this does not undercut their significance as spiritual eyes, as one variant of the circle and dot motif was, in fact, a rectangle with four small projections, one at each corner, within which was carved the dot surrounded by concentric circles. She also notes that the numbers four and five (four corners and the center?) figure prominently in Yup'ik ritual. They represent, for instance, the number of steps leading to the underworld land of the dead (Morrow, pers. comm.). The Raven myth is also full of references to four days, four times; the Bladder Festival rituals use four corners, four sets of hunting and boating gear; and painted bentwood bowls and incised ivories have spurs that occur in units of four. Therefore, the reference to square or rectangular holes and the quadrangle functioning like a circle and dot may form a logical symbolic complex with this added sacred dimension (Susan Kaplan, pers. comm.).

21. An exception that immediately comes to mind is the individual dance traditionally performed by men standing outside the qasgiq in late summer, sometimes as a welcome to guests, and labeled puallauq by Paul John of Toksook Bay. Jacobson (1984) defines the base pualla- as "to stand up and dance [of men at an Eskimo dance doing an Inupiaq-style dance]."

22. The cyclical nature of Yup'ik cosmology has been detailed elsewhere (Fienup-Riordan 1983): for example, images of birth resolving into rebirth, torn parts sewn into whole cloth, spring dying into winter, spring being born again.

23. The above prediction was written in the summer of 1983. The following fall, Toksook Bay did, in fact, host a multivillage dance performance, and Nick and Elena not only attended, but were given gifts as part of the closing distribution.

BIBLIOGRAPHY

Ali, Elizabeth and John Active. 1982. *The Bethel Native Dancers in Performance.* Printed Program, Bethel Council on the Arts, Bethel, Alaska.

Barnum, Francis. S.J. 1896. "Notes on Inuit Ethnography." *Woodstock Letters.* 25:478. Oregon Province Archives, Spokane, Washington.

Boas, Franz. 1897. "The Decorative Art of the Indians of the North Pacific Coast." *Bulletin of the American Museum of Natural History.* 9:123-176.

Bogaras, Waldemar. 1904. *The Chukchee.* Memoirs of the American Museum of Natural History. Vol. 11. Franz Boas, ed. Leiden: E.J. Brill Ltd.

Charles, Nick. 1983. *Life History.* Taped interviews with Ann Fienup-Riordan, June 1983, Bethel, Alaska. Rasmuson Library, University of Alaska, Fairbanks, Alaska

Fienup-Riordan, Ann. 1983. *The Nelson Island Eskimo.* Anchorage: Alaska Pacific University Press.

—. 1984. *Nick Charles: Worker in Wood.* The Artist Behind the Work. Oral History Program, Alaska and Polar Regions, Rasmuson Library, University of Alaska, Fairbanks, Alaska.

—. 1985. *When Our Bad Season Comes: A Cultural Account of Subsistence Harvesting and Harvest Disruption on the Yukon Delta.* Report for the Alaskan Council on Science and Technology. Alaska Anthropological Association Publication.

Fitzhugh, William W. and Susan A. Kaplan. 1982. *Inua: Spirit World of the Bering Sea Eskimo.* Washington, D.C.: Smithsonian Institution Press.

Flintoff, Corey, 1983. *Eyes of the Spirit.* Video documentary of 1982 mask making workshop. KYUK Radio Station, Bethel, Alaska.

Himmelheber, Hans. 1953. *Eskimokünstler, Ergebnisse einer Reise pin Alaska.* 2nd edition. Eisenach, Germany: Erich Roth-Verlag.

Jacobson, Steven A. 1984. *Yup'ik Eskimo Dictionary.* Alaska Native Language Center, University of Alaska, Fairbanks, Alaska.

John, Paul. 1977. *Qulireq.* Recorded 2.14.1977, Toksook Bay, Nelson Island. Translated by Louise Leonard and Ann Fienup-Riordan, Fall, 1984, Anchorage, Alaska.

Kilbuck, Edith. 1889. "The Alaska Mission: Letter from the Kuskokwim." *The Moravian.* 34(34):530-1.

Moore, Riley, D. 1923. "Social Life of the Eskimo of St. Lawrence Island." *American Anthropologist* 23(3):339-75.

Morrow, Phyllis. 1984. "It Is Time for Drumming: A Summary of Recent Research on Yup'ik Ceremonialism." In: *The Central Yup'ik Eskimo. Etudes/Inuit Studies.* Supplementary Issue. Ernest Burch, Jr., ed. Vol. 8:113-140.

Nelson, Edward. 1899. *The Eskimo about Bering Strait.* Bureau of American Ethnology. Annual Report 18, Part 1, 1896-7. Washington, D.C.

Ray, Dorothy Jean. 1967. *Eskimo Masks. Art and Ceremony.* Seattle: University of Washington Press.

—. 1981. *Aleut and Eskimo Art: Tradition and Innovation in South Alaska.* Seattle: University of Washington Press.

Reed, Irene, Osahito Miyaoka, Steven Jacobson, Paschal Afcan and Michael Krauss. 1977. *Yup'ik Eskimo Grammar.* Alaska Native Language Center. University of Alaska, Fairbanks, Alaska.

Schuster, Carl. 1951. "Joint Masks: A Possible Index of Cultural Contact Between America, Oceania and the Far East." Royal Tropical Institute. 39:4-51. Amsterdam.

Smith, Dorothy A. and Leslie Spier. 1927. "The Dot and Circle Design in Northwestern America." Society of Americanists, NS.19:47-55.

Usugan, Frances. 1982. *Qulireq.* Recorded Nov. 3, 1982. Toksook Bay, Nelson Island, Alaska.

Weyer, Edward Moffat, Jr. 1932. *The Eskimos, Their Environment and Folkways.* New Haven.

Zagoskin, Lavrentiy A. 1967. *Lieutenant Zagoskin's Travels in Russian America, 1842-1844.* Arctic Institute of North America. Anthropology of the North: Translations from Russian Sources, No. 7. Henry N. Michael, ed. University of Toronto Press.

ACKNOWLEDGEMENTS

The information gathering process on which this biography is based was two-fold. First of all, during the summer of 1983 I was able to visit with the Charles family several times at their home in Bethel, including a visit to their summer fish camp on the Kuskokwim River. In August, I traveled with Nick and his wife, Elena, to Nelson Island, where Nick's brother lives, and where we have numerous friends in common. There I was able to add to what I had already learned about Nick's early years. I am indebted to Nick Charles, and to his family, especially his wife Elena and his children George, Mary, and Susan, for all the help and encouragement they so freely gave during that summer as well as during the following year. They transformed an opportunity which I approached with enthusiam yet with trepidation into an experience I truly enjoyed and deeply cherish. Nick let me learn a great deal, and I remain in his debt.

On my way back to Anchorage through Bethel I also had the opportunity to view ten hours of raw video footage taken by KYUK television station personnel during the traditional mask making workshop that had been held in Bethel the previous autumn, and in which Nick had played a major role. I wish to thank Corey Flintoff and the other members of KYUK who generously made this material available to me. Copies of the videotapes, as well as a copy of the thirty minute video documentary that was subsequently produced by KYUK from the material (Flintoff 1984), have since been provided to the University of Alaska Archives where they consitute an important part of the Nick Charles collection.

Along with the biography and video footage, photographs collected during the summer of 1983 were an important part of the documentation of the life and work of Nick Charles. Special thanks are due to Susan Charles who made available valuable negatives of family photographs dating from the 1940s, from which a number of illustrations in this volume have been drawn. James Barker, a Bethel-based photographer, contributed numerous more recent photographs to the collection, some of which were commissioned as part of the project and some of which were taken and generously contributed after the project and project funding were officially done. Suzi Jones of the Alaska State Council on the Arts also contributed a number of excellent black-and-white prints which she had taken of Nick and the other carvers that participated in the Bethel mask making workshop.

Finally, while the rough draft of the biography was written in August 1983, it was subsequently refined and greatly improved through conversations with and comments by the Charles family, as well as other friends and colleagues, including William Schneider (the father of the oral history project), James VanStone, Margaret Lantis, Dorothy Jean Ray, Phyllis Morrow, Chase Hensel, and Anthony Woodbury. While holding none of them responsible for errors I may have committed, I would like to thank them all for the generous help they gave.

Finally, as always, last but not least, I thank my husband Dick, whose continual support makes what I do both possible and worthwhile.

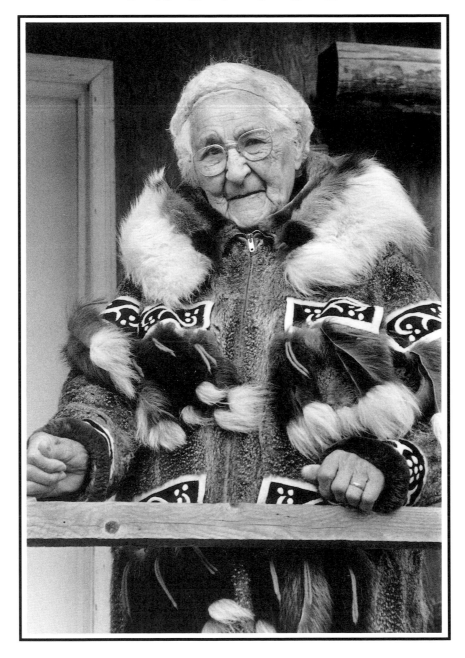

FRANCES DEMIENTIEFF

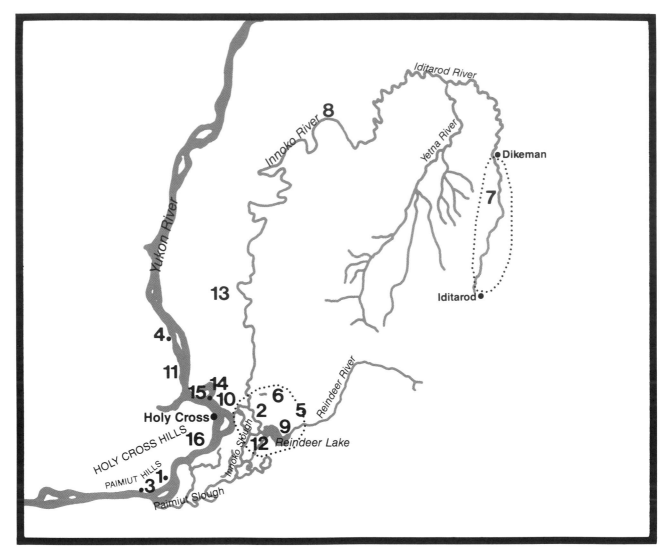

1. **Tabernacle Mountain**
 Frances' family's fish camp.

2. **High Banks along Paimiut (Paimute) Slough**
 Berry picking area.

3. **Paimiut area**
 Berry picking.

4. **Bonasila**
 Site of a big kashim.

5. **Local trapline area**

6. **The Flat**
 Winter trapping area.

7. **Trapping area**

8. Frances accompanied her sons to **winter camp,** following the In-noko River and Iditarod River.

9. **Reindeer Lake and Reindeer River**
 Winter ice fishing areas.

10. **Village Across**
 An Athabaskan village site.

11. **Deer Hunting Slough**
 Deer hunting area.

12. **Reindeer Lake area**
 Spring camp.

13. **Mink trapping area**

14. **Demientieff's winter fishing area**

15. **Lucky Point**
 Area for spring birds.

16. **Fat John Slough**
 An alternate route to fish camp (Big Bend Slough) when water is high and the Yukon River is rough.

This information was provided by Frances Demientieff's son, Michael Demientieff, and his wife Daisy.

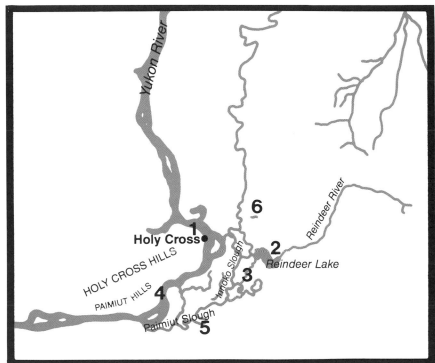

1. Holy Cross, Frances' home
Source of flower designs and landscape patterns.

2. Reindeer Lake area
Source of animal patterns, and fall landscape and berry colors.

3. Paimiut Slough
Source of winter animal and track patterns, and spring plant colors.

4. Tabernacle Mountain
Source of summer plant, flower, tree, and fish patterns and colors.

5. Paimiut Slough
Source of summer and fall colors from plants, animals, and the landscape.

6. Alberts Lake
Source of fall plant and animal imagery and colors.

Page 59: **Figure 1.** Frances Demientieff, Holy Cross, 1985.

"There's lots to be proud of for Frances, not only beading"

INTRODUCTION

Often, writers on the arts attempt to distinguish between arts and crafts, between *art* (or *high art*) and *folk art*. For the purposes of specialists, who must please an audience with interests of its own, this distinction has been useful, and it has taken on a life of its own. But, facing the reality of an artist's work, that is, her life, one finds the definitions inadequate. This is true in the present case, when a writer such as myself approaches a distinguished elder, Mrs. Frances Demientieff, seeking to understand her work as it has unfolded in her own life; and the situation becomes more complicated in a pleasant way, when the writer has been befriended by Mrs. Demientieff and members of her family, as I have been.

Frances Demientieff is an Athabaskan woman, a wife and widow, a mother, grand- and great-grandmother, a Catholic, a fisher, netmaker, skin sewer, bead worker, a good cook, a teacher and counselor, a comforter, a midwife, a nurse. The work which is the reason for this writing, her beadwork and skin sewing, has for more than sixty years delighted and clothed her family and friends. Unlike artists from the mainstream of American society, she has never had to contend with anonymous collectors, or with friendly or unfriendly critics with reputations to build, or with the struggle for recognition—that is, sympathetic response—from an indifferent audience. Her reality has been of a different composition.

"Only connect," wrote the novelist E. M. Forster. That yearning has been a deeply-felt theme in the lives of artists working in the European and American modernist traditions. That desire has been fulfilled, I believe, in the life of this artist, who has lived her years in the net of kinship of her own small community. Since the age of six, she has lived in the village that is called Holy Cross, on the Yukon River. Outsiders catalog this village, founded by Jesuit missionaries in the 1880s, as a sort of border place: the downriver limit of Deg Hit'an Athabaskan settlement, the upriver limit of Yup'ik Eskimo people. Physically, the country around it is considered a transition zone from the forests of the Interior to the muskeg tundra of the Bering Sea coast. But members of the village represent themselves in a more integrated way than this. Their own history, their knowledge and great

love of their home give the stories they tell of their lives the coherence outsiders have often missed. The people of Holy Cross have actively and consciously (and not without turmoil) worked to absorb into themselves the complexities of their history, that is, the identity which the people of Holy Cross claim as their own.

The Senegalese poet Leopold Senghor wrote, "The beautiful mask, the beautiful poem, is that one which produces on its audience the effect intended: sadness, joy, hilarity, or terror." This poet's words have been my guide in the task of representing how Frances Demientieff's work, and her life, have affected her people. For, as her friend Axinia Peters admonished me, "There's lots to be proud of for Frances, not only beading!" She was telling me that Frances Demientieff had played a profound part in the lives of everyone in her village. She has moved in the presence of life and the passing into death. Her hands have been for the sick, for mothers giving birth, for washing the dead. Her handiwork—her sewing, her work with skins, her beading—embodies her devotion to this life; it is a visible form of her passion.

My friend, my teacher, Grandma Frances' relative Mrs. Martha Demientieff has taken a great deal of trouble with me over the years.[1] For how many hours, days, weeks have we talked about our lives and has she gradually revealed to me the intricacy of the web of life in her village. One day last spring, watching the returning swans, she said very casually to me, "Everything—language, handiwork, songs—is art. The way animals blend into the forest, the way people read the weather is all art." She expected a poet to understand this, and it is the definition I take here of art.

Art is more complicated than the production of beautiful or useful objects. Even this latter distinction is useless here: beauty and utility are not separate in this work. In an artist it is, more than anything, a passion to *make*, to *do*. Equally, it implies the need to give what has been made. "Only connect," said Forster. This artist does not live apart from, at odds with, her family and her society, and her handiwork is the sign and expression of this kinship. There is a theological term, *sacramental*, which may most closely describe what I mean, for it is the term for the outward representation of powerful spiritual bonds. It is to such a relationship—the spiritual kinship of people, animals, place, language, history—that Martha Demientieff's insight about art refers. The works are the expression of love in the form of objects which give pleasure as they provide comfort and care.

This returns us to a very old notion of art. Everything I was told in Holy Cross supports it. It is my purpose in this text to illuminate as best a sympathetic outsider might, the vivid spiritual quality which informs the life of this artist and which has its rhyme in the values of those who live around her.

Frances Demientieff's work is women's work. In her society, women know themselves in a fundamental way to be the bearers of life, and their work is valued as it expresses this gift. Needlework is adornment, is protection against hard weather; it is the passing on of tradition from older to younger women; it is the pleasure of making, and it is consolation. The late Mrs. Mary Walker used to say, "When in sorrow, woman, take up your needle."

I have been most interested in this text to allow other outsiders, who may have the pleasure of holding in their hands a piece of work by Frances Demientieff, to see something much greater than the object itself, however beautiful it may be: to see it as a moment in the life of its maker, and to feel some connection to her.

There are several things the reader should know about this text, regarding certain conventions of American scholarship and journalism which do not apply here.

The first point of note is that, among Frances Demientieff's people, no one may presume to speak for anyone else. Her daughters, for instance, cannot pass on their mother's knowledge; for a person's knowledge, like her life, is her own. But one may speak of another's teaching, of what she has learned from another. It is the obligation of a listener, in such a situation, to hear and report accurately. Accuracy, in this relationship, is a standard which the listener must refine in close collaboration with the speaker. Put simply, standard techniques of interviewing and compilation, with the interviewer's right to information as an implicit assumption of the work, do not hold. Put more simply, this is not my story. What I have gathered belongs to others and is presented with their permission. The arrangement is my own, not an inconsiderable task, but not the whole work, either. What I have done is a compilation of many voices, rather than a continuous narration of one voice. And in this regard, I acknowledge a debt of honor to those who taught me. It was their act of friendship, as much as their tutelage, that has allowed me to present this text.

In return, I wish to say that there is no pretense of "objectivity" about the writing. I was not in Holy Cross to "observe" people, and perhaps I would not have learned what I did if I had not come as a friend. I have tried to be worthy of the trust shown me by writing accurately and fairly.

The second important point is that, in a certain way, this writing might be considered a violation of Athabaskan etiquette. It is no slight to Frances Demientieff to note that it is somewhat unseemly for outsiders to single out one person over another for such attention at this. It is also true that people are recognized and praised for their accomplishments, and that it is proper for younger people to go to older ones for instruction.

The third point is related to the second one and has to do with the impropriety of asking direct questions, particularly of older persons; for by asking a direct question (such as asking to write the story of her life), one is demanding a response. This is an imposition on the free will of another, whose response can only come voluntarily. Frances Demientieff kindly agreed to allow me to come to her. I tried to be as indirect and observant as I could be in Holy Cross, but of course one is never so graceful. For example, I arrived with a very good tape recorder, on the off-chance that some audio recording would be of interest to any of the people with whom I was going to be speaking. I did not expect that anyone would wish to address that anonymous audience, and that was the case. People prefer to face each other when they talk.

Often, people were amused at how much I was writing down. Several times, when the talk turned to the most hidden themes, I was asked to put my pen down, which I did. My friends' memories are excellent, much better than mine, which has been trained for print rather than in the disciplines of hearing and seeing. People who talked with me very carefully distinguished what they had heard and seen for themselves from hearsay, and often I was given a hint of what the speaker knew would interest me and directed to the proper person to tell me what I needed to learn.

KM

FRANCES DEMIENTIEFF

by
Katherine McNamara

Frances Demientieff was born Frances Howley in 1895, near Bettles, Alaska, on the Koyukuk River near the Brooks Range. Her mother was T'oyeet, an Athabaskan woman from near Huslia, baptized Amelia by Father Julius Jetté. She came from Hogaadzaakkaakk'at, the mouth of the now-named Hog River; this place is now called Hozatza. This is where T'oyeet and her family were camped when Father Jetté visited. In his records, she is not linked with any other family; but Jetté made only one trip that far upriver, and so here his record is incomplete.

T'oyeet may have been the oldest child. Her brother was Nohʉgho'oɬ, baptized Lawrence in 1888, according to church records. He was also known as Big Charlie. He died in 1927. Other brothers, Harry and George Butler, were taken to Tanana by white people, after the boys' parents died in camp.

T'oyeet was a cousin of Hadozeelo, the father of Bessie Henry, Little Peter, Anna Bifelt Huntington, Ellen, Hog River Johnny, and Sophie Sam. These people, several of whom are still living, are the elders of present Huslia people who are Frances' relatives.[2]

Her father was Frank Howley, whom Frances long thought was of English descent, although later she learned from a member of his family that he was Irish. T'oyeet and Frank Howley had another girl, Margaret Hazel, born in 1902, who was called by her middle name. Hazel died in her teens. Her sister remembers that she had a lovely singing voice and thinks their father would have liked professional training for her.

Mission Days

When Frances Howley was about six, her mother fell ill, and she (and later, her sister) was sent down the Yukon River to Holy Cross Mission, which had been founded in the 1880s by Jesuit priests and the Canadian order of the Sisters of St. Anne. She did not see the Koyukuk River again for almost eighty years. In 1981, she flew to Huslia, her mother's birthplace, in company with her daughters Betty Johnson and Alice Nerby, her son Joe, and his wife and daughter, Mary and Lisa Demientieff. When the plane landed, many people were there to meet her. "Those people, all my people," she recalled with wonder. "They remember me, they were waiting for me." Still, she was apprehensive.

"Is this Huslia?" she asked them.

"Yes, are you Frances Demientieff?"

"Yes."

"Well, we've been waiting for you for three days."

She sat still a moment, to get the feel of the place, and then was taken to the Koyukuk River, which was frozen over. "I got sad when I saw the Koyukuk River and we were on top of it." There she felt she knew where she was, on the river of her birthplace. Finding words was difficult; she sighed, remembering. "All those years we didn't know about them; but they knew," she said. As she was leaving, the people, most of whom are her relatives, told her, "Don't say goodbye, you will come again"

Frank Howley had a store in Bettles. "He was a good looking man," Betty Johnson said, "kind of a ladies' man." He had come north during the gold rush and worked as a miner. (There is mention of him in a book of goldrush lore called *Sourdough Saga*; he is said to have gone to Fortymile from the Koyukuk to winter out.) Like most men of the time, he hunted and trapped his own food and furs, probably following a well-defined route of his own or in company with a partner.

Frances was six when she made her great trip downriver.[3] (Eighty-odd years later, she learned how she had

been remembered after her departure. Bessie Henry, her relative in Huslia, was a girl coming down from spring camp soon after Frances left. Her people were poor, and she went to T'oyeet crying that she needed clothes. T'oyeet, saying her own daughter had gone, gave Bessie clothes. "They were your clothes!" Bessie Henry told Frances.) There was no school in Bettles, and his wife was sick; Frank Howley wanted schooling for his daughters, and the mission took in children whose parents had died or been incapacitated. She was put on a steamer, a small vessel called the *White Seal*, for Nulato, where there was a Jesuit mission, though no orphanage. At the Nulato mission she stayed overnight with the three nuns living there. She had a doll and wandered off playing with it; the Sisters found her at last "in a very nice building": the chapel. In Nulato, she was put aboard the steamer *Rock Island*, bound for Holy Cross.

One important question for the Sisters there was whether Frances Howley had been baptized. They learned she had been christened in Nulato as a newborn, probably having been brought down by her parents. (The record is in Father Jetté's own hand.) Perhaps her father was also Catholic, being Irish; but when the Sisters asked her, she did not know.

Later, her sister, Hazel, came to the mission. From relatives in Huslia she learned that there had also been another sister, although she remembers only Hazel. "But I had brothers, I had uncles!" she exclaims. In Athabaskan way, those brothers might have been the children of her mother's brothers. Recently, in Huslia, several women have been working out family trees; but there were never any records in Holy Cross for her to consult. Frances Howley grew up wondering who her grandparents and family were. But in these days it was difficult traveling, even if the Sisters would have let her go home; and she had no way to find out. "I was just orphan there, I didn't know."

Sometimes her father came to visit, traveling down by steamer. The nuns would receive him in their formal parlor, and he would sit down at the round, cloth-covered table and stack up silver dollars to pay the girls'

tuition. Once he told the nuns he wanted to take his daughters to the States for Hazel's voice lessons. Betty Johnson told me, "They'd say to mama to say she didn't want to go. Maybe they were worried about her losing the faith."

Martha Demientieff exclaimed, "How horrible for us if the Sisters hadn't kept her back!"

Yet, it was a poignant cry; for Frances lost her father. He stopped coming to the mission. Years later, she heard he had died in a train wreck in San Francisco about the time of the earthquake.

Holy Cross village, when Frances Howley first saw it, had existed by the name for only a couple of decades. She saw a little wooden church (fig. 2) and a convent, and a long building, the Babies House, where she stayed during her first years there. The Sisters and the older girls lived in the convent. In front of it, the village spread out and down to the west bank of the Yukon. (Many spring breakups and a shift in the channel have cut away that bank and taken the old village with them.) People had built houses back toward the hill below which Holy Cross nestles. There was a store, owned by a man named Charlie Garhart. Further upriver, at Ghost Creek, James Walker had established his store and family, but Ghost Creek was a world away from the village, which was dominated by the life of the mission and its orphanage.

Before the Europeans arrived, however, the extensive population of that part of the river had favored other sites. About a mile north of the present village is Ghost Creek, named for a major battle between upriver and downriver people. But before that it had been a village site. Where Holy Cross is now was called De'loyitchit, In the Angle of a Hill, according to Jetté. A village called c̆hi ʰe kroge (Village Across) lay almost directly across the river from Old Town, the present Ghost Creek. The people of these places were Deg Hit'an Indian people, and they lived separately from Yup'ik Eskimo people, whose villages, most notably Paimute, were further south. (Many Paimute people moved permanently to Holy Cross when the village burned, in the late 1930s.)

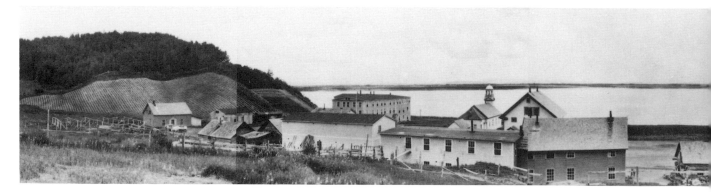

Figure 3. Holy Cross, 1939.

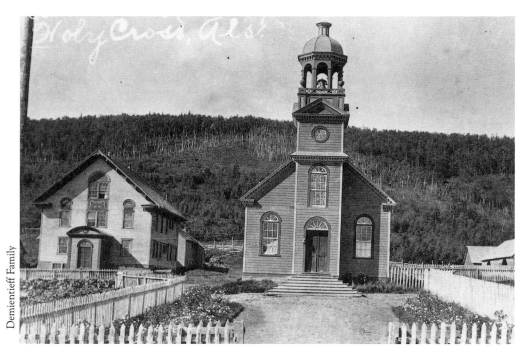

Figure 2. The old Holy Cross church and priest's residence.

But all the people of the area traded and feasted with one another, and many could speak several languages. Only when the mission was established, in the mid-1880s, did members of both groups come together in one place.

This does not mean the mission was easily accepted. A number of Deg Hit'an people moved across the river to get away from the priests. They centered their spiritual and social lives on the kashim, the men's house, about which people still talk, though cautiously in the presence of outsiders, in Holy Cross. Two of the present village elders grew up there and will not talk publicly, for print, or on tape, of those days. Medicine men and priests fought a spiritual war for many years; and their battles of power are remembered by older middle-aged persons.

At the Elders Conference held in Holy Cross in 1980, Belle Deacon, of Grayling, the mother of Frances Demientieff's daughter-in-law, Daisy, spoke gravely to the women and girls about the days of the kashim. She reminded them (I was among her listeners) that the older people had always taught the younger ones how to be people. Women, gathering food, learned the lives of small animals and plants, weather, habitat, and proper behavior; men and boys gathered in the kashim. "That's how people learned," she said.

Another day, I was told, "When we lost the kashim, we lost our freedom."

Before the Russians arrived, Yukon people traveled often to the west in trading parties. They exchanged furs and inland products with the people of the Norton Sound area for food and supplies from the sea. Old stories tell of plentiful migratory birds, fish, and small game, up to the time of the great waves of diseases which weakened and killed many people of the area. Before the worldwide flu epidemic of 1918, there were many villages. According to Luke Demientieff, "Up the Innoko and Iditarod Rivers, you can see places where there were villages every so far apart."

His uncle Uppa Ivan Demientieff used to tell him a

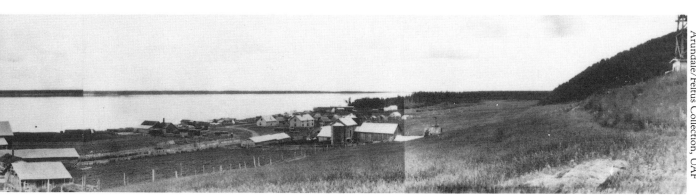

story which revealed how thickly populated the river had been. The first gun anyone saw was brought to Anvik, an old, upriver village, by a white man. Everyone gathered to look at it, everyone wanted to know how far it would shoot. The man was going to fire across the river, but as he aimed they stopped him. "No, somebody's there." In every direction he aimed, and every time they stopped him: "No, somebody's there." "So he shot into the air," Luke grinned, "and they fell over at the noise."

When Frances Demientieff was a young wife, people "never had moose then." Rabbits and fresh fish were the main diet; in the summer, people dried fresh fish and gathered berries and plants. Only later, when the mission acquired a herd and hired Lapp herders, did they have reindeer. "We never had moose in our time. We didn't know what was that. We had big herd of cows." The generations before her had known moose and recognized its tracks; but that animal was scarce for years after that.

Much of my information about these early days comes from Martha Demientieff's own research into the history of the area. "Outsiders wrote about their first contact with our people," she has observed, "but did not often understand what they were seeing and wrote from their own egocentric viewpoint."

"From all I can gather," she continues, "the basic governing unit was the family. Certain groups of families belonged to a certain place or subsistence places. Even today, emotions run high when anyone makes a mistake about where someone is from."

At the Elders Conference, Nick Demientieff, the half-brother of Frances' husband, recalled that, in the village, the chief made a deep impression on children. In Indian, he was called "the oldest man." "He told kids how to behave in just a few words, and that was that." His nephew, Luke, learned in the same way from his mother "not to bother the old people, they don't talk to young kids; they're old and have lived their lives." As a child, he would go visiting with his mother. "An old person would look at you and blink. 'That means she likes you!' There were no words said; it was their way of greeting."

Land and water use were carefully established and generally respected customs; families used their own areas, but partnerships of two men in a hunting range or on a trapline were, and are, common. Luke still runs a trapline used by his father. He learned it from Old Johnny Andrews: "In the spring of the year, him and my father used to walk to Flat to look for work," following the Reindeer River for a way, then up Big Creek, "then up the same trapping trail we use now." He still looks for trail markers, signs of his father's passage. Men and women can run the same traplines, allowing for fallow periods, for years; though generally, if a line is allowed to

fall into disuse for more than two years, anyone else may take it over.

The imposition of the Alaska Native claims settlement on customary land use has meant, in Holy Cross, the drawing of boundaries and the introduction of property rights which are the basis of English and American common law. The details of selection are complicated, and I do not know specific details of this village business; but I have observed certain disagreements within the village about land entitlements. I also sense that, for many people, particularly older ones, the very real and complex differences between traditional notions of land use and the strong association with place which marks their way of life, and the Western belief in outright ownership of land which underlies American law, have not been resolved. It appears to me that, even in contemporary life, deep-seated values rooted in the land use rather than in ownership in the Western sense continue to be in play, and that these values make the settlement law look arbitrary and capricious, even to those who know it well. One hears expressed contempt and even disbelief that a "mere piece of paper" (deeds or shares) can control who may have access to land and animals. In the face of the massive reality of the land, paper shrinks to insignificance.

Given this, an outsider begins to understand how complex has been the existence of the mission in local life. The experience of Frances Demientieff and all her family illustrates this, for all her children were schooled there, and her daughters-in-law and most other persons of middle age were raised there. Individual priests and Sisters had profound, not always benign, influence on the sensibilities of the children in their care, and they are remembered to this day. Betty Johnson observed that her mother raised all her children to succeed in mainstream life; of the five, all but one left to make their living elsewhere. A revered priest, Father Lucchese, may have inspired the young widow's hopes for her children. " 'Frances,' [he said,] 'your children are very poor, and you are very poor, you have no food, you are poorly dressed. But your kids are going to be well-off some day, and you would live like a queen' Father Lucchese's words. I never forget it," Frances Demientieff says.

In this regard, it is important to notice that, here, history is recounted. It is not a kind of schooled averaging of experiences to show "forces" and "patterns" and "change." Holy Cross histories take an older and warmer form in stories about real people; and one of the pleasures of an afternoon or sociable evening among friends there is the chance to hear about the old days. The stories take on weight, even for a visitor, because they are precisely not different from "history." It is the identity of persons with their stories which invests the place of their happening with such importance. Grandma Frances has said that in Holy Cross every-

thing relates to the river. The river has never had a white man's name. Martha Demientieff once described this feeling to me as a sort of homing instinct, and it bears on why many people prefer not to live away from their place. In towns and cities of Alaska, many Holy Cross people express intense discomfort, grief, depression; they suffer when they cannot see the river or eat Native food. Even for the growing number of younger, well-schooled members of the village or for those who have successfully lived and worked in town, that identification with, the intense need of, place remains a constant and deeply-felt emotion.

When Europeans—that is, Russian and American soldiers, traders, missionaries, teachers—intruded into the country, their presence of course offered interesting new possibilities; but also, and especially, they caused by their very presence profound dislocation. Even now it is difficult not to feel, as a non-Native visitor, that one must always be only a visitor, one who will go away; and that this difference is, in an essential way, something that is real and unalterable, however deep the friendship which works to heal the original, still open, wound.

The wound of invasion is real and still deeply felt. Among the ways it exists are in painful memories of disease and death brought by white people. At the Elders Conference this disturbing subject was raised by school children. Miska Savage described for them Holy Cross as he saw it in 1900, when he came over from the Kuskokwim with his father. It was a big village, he said; it was the first time he had seen such a place. There had been a big flu, and many people had died. Father Lucchese was the pastor. Miska Savage watched his father and the priest hoist bodies across their shoulders and carry them up the hill to the graveyard. In each grave there were two or three people; there was no time to build coffins. "I don't talk about what I hear," he emphasized, "but what I see."[4]

In 1915, in an epidemic, "people died in the woods."

A measles epidemic killed many people in Holy Cross and Paimute.

Nick Demientieff told of two gold miners who passed from St. Michael, downriver, to Dishkakat, an old settlement nearby. "They had disease. They say most Dishkakat people got it and died."

John Deacon of Grayling tried to speak of a man who came from Nome. "He made the people die. I can't talk about it." He stopped, grief-stricken.

Johnny Paul described how the big flu had come down on them. "There was no protection, no medicine of no kind. You got sick, you kept a-goin', kept a-goin'."

It is in this web of memory that the complexity of the legacy of the mission is caught. According to Frances Demientieff, it was the intention of the priests to establish a Catholic village. One can see that they, as much as anyone, disrupted the life on the river; then they provided a place for the orphans of disruption, so that those children can now imagine no other life, so that that is their history. Without exactly replacing it, they displaced the power of the older form of spiritual life, in which the identity of the people was formed. The religion they brought, often antagonistic, sometimes complementary to this older life, provided a form and a

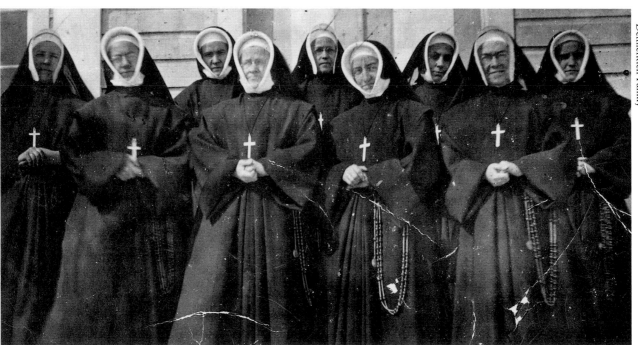

Figure 4. Sisters of St. Anne, Holy Cross Mission.

channel for that intense spiritual life which the people never allowed themselves to abandon.

The little girl Frances Howley began her life in the mission with other preschoolers in the Babies House, which has, she remembers, a big room downstairs; upstairs was a dormitory with rows of beds. One of the big girls and a Sister slept with the small children. The Sisters kept strict order, and the day was carefully scheduled. It went like this:

6:00 a.m.	rise
6:30 a.m.	Mass
7:00 a.m.	breakfast
8:00 a.m.	offices (chores): dining room, dormitory, parlor cleaned; wood chopped; etc.
9:00 a.m.	school
11:00 a.m.	kitchen duty
12:00 p.m.	dinner
1:00 p.m.	school
3:00 p.m.	a little lunch: tea and fish or bread
4:00 p.m.	school ends
	workroom: girls to kitchen or laundry
6:00 p.m.	supper
8:00 p.m.	bedtime

"To this day I remember," Frances says. As she grew older, she loved to read in bed, although this was forbidden. "Good books we had. We'd sneak up books and read, and we'd get caught. And for that we had bad notes on Sunday. The Sisters tell us, 'If you take to reading you'll always be a lazy woman, your work would never be done.' " Although the children did not often receive a great deal of personal warmth, they received careful training. "We have to play [pretend to be] good, we have to work when we learn how, did everything perfect. They teach us, and that's how we learn to work,

you know. And one thing, I never heard the kids answering back. That's how you were trained. And to keep silent. Perfect silence." She pauses. "Oh that's the one that used to be so tough sometimes! We'd want to talk, you know."

She laughs her characteristic laugh. "And in the dining room, there were some occasions when you were supposed to talk! Sister would ring the bell [they ate in silence] and say, '*Benedicamus Domine.*' And we'd all scream '*Deo gratias!*' and it meant we can talk." She laughs again. "And when Sister rings the bell again, perfect silence."

She recalls that there were about two hundred children in the mission, lodged in the Big Boys House, the Little Boys House, the Big Girls side and second course sides of the convent, and the Babies House. "When I went to the Big Girls side, forty-two girls!" The Sisters took in Native and non-Native children, and she remembers several blond children from the Kuskokwim. Children came from the Yup'ik villages downriver and the Athabaskan villages well upriver, and not all were orphans. In those days, there were only a few good schools, and most were not open to Native children. She thinks they all got along very well. "Funny thing, you know, we don't know how to quarrel. Those downriver girls used to call us *Inglertuk.* To this day I never forget it. It means 'upriver woman.' And us, when we quarrel with them, we call them *Malemutes,*[5] and we thought it a terrible name! It was a terrible name, and we were just mad at them," she laughs. "But it don't mean anything. To this day I don't even know how to swear."

When Frances Howley arrived at the mission, she could speak Indian and English; but the priests and Sisters forbade the children to speak their own lan-

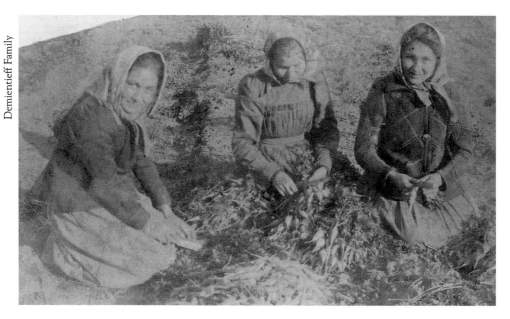

Demientieff Family

Figure 5. Frances Howley as a young girl working in the Mission garden. (L to R) Lucy Newman (Whitley), Paula Demientieff (Walker), and Frances.

guages. "They didn't know what we were saying, that's why." This need for control was met, in many cases, by hospitable deference. Belle Deacon recalled that when she was a young girl, Dr. Chapman, the Episcopal missionary, worked in Grayling. Parents told their children, "Don't talk your language in front of him, he may think you're talking about him. Try to talk like he does." In 1982, several women from Huslia were coming to Holy Cross, to return Grandma Frances' visit, as it is important to do. Grandma Frances began to worry that one elderly woman would not understand English. At last, diffidently, her daughter-in-law Daisy volunteered that she could translate. This came as a surprise to her mother-in-law. The notion of privacy she had learned from her mother, Belle Deacon, had coincided with the carefully nurtured virtue of playing down one's own accomplishments.

The schooling offered by the nuns was strict and thorough. Children were not advanced to the next grade until they had learned their subjects well. Frances Howley was taught English grammar, reading, penmanship, mathematics, and handiwork. She went through the fifth grade, the equivalent of eight modern grades of school; these were called ABCs, Primer, Chart, and first through fifth grades. (In Holy Cross today, many parents I talked with do not think their children receive as good an education in the present public school.)

But schooling did, and does, not exhaust the village education system. "Everybody's a teacher, and everybody's a student in our way," said Martha. "First you have to listen to someone, you cannot learn to live in isolation. Then, if you want to learn something, you help that person and then he will teach you things, if he wants to."

This is a delicate and complex relationship, then, between teacher and learner, elder and younger person. She has described a balance of mutual obligation without overt constraint exercised by either person. If a boy wanted to learn how to make fish traps, he might begin to pass time with the man who could teach him, watching him at work and making himself useful. He might chop wood or carry water or run errands, without expecting a reward. In return, the older man might begin to point out how to use tools properly, how to look at the right tree for his wood, how to assemble the trap, where it worked best in the water. This would happen over time, and often without many words, particularly descriptive words; the process was expected to be learned by doing. The child was expected to behave respectfully, not "bothering" the older man who, in his turn, did not embarrass the child in front of others (though he might tease him privately) by exposing his ignorance. The older people knew the younger ones: these were not teachers who came and went. Even in the mission, the Sisters and priests were part of daily life,

and many lived their adult lives there and are buried in the graveyard on the hill. Martha put it precisely: "How can they teach me," she asked me, "if they do not know me?"

What was, and is, valued in this way of life is the relation of mutuality built on shared experience, and what is identified as knowledge is, in the highest degree, recognized as the artful combination of an alert and observant spirit, physical facility, long experience, proper technique, and reflection. Education in this traditional way might be compared to that which, in the best of circumstances, artists—poets, dancers, painters, singers—undergo: a long process of developing body skill, fresh observation, self-discipline, emotional knowledge, and the recognition of the play of luck. These are qualities which are difficult to catalog from outside the process: knowing the history of modern painting does not mean knowing how to paint, for instance. Artists know their own history differently than critics or art historians do. I heard a similar remark once by a language teacher from Shageluk. She was listening to an academic historian recount Yukon River history since contact. "That isn't how we tell our history," she murmured to her companion, who nodded.

Romance and Marriage

In the mission, young women learned the modesty of nuns. When Mary Demoski fell in love with James Walker, she persuaded Frances Howley to call to him from the window, "James, Mary Demoski wants crackers." Frances Demientieff laughs about it now, but she was punished for this boldness.

Marriages were arranged by Sister Superior. When a young man was ready to marry, he would ask Father for a certain girl, and Father would consult with Sister. Often, Sister counseled refusal; "He's not made for you," she would say to a shy and curious girl. But if the answer was yes, then a wedding was arranged, and the young bride-to-be received advice from Sister. "We didn't know," women told me, shaking their heads in amusement, "we thought you got pregnant by kissing."

Romance flared up despite Sister, but it did not always go smoothly. Frances' friend Annie, called Big Annie, fell in love with a non-Native boy and began to make boots for him "full with beads." But his mother opposed the match. "We heard he went away," Grandma Frances recalled. "We went for a boat ride. Annie said, 'Oh, that's how it's going to go!', " and she sank the uncompleted boots in the river.

Frances was tall and willowy (La Grande, the Sisters called her) and had many admirers. Betty Johnson told about a man from the Tanana army fort who came down by steamer to ask for her hand. Sister refused him. Later the girls heard he was killed in a swordfight.

"What romantic dreams did girls have?," I asked. Betty, Martha, Mary D., and I had been listening to a tape of Grandma Frances reminiscing. "He had to be handsome," came the answer, "and be a good provider, a good hunter and trapper; and he had to have a house. The Sisters warned the girls, 'Don't marry a man who is mean to his mother or beats his dogs,' it meant he might treat his wife like that."

Frances Howley was eighteen when she married. "I wanted to leave but did not know how," she says. "I was old. My friend said, 'My brother is going to ask for you.' 'What does he look like?' 'He's light and has blue eyes.' I fell for the blue eyes." She laughs. "He came up. We sat far apart. Sister Superior sat between us."

Her friend Katie Demientieff's blue-eyed brother was named Eluska (Frances called him Elia). He was her age and earned his living in various ways, including as a carpenter, a Demientieff speciality. She was embarrassed on meeting him: he was too good looking. They hardly knew how to talk to one another. ("We weren't brought up among people," Alice Demientieff remarked about that.) The night before their wedding, he came up to the mission. "Sister Superior said, 'Kiss him goodnight.' I was shocked! I didn't know what it was. I said no. Next day we had a wedding in church, then went down to the village and had big feast."

The nuns, being French, had dressed her prettily and given her a corset; later, though, she threw it away; because it was too uncomfortable.

Eluska Demientieff had come to Holy Cross from the Kuskokwim River. His family owned the trading post at Kolmakofsky Redoubt, near the present village of Chuathbaluk, where he had grown up. It is not clear why he came—perhaps there had been a fire at the mission, possibly famine as well—but he arrived with several other members of the family, including his uncles, Petruska, to whom he was very close, and Ivan, known as Uppa Ivan.

The first Demientieff, Nikolai, married Axinia Kolmakoff, whose family must have established the fort. They had three daughters: Aniska, Tatiana, and Lizzie; and four sons: Ephraim (Eluska's father), Petruska, Nikolai, and Ivan. The latter was known as Uppa—grandfather—Ivan. He married twice. There were three children of his first marriage, including another Nick (who also married twice, first, to Big Annie, then, to Frances' friend Margaret, whose mother came originally from Paimute). Uppa Ivan's second wife, Mary Elizabeth Newman, from St. Michael, was always called "Mrs. Ivan." She taught Frances how to nurse, and Frances' oldest daughter, Elizabeth Margaret Mary, is named for her. She and Uppa Ivan, who people remember as a gruff man, had a son, Stanley; Stanley married Edith Bifelt, from Huslia, who was related to Frances through T'oyeet, her mother. One of Stanley

Figure 6. Frances Howley and Eluska Demientieff, both 18, on their wedding day, 1913.

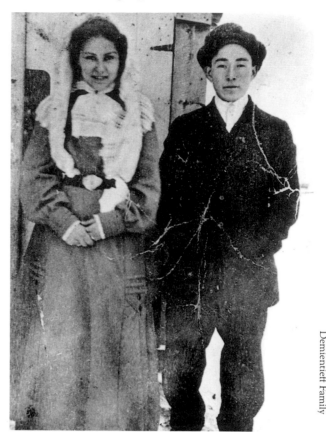

Demientieff Family

and Edith's children is Claude Demientieff, who married Martha Au Coin, from Chignik, who was raised in the mission, as were Mary Dahlquist and Alice Withrow, two of Frances' daughters-in-law. (Thus, Claude Demientieff is doubly related to Grandma Frances, who has always treated Martha like a daughter.)

Uppa Ivan's brother, Ephraim, married twice, the first time to a woman from the Kuskokwim whose name is not remembered. Their children were Eluska (Frances' husband), Axinia, Katie (her friend), and another daughter. When that woman died, Ephraim married again, and this union produced four children: Alphonsus, Nick, Justine (Dena), and William.

Frances and Eluska had eight children, of whom five lived: John Baptist (dead in infancy), John (dead in infancy), Elizabeth (Betty, married Jim Johnson), Joe (married Mary Dahlquist), Alice (died in infancy), Luke (married Alice Withrow), Alice (married John Nerby), and Mike (married Daisy Gochenauer). They have given Grandma Frances fifty grandchildren, who have given her thirty-nine great-grandchildren (including, as of this writing, several expected).

On the day when Mary D., Betty, and Martha were explaining the family tree to me, there was some discussion about how to count all the grands and greats, as

they put it. "Count the illegitimate ones," Betty decided. "Mama always does."

These intricate family connections are not limited to Holy Cross. The family is very large and its children are spread throughout Alaska, although most live in the Yukon valley. They have been prominent in Holy Cross since Eluska and his relatives arrived; Uppa Ivan is credited with having built a good part of the mission, and much of the carved woodwork in the old church was Demientieff work. When Frances arrived in 1903, there were fewer families than there are now: the Edwardses, the Whitleys (who were closely related to the Demientieffs), and the Demientieffs were the largest. James Walker and his family lived in Ghost Creek. Until the 1950s, many people lived across the river, in Bonasilla, the Sims family among them, and also in Paimute, about twenty-five miles downriver. George Turner married a woman from Shageluk, on the Innoko, moved from Flat to the village, and opened a store. Gradually, people from Paimute and Shageluk moved in, often because of marriage to one of the young women raised in the mission.

Newlyweds in those days generally went to wherever the husband cared to live. "Women were more subject to men than now," I was told. Frances taught her daughters, for example, "to respect our husbands—not ever to wear their clothes, not to sit at the table til they sat."

The Demientieffs had been well established on the Kuskokwim in the days when people traded from village to village. Trade was an important social activity, as it created and reinforced friendships and alliances, as well as an economic one. Eluska's Auntie Tatiana told many stories to her young relatives about the days of the old post. Trading began in the spring, after breakup. Inside the fort, they would hear the sound of rifles, shot off in greeting, and they would see the banks of the river crowded with canoes. The trading went on for days. Her father would stack up beaver skins against his rifle and make payment; and when the settlements had been completed, he would bring out barrels of vodka. Then the women were sent, with their servants, to the inner fort, while the celebrations lasted. (Women also had their own kind of exchange. One woman of the fort is remembered because, unable to have a child, she traded a cup of tea leaves to a mother for her baby. There was distress in the retelling of this story.)

The Demientieffs lost the fort, however; one family story is that there had been a swindle by a trusted friend, and family money supposed to be banked in San Francisco was never recovered. Thus, it was of necessity that the men struck out for new territory.

Frances and Eluska Demientieff had fourteen years

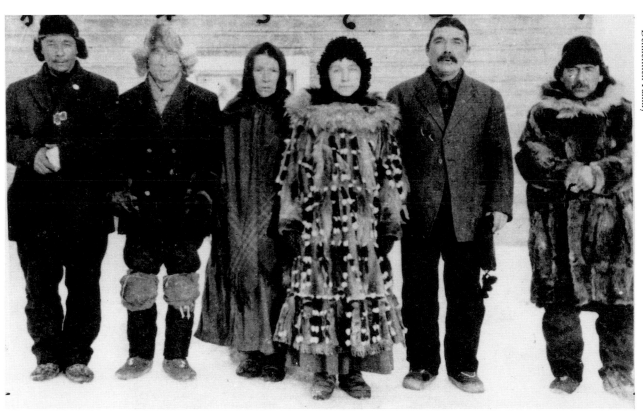

Demientieff Family

Figure 7. The Demientieff family came from the Kuskokwim River area where they owned a trading post: (R to L) Petruska, Nicholas, Aniska, Tatiana, Ivan, and Ephraim Demientieff. Ephraim was Eluska's father. An old-style snowflake parka is worn by Tatiana Demientieff.

together. In their wedding picture, Frances is a slender, tall, lovely young woman with dark, lively eyes, and Eluska is handsome and sturdy, and a little shorter than his wife. Betty Johnson remembers that her father's voice was very soft. Martha observes that Frances always smiles when she speaks of him, as if she has happy memories.

One of her first tests came in cooking. Frances had learned to cook, as she had learned everything else, in the mission. "When I got married, I cut a whole slab of bacon for breakfast. In the mission, we cut the bacon—just lots of people." Her husband's Auntie Axinia tried to advise her. "I tried to make pies. Auntie Axinia tell me, 'I need axe for your pie.' Of course I cry." Much of the food was dry stuff—apples, beans, mush; everything expanded and became excessive. "Auntie Axinia used to say, 'What did they teach you in the school?' and I'd cry. I would just cry. But she sure helped me lots. She'd take it home when I cook."

In the mission, "they teach us abundance. Sister put stuff in the pot; we stood on benches and stirred with a big wooden paddle." (She had had a double wedding, with her friend Big Annie, who married Nick, Uppa Ivan's son. The two young women had to bake their own cakes; but all they really did was stir the batter. Sister put the ingredients in the pot and, when they finished stirring, said, " 'Now you know how to make cake.' We didn't know what she put in!")

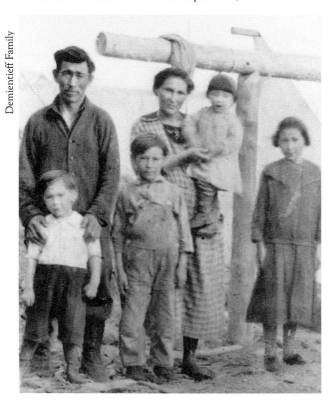

Figure 8. Eluska and Frances Demientieff with their children, (L to R) Luke, Joe, Alice, and Betty.

She learned to cook by trying it. Women wanted to cook well for their husbands. "I used to go to Mrs. Ivan. I watch what she do: one thing she do, you know, like mashed potatoes. Next day I do it, I'm so proud! I'm just *doing* it." She is still grateful: "She taught me lots." Her family considers her an excellent cook; she knows ingredients by feel and smell.

Eluska was a very strong man. It is said that to cure a toothache he would set a skin-sewing needle into a piece of wood and, holding himself tightly, jab the throbbing nerve to kill it. At Christmas, he would bring his growing family back to the village from camp by dogsled. His sled had a big willow frame with a canvas cover, in which his wife and children rode, and he would put a heating lamp (perhaps a kerosene lantern) in to keep them warm. He could so control his dogs and guide the sled smoothly that there was never the danger that the sled with its fire and people would tip.

Before his marriage, he had worked in the Iditarod gold fields, with three thousand other men, at a daily wage of $2.50. There was better money on the steamboats, at $2.50 an hour. Until the late 1940s, steamers carried supplies to the river villages, traveling upriver from St. Michael, instead of down from Nenana, as present barge lines (including Claude and Martha's outfit, Demientieff Barge Service) do. Grandma Frances can remember seeing seven boats at a time tied up at the Holy Cross docks, and from the windows of her first house she could watch stevedores unload goods into the freight wagons bound for the mission and the store. This old house was near the old bank, now gone. It had originally been a trapper's cabin and then was turned into a duplex, with Petruska and Nathalia Demientieff living in the other half. "Mama's two children would cry," laughed Betty, "and then Nathalia's kids would cry, and they'd have to bang on the log wall to keep them silent."

The steamboats went up into the Iditarod, to Dikeman, a big gold camp port then, deserted now. Luke Demientieff remarked, "That river still holds names where all those boats had one time or another holed up in winter or ran a sandbar." The boats burned wood, and contracts were let to local suppliers. Eluska and Frances cut cordwood. Out in their Redwing camp, he felled trees, she trimmed them, and together they bucked up the wood into cord lengths with a two-handed saw. They made five dollars a cord.

Eluska was good with his hands; he built a carpentry shop onto the house, where he built sleds for the mail carriers. One he built, a fourteen-foot hickory sled, lasted twenty years that his son knows of. He rebuilt a boat, from outboard to inboard, and put in a one-cycle Farrow motor. The rig was still operating in 1935, five years after his death and at least ten years after he built it. He made many of his own hand tools, as well, and

kept them in top shape. At his death, they went to his son Joe. Luke got his father's shotgun, a sixteen-gauge Ithaca gun, "a sure shot," he said, as he brought it out. He had had the stock rebuilt and the barrels blued. It had been Eluska's first gun, bought in 1916. "I use it all the time," he said.

The oldest child, Betty, was ten when her father died. Years before, a boat had fallen on him, crushing his chest, and he had never fully recovered; then he developed tuberculosis. Luke's last memory of him is that one day after lunch he hemorrhaged and died. The year was 1930. At thirty-two, Frances Demientieff was left a widow with five children.

Work

Fifty years ago there was no government help for widows and orphaned children. Old people talk about tough times. "It's hard to make a living in the country," one person said, "but we're used to it." Frances Demientieff worked "steady all the time." She had to feed five children, herself, and a nine-dog team. She had to cut wood for her stoves ("we didn't know about driftwood then," she sighs, "we thought it would not burn"). To make money she sewed: for the mission, where payment was in food and supplies, and for a widower with many children. For ten years, she cooked for his family, as well. (One of her children wondered why she did not marry this man. Thinking of his many children she shook her head. "I'd be steady on my needle!" she smiled in jest.) She minded the children for the mission, for five dollars a month. She scraped sealskins for fifty cents a skin. "I don't know what she didn't do, really!" exclaimed Betty Johnson. She cut wood, checked fish nets and traps, sewed, knitted, cooked. An old man told her family that, in hard times, women went from house to house with open aprons, into which people dropped food. "Not Frances. She worked for almost nothing."

Martha learned from her that work of itself is important for one's own well-being. "It's really good," Frances says flatly. "You see, these kids are good kids, but they need to work. Nowadays, like, you have to have schooling to go to work. At home I raised my kids: they didn't need schooling, they worked at home. That's how I raised them. They all done well, too; they know how to trap and how to fish and how to make boats and sleds. I think they *should* learn those things! They should learn how to whipsaw lumber. Because *I did*: I whipsawed even lumber, for our boat up in Reindeer Station . . . For a boat, because we had no boat to come down in spring-time. Could you believe it?"

Her son Luke remembers her as "big and tall and very strong," wiry and muscular. "She could lick us any day," he admitted. She taught her sons how to snare rabbits with a hanging snare so foxes would not get them and the meat did not turn watery from fighting.

Figure 9. Frances Demientieff, 1935.

Demientieff Family

Joe was nine when his father died. He quit school at nine and went to work to help his mother, hauling wood; it took one hundred cords to fire the mission stoves. Afterwards, for a long time, only he and his family lived in Holy Cross; the others, as they grew older, scattered to town to make their living. Betty left at sixteen, to go to work; Luke, after working on the steamers, went into the Army; Alice followed Betty's lead; Mike worked on a steamer as a waiter in the elegant dining room.

Though they had to quit school early, the children attended catechism classes after school. Their mother would quiz them when they got home. " 'Now, what's this picture?' [A picture of purgatory.] Joe said, 'That's where they warm themselves and then they go to Jesus.' " All the women used to take a few minutes when their children got home, to review what they had learned in school.

"She worshipped the ground the boys walked on," her daughter said, "while the girls were slaves." They ironed the boys' blue serge pants and white shirts for Sunday Mass, and they always did the dishes. Girls' jobs were in the house, and boys did not help, although girls could sometimes help with boys' work. I wondered if much of this attitude had come from the nuns. The women

Figure 10. Frances Demientieff and her children stand in front of their trapped furs.

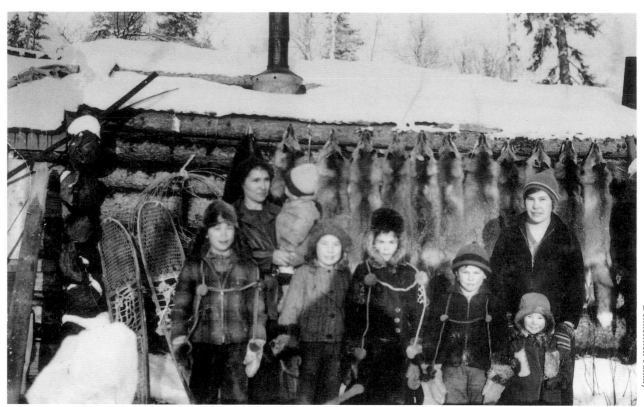

Demientieff Family

clearly recalled how well the priests and the "big boys" were fed: "they ate the best." Mary D. and Betty both admitted they had raised their sons to take care of themselves. But the attitude is deeply rooted and complex, for there is still a deep sense of the range of men's and of women's realms. Frances Demientieff still speaks well of a certain man, because he always gave her meat before her sons were old enough to hunt themselves. In the calendar of festive events, there were dances and potlatches in which men and women were partners and exchanged gifts. Thus, there is always, in discussions of relations between men and women—no matter how exasperated women might become—some still deeply-held feelings that the relations of men and women are, ought to be, complementary.

What did she do for fun, I wondered. "Visit around," her children said. Visiting used to be a big part of village life. Trapping and hunting were usually men's jobs. Women had their children, and there were no babysitters, so they visited each other, bringing their children along. Bingo was another favorite; and Frances liked the card game "500." She remembers Holy Cross as a lively place. "Sometimes we used to have seven boats tied up in the mission, and they were not small, either. I guess what they call tourists used to come to the mission. And then, Fourth of July, there's lots all over the mission, around the convent. We give play, we sing for the people. There was a man at the door, and only now I

know they were collecting. A hat by the door." In the mission, they had always put on a Christmas play; children learned to speak in public and to sing. "We really sing. I used to sing pretty good you know." But sometimes she would stop and just mouth the words. "Sister would say, 'Miss Howley, come here.' " After that, she had to sing in front of everyone. The children were taught beautiful singing, harmonies, and parts. "It was well-done, too; they stormed that big church."

Adults liked dancing, and people got together often for that. "We really had fun," she recalled: they danced the one-step and the two-step, heel-and-toe, polkas and schottisches, Virginia reels. "You didn't stand in the middle of the floor and shake yourself," she said firmly. People danced to the music of a hand-cranked Victrola, the needle of which they sharpened on a stone ("it got dull a lot"). They gathered at someone's house, or on the barges owned by Frank Walker and Ira Woods, dancing by gas lamp out on the water. People looked forward to dancing when they came in from camp.

Talk of work, even talk of festivities, is in a basic way inseparable from talk of food. Perhaps it is nearly impossible now to understand how hungry people could get, particularly before spring breakup, when winter supplies might, and often did, run out before the spring birds and fish came back.

One evening, visiting with Martha, Betty, and their friend Axinia Peters, I asked about what people used to

eat and how they caught their food. Their reply was that to think about food, you should think through the yearly cycle of gathering it. Again I heard this theme of the importance of place, this time in connection with the seasons. "We feel it in us," said Martha, "it's in our blood." Grandma Frances, like her children, "thinks by the seasons. 'It's time to do this,' she'll say, and that season's activities begin."

The seasonal round has always occurred outside the village. As a wife, Frances lived with her husband and children out on the trapline in winter, and, in summer, in fish camp. "We'd go in the fall time and we'd come back in the spring, with the boat. And we'd go down there to fish camp. We hardly stay home. Just keep a-goin', keep a-goin'; that's how I learned. How to put a fish net and everything, you know. I can just run it myself. Row, in those days! We had a little motor, but we never used it, just row."

It was spring when I was in Holy Cross. Geese, ducks, swans were coming back, and people were happy. They were looking forward to fish camp—"that's when you should be here!" Grandma Frances, in therapy in Anchorage, was working hard to be ready for the first salmon run.

In early October, when the water begins to freeze along the shoreline, the family would finish putting up the last fish and come by boat back up to Holy Cross. There, they prepared for fall camp, "falling out." This is the time of fall geese and of moose. Late blackberries ripen. People go out for cordwood. After the hard freeze, the men would gather for a rabbit drive on an island upriver, near Anvik; and spruce chickens were shot. Then came falling out: going out to camp to trap mink. Men also checked for bear dens. (Women stayed strictly away from any involvement with bears, as these animals are imbued with great spiritual power, and women should not even speak their name.)

After camp, the family might return for a while to the village. November meant the eel run in the Yukon, which by then was frozen solid. Grandma Frances said that anyone who had lost any relatives during the year was not to go on the ice during this time.

Until Christmas, men went out full-time to their traplines. Women and families usually went, as well; Frances always took her children. Betty Johnson trapped weasels as a girl. "It was a good life," she agreed. "People never stayed home."

While men ran their lines, women sewed for Christmas. Frances did all her sewing by hand, not machine. She made the girls' dresses and underthings, pants and shirts and suits for the boys, coats for all. (She earned money this way, as well, charging fifty cents for a dress.) She knitted stockings and sweaters for the children, using no patterns. Sometimes she sewed into the early morning hours, by kerosene lantern if she could not afford a gas lamp. In camp, if there was no oil, she put lard and a wick in a jar and lit it.

Christmas was a festive time, when everyone gathered back in the village. People made their own gifts, as there was little to buy in the store in those days: calico, staples such as canned and dry fruit, flour, sugar, and tea.

After the holidays, around January 25, the men went back out for beaver trapping, and they stayed out until about April 10. Preparations for this time were elaborate. Frances made "freezerless" biscuits for her sons to take, baking powder biscuits with extra lard and sugar to keep them soft, as well as doughnuts and sugar cookies. She gave the boys lard rather than butter, since lard does not freeze. Fine salt was saved for trapline; home cooking was done with salt one grade finer than rock salt. She made baked beans and froze them into bricks in bread pans; on the trail her sons could chop off what they wanted and boil them with bacon. "This was good anywhere," said Alice Demientieff, who still goes out to trapline with her husband. "And then, we're fish eaters," her husband added. He always carried dry fish and smoked salmon strips. "I crave it so bad out there I would come in if I didn't have it."

Men went out with three or four hundred pounds of supplies pulled by old-time work dogs. "They were a different breed then," Luke said. His brother Joe taught him to drive dogs. "They were fighters and workers." He laughed about the Iditarod race sleds of today, fast, lightweight racing sleds. "The brakes on those sleds wouldn't hold even one dog. You had to just hope they'd stop sometime." On a downhill run he would tie a spruce log drag behind the sled and roughlock the runners with chains, and then he would hope the dogs would not light out after ptarmigan. "We would always cross moose and caribou tracks. When the dogs smelled caribou, there was no way to hold them."

Their mother was strict with the girls about the boys' trapping gear. "They had no business touching anything like that," Luke recalled. Before the trappers went out, when Frances' children were young, there were yearly sacred dances in the kashim, when "the old Indians prayed to their spirit for good luck." The priests fought the village for many years over these dances. Frances took her children once to one of these potlaches; Luke and Betty have vivid memories of it. The old people honored their old beliefs about hunting and trapping in many ways. As a young man, Luke often helped old Albert Edwards, Old Callaghan, Old Charlie. "Those old people had the same tune, like: they'd thank you and say, 'When you grow up, you're always gonna have good luck.' It was their way of wishing you good luck."

What the old people called "luck" is still important in daily life, and yet it is a belief that outsiders do not often grasp in its full implications. This was explained to me in a number of ways. It is very complex, having to do with

respect owed to all beings, persons, and animals. Young men were taught this as they learned to make their living in the woods. Few people now refer to it openly before outsiders, although there are oblique references. It has to do with a sentiment I heard in connection with the school district, which—and the irony is typical of the constant collision between Native and non-Native ways—has a reputation in Alaska for paying special attention to "Native subjects," such as sled building, fish trap making, and survival skills. What the old people taught, I was told, was how to put something special into a sled, or what to use on a trap or snare to make it effective, to bring good luck. Even more important, young men were taught how to behave respectfully, so they would not offend the animals, for offending the animals would ruin their luck. People of that generation shake their heads: how can the school teach this? Good luck in the woods is not a technological matter.

The end of the winter could be bleak. Trappers had to catch their own food, and often animals were scarce by then. It was hard on families in camp. "If you're out of groceries you'll never catch anything," I was told. Luke learned to save fish skins to boil for broth. Once he went for a week like this, drinking broth and tea, and feeding the skins to his dogs. After a long walk through deep snow, his dogs crossed a trapping trail about thirty-five miles from the Innoko River village of Shageluk. They knew the trail, and in one day they ran the distance to the village. Luke arrived hollow-cheeked; people asked no questions but fed him at once.

When beaver trapping was over, in early April, it was time to "spring out" for muskrats. These were considered good eating if caught before the lakes opened and the muskrats began mating. Trappers would go out by sled and return by canoe. They carried out canvas, nails, and a quart of paint, and they built their boats from greenwood, burning the nails to hold the frame.

With breakup come the welcome spring birds. One afternoon, as we watched swans winging down the flyway, Martha said, "As the whiteness leaves the ground, it goes to the air. As we were regretting the snow leaving the ground, we had the happiness of seeing the whiteness in the sky."

This was also the time to dipnet for whitefish, to put up *xilivisr*, half-dried fish.

Eliza Jones, of Huslia, has written of this time, "Soon after the ice go out and sometime even before the ice go, people sit and put their dipnet in the water any place where there is a small eddy, as the fish of the spring would go into these eddies. This would usually be the first way of getting fish in the spring, a welcome treat" (personal communication).

Summer is for fish and berries. During the first week in June king salmon begin to pass Holy Cross in their great runs to the spawning grounds all along the Yukon. This is the time for fish camp, a happy, busy time of year. Until very recently, Frances still prepared for it during the winter by knitting and mending nets for silver and dog salmon. Years ago, when materials were scarcer, she used to pull apart blue drill, or mattress ticking, twist the threads into twine, and re-weave them into vari-colored nets. Her daughter Alice Nerby wrote of learning this from her mother.

> On my visit to Holy Cross for Mom's birthday, while teaching me to knit a salmon net she told me how she used to knit her own nets, and years before, when her children were small, she saw some of the older people make nets with the

Figure 11. Frances' summer fish camp in the 1950s.

Figure 12 (Left). Frances Demientieff with her son and grandchildren on their way to fish camp.

Figure 13 (Right). Frances often fishes with her oldest son, Joe.

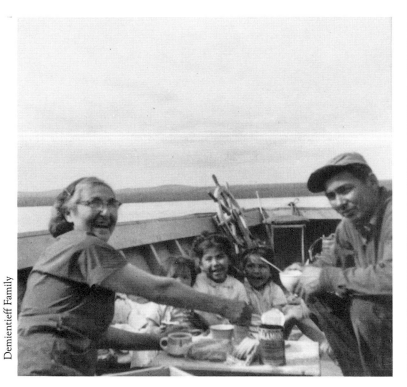

Demientieff Family

Demientieff Family

inner part of willow bark. She herself remembers making rope out of the inner part of the willow bark and also making rope from gunny sacks for the anchor line on her salmon nets, which of course were handmade also.

(Personal communication)

"Since I was a little girl in the mission, we go to fish camp," Frances said. "We fish for the mission, in groups. But in 1914, I got married; since then I was fishing every year."

Her camp lies about eighteen miles downriver (fig. 11). Her children know the exact distance because for many years they rowed it, often with their boat loaded to the gunwales with bundles of dryfish. It took four-and-a-half hours. When her children were young, Frances sold smoked fish to the local game warden, fishing for forty or fifty dogs. Betty Johnson recalls cutting seventeen thousand dog salmon in one summer to sell to the warden and to the priests for their dogs. Her mother also sold fish to the storekeeper, George Turner, who shipped it to Flat for the miners' teams; she made ten cents a pound. Every day she, or her children, picked the fish wheel; if the wheel did not have enough fish, she set out two dog salmon and two king salmon nets. "There was no end to picking those nets," Luke said. Often his mother would work until midnight, with her children,

and later, their spouses, at her side.

On the way to fish camp, she and the children would keep an eye open for berries: cranberries, currants, especially raspberries. Frances put up barrels of berries in sugar; for special occasions, she jarred raspberries and salmonberries. There are still secret, favorite spots for berry picking: "You take notice of all these things," Luke said. "You find things in the woods by smell," added Martha. At fish camp there is a hill, called Tabernacle Hill, which Grandma Frances climbs each year to look for blackberries and mossberries. "She sends grandchildren up, like runners, to see if there's berries," Betty said, laughing. " 'No, grandma, there's no berries.' She don't believe them and go up to see. Her last climb was when she was eighty-eight years old, and took us about two and a half hours to climb."

A few years ago, at the Elders Conference, a high school student raised the subject of fish and game wardens. This opened a lengthy discussion, for game wardens, and regulations, are the object of passionate feelings. *"Before, nobody owned the animals,"* one man explained. It is important to understand how deep this sentiment lies, what roots it touches. There were several versions of the following story, which showed how people felt about their loss of freedom. Grandma Frances addressed the students. "The game warden I knew was my next-door neighbor. I sold him dogfish for his team,

big team." In those days, people had a legal right to take spring birds, but the warden tried to scare them off hunting, warning that a marshal would arrest them if they brought birds back to the village. (They knew he needed a warrant.) That night, someone soaked a crane in kerosene and hung it from the warden's radio antenna. "We hear you like crane," the note attached to it said, "so we give you this one." The warden had to move away. Frances finished by lamenting, "Before that, people were just free, no rules of any kind."

Belle Deacon also spoke. She had six dogs, she told the audience, one of which was a good leader. A boy wanted to buy this leader, but he had no money. She asked one beaver from him, though the dog was worth more. Two wardens came and confiscated her team. Disdainfully, she said, "I wouldn't fight them."

"I love to hunt free," she said. "I used to hunt free. I kill anything I want, to eat, not to waste."

One person told me, "We want to respect the law, but often we must live outside it." It is clear that this is a saddening state of affairs for most people, and also that it has nothing to do with the necessities of conservation. According to the old people, before the epidemics, that part of the Yukon supported many people, who were careful with the animals.

The value that underlay these relations was mutual respect, and it was expressed in acts of reciprocity. This is true in Grandma Frances' life. She still goes to fish camp, but she can no longer do all the work herself; particularly, she cannot pull the net herself. Recently, the law was changed, so that subsistence nets have to be pulled up out of the river when commercial fishing closes; the two categories of fishing are practiced on that part of the river. And so, her grandson helps her. In return, he receives enough fish for his dogs, "living beings that need to eat, even if the nets are up." Thus, although Grandma Frances is officially the person fishing, the person who owns the license, in fact she is trading "her" fish for that boy's labor.

Several years ago, she left her net in the water during a commercial closing, and it was (briefly) confiscated by a fish and game officer. What an uproar! Her family feared for her life, so upset was she. They began, using their considerable influence, to marshall forces to intercede with the law. In the end, probably because of her age, the net was returned, and she was not punished any further. Recounting the event, Martha asked me sadly, "What if she had died. Is death the penalty for fishing illegally?"

"Lots of fish," said Frances, "but the trouble is, when the run comes, they come by in three runs: we can tell right away when the run comes. We have to pull off the nets and the fish pass, while long ago we just kept the wheel going, nets going, and if we have too much fish, we give it to our neighbors who have not much fish.

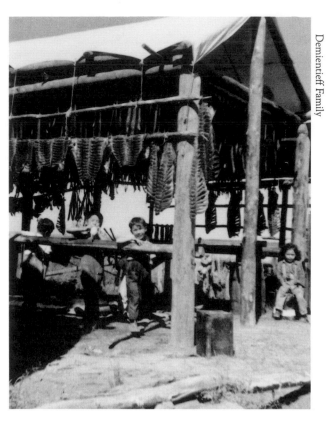

Figure 14. Frances' grandchildren with drying salmon at fish camp, 1960s.

Figure 15. Frances cutting salmon at fish camp.

78

Never waste no fish." She paused. "There's lots of fish. We don't know no more how to do. Even us, even me, I have to pull up my net (I don't commercial, you know, I'm subsistence) and every time they put the net, of course I have to put net, too. And every time they pull it off, I have to pull it off. And that's a *nuisance*! Why not they let us leave our nets, we old people? We're so used to have our nets in. It's just, you know, like a vacation: to go down to fish camp, fish. We're *free*, you know? Do what we want."

Life and Death

Family ties are deeply revered in Holy Cross. The dead are counted with the living as family members. Children born outside of formal marriage are counted in the mother's family, and sometimes in the father's. Adopted children are counted; and their biological parents join the adoptive family. Alliances and kinship are a common theme, death is a common theme.

There was a funeral soon after I arrived. The dead man had fallen away from the Church; but, during the last year of his life, he had returned to the sacraments, and his death was what the Church calls a happy death. His last letter had been written to Frances Demientieff; it arrived while she was still in Anchorage, and, for several days, there was speculation about its contents. Later, it was understood that he had written her of his happiness at his reconciliation with the Church, and to thank her for a gift of salmon strips.

The letter aroused joy and satisfaction among the Demientieff women, who are close to the stepmother of the dead man. It could be called a liturgical joy in his atonement; there was great relief and happiness in his coming home. His respect for Frances was felt and appreciated, particularly at that moment. Their happiness had, as well, another dimension of feeling that is perhaps the hardest for an outsider to express well, but which is embedded in life. Not only had he taken the sacraments, not only had he returned home: he thanked Frances for her gift of salmon, Native food.

Outsiders have not easily understood the deep attachment of people to their food. Native food is always, everywhere I have been in Alaska, distinguished from "white man's food," and in this distinction is a subtle implication that the latter is inferior, even somewhat decadent, although it is equally important to state that no food is ever scorned. To denigrate or refuse food is something more than a social *gaffe*; it is felt as disrespect to life itself. One of the ways people express and define who they are is by Native food.

An outsider might see this as a symbolic attachment, in the sense that the importance of family and social ties are simultaneously manifested and reinforced in this shared food. But this is not enough; there is something more literal in this connection. The cycle of catching, preparing, distributing, and eating food from *our place* makes people who they are: it is a relationship of kinship, which is often spoken of as the subsistence way of life, as "our way of life." It expresses a spiritual connection embodied in family ties and alliances, but it is not completely defined by these. An outsider might observe that it is a relationship of identity as defined by the people themselves. The dying man, in speaking of Frances' gift of salmon, both expressed and reaffirmed this identity with his home and people. But even this is an abstraction made of a meaningful action. The dying man took the sacraments and he wanted to eat salmon: in this, his people knew he had come home to them.

Several days later, the man's mother explained to me how the family comes together for a funeral. (Her family is Yup'ik; but I think the general principle is similar for all Holy Cross families.) Every member contributes something: money, food, shelter. There are plane tickets to be bought, to bring home not only the body but also relatives living in town. Beds must be provided for visitors, often in the homes of relatives or close friends. People must eat, and food is contributed. There is a sense of family obligation: this is what families *do*.

Later, after the funeral, in which the whole village has participated, it is important to visit the grieving family, to allow the mourners to talk about the one they have buried and their own feelings. This woman has known grief in her life. One evening she said, "I tell my boys, when we lose a grown-up child we are sad for few weeks. When I lose my daddy, I am sad, but not for long. When I lose my mama, I never get over it."

In one year, she had lost a daughter and two grandchildren. Frances Demientieff, Mrs. Margaret Demientieff, and the town's trooper came to visit her. "What can we do to make you happy?" the trooper asked her. Frances replied to him, "Nothing, let her alone." They left. This woman wept and wept. "After a long time [Frances] came in. I quit crying, I'm happy. Some people have the gift of comforting."

As Grandma Frances had attended the dying, so she has assisted those being born. Over the years she has delivered hundreds of babies. Mrs. Ivan, the wife of Uppa Ivan Demientieff, Eluska's uncle, trained her. "You're going to be the next one," she said. "Come with me."

The Sisters nursed, and they identified girls with healing gifts. They used to encourage the girls to pray for a vocation to be a nun. "We prayed and prayed," Grandma Frances said. "Ah, I gave up, and I thought to myself, they used to come for me to sit with the sick, you know. I got interested, I was always helping. I must have been thirteen, fourteen. I really interested. I took care of the sick in the infirmary. 'Sister, I'm just the one for it.' Never scared, even, like, they have erysipelas, or diphtheria, or something, I just handled it. We didn't put

anything on our hands or apron or nothing, we went [just the way we were dressed]."

Later, she began to work with Mrs. Ivan. "When I got married, Sister Mary of the Passion told Mrs. Ivan. Right away she took me for training as a midwife. She taught me lots of things. Afterwards, when she couldn't go out in the evening, I go with Irina [Wood, whose husband Victor had been a friend of the Kuskokwim Demientieffs], and after, I go with Mrs. Anthony [Mary Anthony, the mother of Axinia Peters]. And that way I was always there, and maybe sometimes I was in the way, I don't know."

It was, and still is customary for older women to teach the younger ones in this way. Mrs. Ivan had the double advantage of being a relative, but any older woman felt free to instruct a younger woman about to wed, and her discretion is still appreciated. "It's always the older teaching the younger," Martha observed to me one day. "Everybody knows something." The elders attend to the comfort and nourishment of the family, and this is ingrained even after nearly a century of American schooling; though, to be fair, such relationships were part of American family life to a greater degree in earlier generations than they are now. "I don't have to fall apart now that I'm fifty," Martha went on, "because what Mrs. Ivan and Auntie Axinia did for Grandma Frances, she did for me. Now I don't doubt what I have to do. I have a path I know is important to follow."

Perhaps such valued relationships will seem more harmonious to the reader than she or he may have experienced elsewhere. This is the moment to say a word about the daily realities of a small, closed village. "There's a certain danger in trying to govern someone else," Martha pointed out. "Enforcement is difficult, especially when there is such emphasis on personal freedom as here. Dividing the group is terrible. And there's the risk of being made a fool of." Any person who advises another must know exquisitely well what she is doing, and often such tact and knowledge come only after long experience. Younger women remember the prick of resentment (if only for a moment) of a "bossy" old person's "interference." "They could say anything to us!" a woman said, with just a shade of indignation at the memory. More often, advice came indirectly, in the form of teasing or mild ridicule ("I need axe cut your pie").

Marrying someone from the village is part of the same difficulty. "It's like marrying your brother," Martha said, "someone you've known since childhood. You remember how he was, and it's hard to see the adult for the child. You're always conscious of family status and habits." So, in one sense, it is as if time does not pass; rather, layers of experience are overlaid on one another, deepening and rounding out existence. One *becomes* a human being. But because people live so close to one another, often for their entire lives, they know each others' intimate secrets. There is constant encouragement, and even social pressure, to act correctly, that is harmoniously. Respect for another's feelings is a value that has many expressions. But always a time comes when people act out their envy, or anger, or resentment. Adults and children learn this quickly, to avoid, if possible, the worst effects of such action.

But more than hard feelings are the carefully nourished friendly ones, for alliance and friendship are primary virtues: those of peace-keeping, which is, in one sense, often in jeopardy. It is a question of balance: the weight of feelings, the channels into which to properly direct them. It is a matter of directing, not repressing, strong feeling; this is an analog, and a counterweight, to the importance given to individual decision-making. The rules exist, although they are complicated and may take a lifetime to master; but anyone—everyone—chooses whether or not to follow them, whether or not to accede to what can be massive social pressure. In the old days, I was told, anyone who chose not to obey would leave, either for a time or permanently. There remain strong memories of, very strong feelings for, this freedom. Older people say it has in important ways been usurped by non-Native law ways. In the older way, still practiced by the elders of Frances Demientieff's generation, the good of the group is the first value; balancing it is the power of individual decision.

One (only one) of Mary D.'s twelve children was delivered in the old way by her mother-in-law and Irina Wood. She knelt on the floor, and, as she knelt, they tied a rag strip about her, above the baby. "Every time there was a contraction, Mom grabbed me from the back and pushed. They tightened the cloth every time. Irina caught the baby." The birthing was very private; the women respected the modesty of the mother. The midwives made her walk about until she was ready to deliver. As they waited, they prayed, and Frances gave her Lourdes holy water to drink. It was a tough delivery, kneeling down, said Mary D., "you get very tired."

The infant was bundled, a custom until fairly recently. Women considered it a cure, to keep the infant's insides stable and give it straight posture, and to keep it warm at night. The baby's arms were held close to its sides in a receiving blanket; Frances said this would keep its arms from striking its head and waking. It kept the baby peaceful, and the mother could sleep through the night.

Three of her own babies died, possibly of meningitis; they died of convulsing. Her daughter Betty contracted the same disease as an infant, and Frances treated her with hot mustard baths. Her grown children remark on her care of the young ones in the village; for her grandchildren she used to make up little nonsense songs, a song for each of them. "She sure loved babies, and everyone of her kids loved babies. Even you watch her

sons with babies; it's almost unusual for a man."

She talks eagerly of how she loved the work of healing. "It's just in me, I don't know how to explain it. I had the knack of it, that's all, it's the way we do it. Anytime they came in the night for me, I'll go. My husband didn't like me to go out at night. I tell him, 'I would not listen to you. I listen to you for everything else but that; I will go. When they call me, I will go.' At the end, he didn't mind that I'll go. He know that I just loved that job."

The dying and the dead were in her care. Mrs. Ivan taught her to handle the dead as if they could still feel. Women tended women, men tended men; they cleaned and bathed the body, closed its hands around a rosary. Someone would make the coffin, and, after requiem Mass, the village would go in procession to the graveyard hill. The bells tolled. "So many people died, so many babies were lost," I was told. "But the older people protected us kids a lot from the news."

"When I got married," Frances said, "my whole plan was to help the people, delivering babies and seeing to the sick and dying. And how many bodies! How many bodies we washed and dressed. Always they come for us.

I told Margaret, 'My hands are always good for dead people.' "

In 1963, when she was seventy, she took a medical self-help training course. She says, "It stop now. I don't get called for nothing. I'm too darn old, and I'm off the picture, like. But I'm glad I did all that, it's really a good memory that I have done that. Not that I praised myself: I never learned to do those things; but I was just interested in those things. I did what I could."

The Sacred

Overlooking Grandma Frances' fish camp, there is a shrine with a statue of the Blessed Virgin. The statue came from the old church in Holy Cross, which her husband's family had helped to build, and which was torn down when she was a young woman. For her, the demolition of the church was a mournful day. It caused a subtle change in the village, a change in the landscape, perhaps a change in the relations of the people to their priests and Sisters.

The old church had been erected with a good deal of Demientieff labor. Much of the interior carving was the work of their hands (fig. 16). In the steeple hung the bell

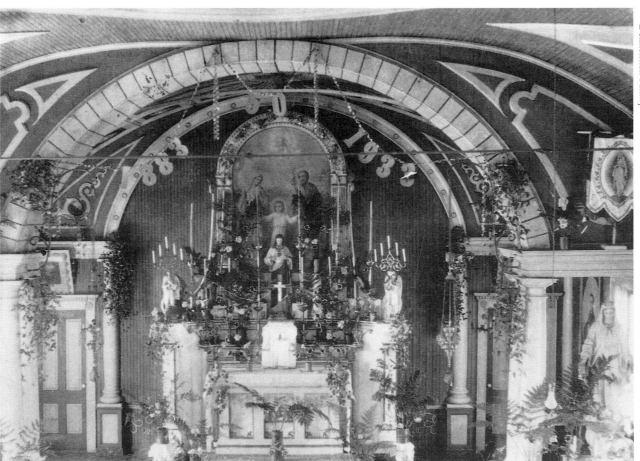

Demientieff Family

Figure 16. The interior of the old Catholic church was torn down when Frances was a young girl, 1933. Much of the carved woodwork was done by Demientieff men.

which rang out the daily life of the village. When the priests decided it was a fire hazard, the people tried to resist. Men from the village were called to help in the destruction; they came reluctantly, and they took their time at the task. "I see them starting pulling by the steeple," Frances recalled sadly. They had hooked a cable around the steeple and attached it to a caterpillar tractor, but it resisted their efforts. Frances went into her house; it was too hard to watch. She came back out again. "I threw on my clothes and went up. I went to Father and *looked at him*, and he said, 'Too bad, such lovely memories.' 'Yes, you sure break our heart.' " The impact of her direct gaze, a sign of distress, and the tone of her voice must have impressed the priest, though it did not save the church. Remembering it, her voice grew soft. She whispered, "I talked like that to Father!" As she stared at him, the steeple collapsed.

The cross it bore had broken. She gathered it up, along with the top of the steeple, and carried it to fish camp to build "a nice shrine for the Blessed Virgin." She put a statue from the church in it, and later her children rebuilt it when dry rot weakened it. It is there now. "Too bad, that old church," she said quietly.

In Holy Cross I spent many hours with the Demientieff women discussing how to write about Grandma Frances as she was known to them. What qualities did they see in her, I wondered; how did she appear to them? They did not hesitate about what was most important. Grandma Frances' spiritual life invests all her days with vitality. Her Catholicism is fervent, in a way which seems entirely natural in Holy Cross; her piety is well known. But there is a quality of spiritual life which seems to me to have older roots, and which is only hinted at, only shadowed. Martha again let me try to see; without speaking for Grandma Frances, she explained her own perceptions. "Maybe she's not 'Native' the way Koyukuk River people are," she said. "But she *is* Koyukuk River Indian." The people she comes from have always expressed intense spirituality, although that has taken different forms, including that of Christianity. Frances' uncle was a medicine man; and she and her husband lived with a medicine man for a time in camp. Perhaps, my friend speculated cautiously, this intensified her spiritual life.

Her religion is its public expression. Her family knows it is her habit to drop on her knees upon rising, and to say the rosary morning and evening. Several times I was told about the priest known as a holy man, Father Lucchese, much loved by the small children, for whom he always had some treat in his apparently inexhaustible pockets. Alice Nerby wrote:

> Mom remembers that Father Lucchese used to make the trip to the states to buy food for the mission. He used to go by boat to St. Michael, then board a ship from there. Then when he'd

> return, he'd have all the little children in the babies' house line up, and he gave them something to eat. They all ate it. Then she found out later is was a pear. The Father also gave them candy which looked like a clear rock, "rock candy." (Personal communication)

Grandma Frances still tends Father Lucchese's grave, as she does other family graves, on Memorial Day. Once I helped her paint with felt-tipped marker his birth and death dates on the white wood cross, because they had faded during the year. She laid flowers inside the grave fence. She did the same for her husband's grave.

Frances sat with Father Lucchese when he was dying; he had dropsy. During his last night, she and her friend Sophie came to attend to him. "He was making noise. Every time he make noise we go and check him." At that time she had a bad infection in one finger. "And I had that fellen finger that time, and I was soaking and soaking it." She went to him, and he motioned for her to kneel. "My finger hurt, but even so, I went to him." Her voice began to drop in sorrow. "He said, 'I'm going to Jesus. What do you want me to tell Him?' I look at him and tears were pouring down my face. 'Father, no.' 'I'm going,' he said." She was holding her sore finger. "He said, 'I'll take care of that.' It was this way—one hand laid in the other—he blessed it. His voice got weaker." At five, they went to waken him for the six o'clock Mass. "Father, Father," they whispered. There was no answer; he was gasping. They called Sister, who suggested they go home. "Sister fixed his feet. We went home. I made fire. And I told the kids, 'I'm going to church.' I came up. As I was going in, someone called me from the hospital. I ran over there. All the Fathers, Brothers, and Sisters were there, everybody crying. He knew he was going." She motions that he died. "I asked him for my children so they all go to heaven. He said he'll do that. That's the best I could ask, that's all I want. I didn't even ask about myself."

Her daughter Betty spoke one day about "superstition," a word widely used in the Interior to refer to Native practices in the spiritual realm. Her mother, she agreed, knew a great deal about this, as she and her husband had been at Bonasila, the old settlement up the river, with Big George Reed, a prominent medicine man. She gave several instances of beliefs about animals and their relations to humans which she had noticed in her mother. In fish camp, a bird ("from-the-mountain bird") had flown into the tent; her mother had exclaimed, "That's no good, that always means death." (Told of this, Belle Deacon said always to kill such a bird.) Her mother also feared bears. "One time, after my dad died, we went to fish camp. Johnny Parks and Bernice were there. A bear came to the fish cache and pulled fish down. Johnny shot and wounded it with a

thirty-thirty. This scared everyone, bears sound so *human*. Finally he killed it. While he was pulling it up on the tripod, the rope broke, and the bear fell on Mom."

Such an event is frightening; it can be a spiritually serious matter to encounter a bear. All through the upper Yukon valley, men and women learn to observe a very strict etiquette toward these animals. At the Elders Conference, I saw a woman Elder slip quietly away when that animal's name was spoken in an incorrect way, in front of young women and girls. One of the students continued with a question about old-time belief in reincarnation; this was in public session. The question was met with silence, a pointed response that signified the impropriety of discussing such things publicly. As the silence grew, Brother Feltus, one of the former missioners, undertook a graceful answer. Uppa Ivan Demientieff had been his good friend, he said; and when they hunted together, Ivan had talked about beliefs. "Ivan personalized the birds and animals, and gave them names." The old people, he went on, were very close to the animals, about whom they told many stories. They believed in a great creator, who supplied them with the means of living; but in order to be allowed to receive them, they had to lead good lives. "They were wonderful stories," said Brother Feltus. "They don't begin and end but are endless."

He suggested that Frances Demientieff might wish to speak. But she, too, remained silent.

I was told a little about the days of medicine men and women, the days of the kashim, and dancing. What I learned was carefully told, and often I was asked to put down my pen and just listen, meaning both to pay attention and to refrain from writing or putting into print what was being said. Nothing written here violates those requests. What seems important to say is that in the tightly connected world of Holy Cross, the old beliefs still remain powerful among those people who were taught them, even though their religion is Catholicism and even though that religion is practiced in good faith. Perhaps it is wiser to think of the old beliefs in a broader sense than that of established religion: they are the expressions of the sacred bonds which people and animals, and the special place they inhabited together, were linked in mutual regard and necessity. What an outsider is allowed to see and learn represents very little of the richness which remains carefully hidden from insensitive or disapproving eyes.

These intimate connections are everywhere. One day, Martha said to me, "How important even a person's *name* is." Often, people are named for dead relatives; their names must be treated respectfully. Ideally, a kinship term would be preferred to a given name; but English kinship terms are inadequately developed to express the more extensive catalog of Athabaskan relationships. One reason children are seldom punished

physically is the feeling that "it would be like slapping a dead relative." Writing this piece, I was listening to a tape made in Holy Cross about ten years ago, in which a broadcast reporter was interviewing several elders, including Frances Demientieff. To establish personal identity, the reporter asked (in a rather gruff voice), "Would you tell me your name?" "No," came Grandma Frances' voice. The reporter persisted. Reluctantly, she answered, "Mrs. Demientieff." The reporter pressed further. Even more unwillingly came the answer, "Frances." Startled, I *felt* how rude this exchange must have been; it violated a deeply held sense of personal identity.

It also violated the sense of personal volition which is of the greatest importance. Martha explained it succinctly: "No one can force anyone else." This does not mean there is no social code, or social pressure to conform to it. But social pressure is exercised, ideally, in such a way that one always retains the right to act as she or he sees fit, even if that disrupts daily life. In former days, people paid social prices for their transgressions, perhaps by leaving the community. But the price was, and is, not only social: "There is an *immediate* response to incorrect behavior from the spiritual and physical world." The idea of luck can be introduced here. "We are disciplined within our whole world, yet we have personal freedom. We can only be an individual in the group; there is no such thing as an anonymous person."

The theme of the men's house, the kashim, was a lively one. Vivid memories and strong feelings are attached to this institution. While Frances' children were very young, the kashim was the center of life across the river, especially at festival times of the year. Big George Reed and his wife Clara, who lived at the Point, had a kashim; and across the river, Big Paul, who lived in Holy Cross, also had a kashim. There was no men's house in the village itself; the mission fathers considered kashim activities, especially dancing, "devil's work." (Grandma Frances recalled that as a little girl, she and a friend had climbed up and peered through the smoke hole of a kashim. Her friend fell through, a terrifying experience for a little girl. She thought she had fallen into hell.)

Luke Demientieff recounted what he had heard and seen as a child about the big mid-winter dances held just before beaver trapping. Runners would go out to neighboring villages to invite the people to a mask dance; the invitation went as miniature masks worn on the runners' foreheads; no words were necessary. As families arrived in their big sleds, messengers—Eluska Demientieff and his friend Vaska—stationed on the trail into the village would hurry to the kashim to announce the arrival. Then, just at the entrance to the village, the two men would be waiting, one on each side of the path; and as the team passed, they would leap across the running sled, passing each other in midair, to land on the other side. "That's the way they greet the sleds from each

village." According to Grandma Frances, her husband and his friend Vaska began this exuberant custom. At the kashim, the visitors would be welcomed with food and their dogs fed and bedded down.

These mask dances were special times, and for children they were awesome. Both Luke and Betty spoke across fifty years of memory to the time they had seen one of these dances, and their wonder and even their child's sense of fright were still fresh. Children were required to be very quiet in the kashim; otherwise old people would tell them, and their mothers, to leave at once. They considered that if children cried in the kashim, they would cry habitually. Everyone entered by passing down a sloped passageway blocked by a bearskin, under which they had to crawl. They came into a middle passage, a dark place. Still stooped over, they bumped against another skin, bear or caribou, an eerie feeling; and then, past that, they were suddenly in the kashim. They stood up into a large, square space with solid walls and a skylight/smoke hole. The Elders preferred the soft, low lights of kerosene lamps. Around the wall ran tiers of benches, at least two rows, and ground space. The first tier was about three feet off the floor; the one above it was about four feet higher. Usually children and women sat on the ground space. ("I didn't like that," said Frances. "I was from the mission and didn't sit on the floor." The older village women were accustomed to this, however.)

The dances held during this time were sacred dances; they were intended for the people only, and outsiders—non-Natives—were considered bad luck. "No kid wanted to go in there," Luke said. "It was too strict. The drumbeat just knocked your ears out. Their masks were out of birch bark; they can really make some dangerous-looking masks." The songs they sang were sacred and preserved from strangers' ears. The lamps threw the shadows of dancers on the walls. "It was not entertainment, not like now. There was laughing only at the right time."

Betty Johnson remembers this kashim, Big Paul's; the drumming was powerful. She went only once, with Anutka and Angela, Mrs. Ivan's daughters, and saw there piles of caribou skins, cases and cases of pilot crackers and cookies, yards of calico, and quantities of other goods to be given to the visitors.

Big Paul and his wife Serafina were powerful people. When she died she was given an impressive funeral. There were wolf skins, for the wife of a powerful medicine man, hanging above her coffin, which was set up outside. There was drumming. Each of them had a house; her husband and sons burned hers. When he died, the funeral was less elaborate, but his house was also burned.

Over time, the relationship between the mission and the village grew somewhat warmer, perhaps as the hold of kashim began to wane somewhat. Grandma Frances speaks often of the celebrations put on in the village, in which each group took turns entertaining the other at plays and singing.

Dancing was popular among the people, and they got together often, but these were "for fun," not the kashim dances. The memory of these dances did not die out, however, even when the last kashim caved in and went into the river. When a hall was built in the village, people carried on with mask dances and potlatches, and the young wife was asked to take part. This was a big step for a mission girl. She did not know what the mask dances were, until some village women asked her to join them. She rehearsed with them and, because she was an upriver woman, they told her she should dance an upriver dance. "I was as stiff as a board," she laughed. An old lady grabbed her arm and shook it: "Make your arm soft," she commanded. As the time of the dance approached, she and the other dancers made costumes, beaded boots and fringed jackets, and paper and cardboard masks. The night of the dance, the first of the three days of the feast, the six dancers lined up—"all greenhorns"—to take their turns. "We watched our instructor in front of us, watch her very close and try not to make mistake. And she was only laughing at us because I guess we were so clumsy. But then we made out all right, and the dance stop, the curtain close, they holler 'some more,' they encored. So, we start in again, and this time *fast*, really fast, we were pouring sweat and we were just—oh, we didn't care anymore, we just threw our arms and stamped our feet." She laughed again. "We got through it and we're so glad, it looked like that thing was never going to end!"

This kind of dance was held during midwinter potlatch, during which the men and the women took yearly turns honoring each other. This potlatch was a big event, and the sponsoring group, men or women, spent months preparing for it, accumulating goods to give as gifts. Men put aside good skins and hides. Yards of calico, cases of canned fruits and crackers were piled up in the hall. Women sewed and beaded. "Each woman had a man partner and each man had a woman partner, and then they have to feed them." A woman picked her partner by going up to him and giving him a gift, a shirt perhaps, "so that's your partner. But for the next mask dance he'll be still your partner. They keep on keeping the same partner. Suppose your partner move away or die: you get another partner. Some of them have had six partners!"

The feast lasted three days. On the first, the women greeted their partners in the hall with gifts; then they took them to their homes and fed them. That evening, while the men were in the hall, the women gathered their special food at home—fish ice cream, crackers, strips, and so on—and brought it up to the hall. "We let

the children bring [the food] in, what we can't carry the kids bring in, and then we pass it around, mostly to the old people." After they had eaten, there was a big dance, with much drumming.

The second day passed much the same; but in the hall that evening "they ask for the best songs, and we have to dance the best ones." Small presents were also given out.

On the third night, great piles of gifts were given out. Everyone received something. Women served food to their partners only and took care of their goods. Again, everyone joined in the dancing. They finished the evening before midnight, by shaking hands.

This potlatch took place no more than once a year, for it was costly; and, although the men and women were supposed to take turns putting it on, "once the men waited ten years to pay us back." In the early 1970s, "we feasted the men, we paid them back; and now the women owe the men. The men paid right back, and so we owe them now."

When the mask dance began to be held away from the kashim, other changes occurred, for example, in costumes. "The expert ones [women] used overparky," she explained. "But the men—you ought to see how they dressed: even they have nylon socks and leather shoes—just, you know, something to laugh about!"

"Us women, we used paper masks—cardboard—and make eyes and nose and mouth. But the men: they still have those regular masks and they use them." Wooden masks? "Rubber masks. But it's no good. I never see any wooden masks." The paper masks were fashioned to look like people, and, for her at least, were a disguise. "That was my intention. Because we're too bashful. Too clumsy, anyway." Actually, Grandma Frances is considered a very graceful, very feminine dancer.

Although an outsider might wonder if this potlatch she describes is a secularized form of the old kashim dances, certain characteristic relationships remain constant: gift-giving, mutual obligation, free will, and the complementarity of relations between men and women. At the heart of the matter is implied a sense of balance, of symmetry, in which outstanding obligations are not left hanging, in which people renew their friendships by forming a multiplicity of social alliances. This ideal of balance is played out in time, as well as in space (or place); and it might be noted that Grandma Frances is not the only Elder to point out that the women still "owe" the men. This deserves elaboration, for I have heard often from non-Native people that the old customs are "dead," or that Holy Cross people have become "assimilated" to non-Native life and have given up their own form of relationship. As an outsider, I do not intend to try to define in such a way identity or the "loss" of identity. What seems more important is to understand what Holy Cross people mean when they speak of

their identity, without assuming one can easily know what has "changed" or become "different." In matters of identity, what stays the same is at least as important; and an outsider must try to learn what "same" means.

As I understand the notion of balance here, of "paying back," it is a sense of mutual obligation. It is expressed, in this case, in relations between men and women. But it extends in other directions, as well; it is expressed in the theme of the relations between age groups. Grandma Frances spoke, for example, of the old lady who was her teacher. At the Elders Conference, it was displayed again, in what seems an oblique way, but which, in fact, was extremely pointed. Martha explained it to me. A student asked the question, "Can we ever have potlatch again?" After a pause, Nick Demientieff replied, "You have some people here. It's up to you." This meant approximately the following: There are old people here who know how to organize the potlatch. But it is not their responsibility to impose their knowledge on you. You must come to them privately and, in a respectful way, learn from them what you must do. In addition, it is not the responsibility of the old people to put on this feast; that belongs to the younger people, those of middle age, whose responsibility it also is to honor us in this, as it is also for the men to honor the women and the women to honor the men.

In this event, which has given people so much pleasure, there is in fact a complex system of honor and mutual obligation—that of giving gifts—in which men and women are linked in one way, older and younger people of the same sex in another. Younger women learn from the older ones how to dance and sing (though not how to drum; this is men's knowledge); in return, they are honored with gifts and are fed.

What is given here is honor and respect, as shown by the gifts, the food, songs, dances, and, equally, by the way in which the younger ones learn from the elders. Perhaps it can be understood as the obligation of the younger ones to learn how to be human beings, to learn their identity in the group. In return, the Elders teach in their own *particular* way, that is, from their own knowledge of how to live. This sense of mutuality is so deeply ingrained, I suspect, so obvious to the people who live by it, that they are often astounded when outsiders cannot see it. It is also important to say that this sense of connection is learned in experience. In the old days, it was not always expressed in words, and it is not now taught by the same means as the schools use to teach their own kinds of knowledge.

There are other kinds of exchange between men and women; one of these is called *bidguta*, "we are sharing." This kind of potlatch was organized rather differently; and it made visible the respect for individual choice, free will, which characterizes relations between people. Again, men and women alternated in feasting each

other, but these partnerships were not considered permanent. They were established according to what gift the giver chose to give, the receiver to receive. A runner would come around with a staff to which were fastened small replicas of handmade items. If the women were sponsoring, the staff might show tiny gloves, slippers, boots, shirts, scarves, and so on. A woman chose from this array whatever she wished to make, without knowing who her partner was. At the potlatch, she discovered who he was and presented her gift; in return, she received something from him, perhaps a beaver skin; and then she fed him. At the next potlatch, the men took their turn waiting on the women.

Thus, mutual friendship was reinforced, across age, family, and sexual ties, within the circle of the community, in such a way that individual wishes were honored.

It is inappropriate for me to speculate about Frances Demientieff's personal beliefs. Her actions, however, as described by her family and friends, illustrate how clearly she teaches those values. It is remembered of her that as a young widow she was generous. In the days when people traveled long distances to Holy Cross for Sunday Mass, many of them would stop at her house for tea, go on to church, and come back again to eat. She is not known to have ever begrudged food, even food that was hard to get, food from the land. It is this spirit, I was told, which underlies the subsistence way of life. Food gives life; sharing food honors life.

Figure 17. Frances Demientieff at the shrine of the Blessed Virgin overlooking Holy Cross. Every year Frances paints the statue with the help of her grandchildren.

In her piety, she has shown great devotion to the Virgin. On the hill overlooking the village is a statue of the Virgin (fig. 17). Every year she buys "good, high-priced" paint in Bethel and, taking grandchildren along to help, repaints the statue: the face, the hands, the robe, the crown of roses, the globe on which the Virgin stands, the snake she crushes beneath her feet. (Grandma Frances admits she does not know how the snake should be painted, as there are none around there.) It is true, though, her daughter confided, that she sometimes becomes a little put out with the Blessed Virgin, perhaps if the weather turns bad, and then she turns the small statue on a shelf in her house to face the wall.

Sewing

When Frances Howley was about sixteen, she quit school to sew for the mission. In those days, women came from the village across the river to do handiwork for the mission. These women were dressed in overparkas, their faces and hands were tattooed with beauty lines, they carried good knives and wore their work needles in the pierced septa of their noses. One of the women wore a beautiful beaded cap. Frances was delighted by it and asked Sister Superior if she could "look nicely" at the cap to see how it was made. She wanted to make a doll's cap like it. "Try it," came the answer. " She gave me permission to walk around and look. That grandma smiled."

The cap was made of a spiraling strip of moosehide sewn with a slender net of bright beads and edged with a row of bead fringe (fig. 18). She still makes these beautiful caps for the dolls she dresses. They are another kind of memory of those women who fascinated her, whom she thought were beautiful.

The mission girls were not encouraged to speak, but they observed everything. One of the village women, teaching her to mend shoes, took her needle from her nose and threaded it with sinew. Frances noticed a sore behind her right ear and, later, told Sister about it. Sister discovered it was the woman's *ikmak*, her snuff, which she, like other women, stored behind her ear. (The girls would imitate people who came up from the village, most of whom dipped snuff. They would pretend to put snuff up their noses, then sneeze, laughing and laughing.)

The village women spoke their own language; but Frances Howley worked often with Auntie Tatiana Demientieff, her future husband's aunt, who taught her to sew; Auntie Tatiana spoke Russian, Indian, Yup'ik, and English, and translated.

She wanted to quit school and go to work sewing for the mission. This was around 1912. "Because I didn't like fractions and decimals. I didn't like it! And I just liked to sew. And so I asked Sister Superior: 'I want to

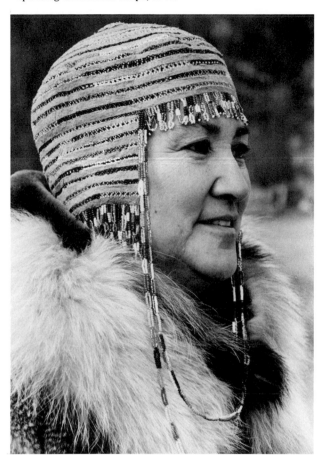

Figure 18. Alice Nerby wearing a beaded cap made of spiraling moosehide strips, 1985.

quit because I want to sew. And I'll be very good, I'll do my best,' and, boy, I really sweat! In order not to go back to school."

The Sisters of St. Anne are a Canadian order, and the work they taught in the mission was not just ordinary sewing. When Frances Demientieff was a young girl it was considered proper for young women to learn the arts of the needle. Girls may have worn plain dresses in the mission, but they applied lace to their underthings and learned the charm of personal adornment. She learned fancy work, just as she learned the ordinary, necessary handiwork all women were expected to practice, for there were clothes to be sewn and socks and scarves to be knitted in great numbers, with no patterns.

As a young wife, Frances learned what other wives learned, that is to do fancy work for their husbands. Women were taught not to brag about their accomplishments, but when they sent husbands and sons off to Sunday Mass in fancy work hats and gloves, even (if they could get Native-tanned hides) in beaded coats, they were able to show off their work without having to draw unwelcome attention to themselves. Yet everyone could see their talents, and their social status was thus enhanced.

Mrs. Ivan continued to be her teacher. Frances helped her with everything: bottling, canning, butchering. Mrs. Ivan repaid her with bread and garden vegetables. She beaded for Mrs. Ivan. She had learned this, as well, in the mission. "In the mission we beaded. Tatiana was a very good sewer—beading, crocheting, everything we used to do. I really copied her, but I improved it."

It is often supposed that traditional arts are unsigned, anonymous. In Holy Cross, as in most villages, no woman had to put her name on a piece of work; everyone who saw it could tell just by looking who had made it. In the Interior, women usually can tell which village a particular piece has come from and often they can name its maker. This is true for beadwork, which, across the subarctic, often is worked in floral motifs. It is true for skin clothing and decoration, such as the "fancy" on parkas. It is true for the skin applique work which is a favorite form in Holy Cross and villages downriver. Martha explained this to me one day as we were walking up to visit Grandma Frances. "See that blue," she said, indicating a bright blue boat sitting overturned in a yard. The blue covered not only the boat: as I looked around with more attention, I saw it also on a child's bicycle, a racing sled, and any number of other things, as if someone had once been given a very good deal at the hardware store. "That's what we call 'Shageluk blue.' Women here do not use that color much, but in Shageluk they use it all the time. Grandma Frances would never bead a blue rose: you don't see blue roses."

Colors, placement of flowers in relation to each other, variations in tone and contrast, background material and color, the use of imported skins and fabrics—all of these elements, and others, are at play in the fabrication of an article. Certain kinds of combinations are likely to be characteristic of a place, for rather simple, delightful reasons: a woman whose work is particularly admired simply liked certain colors, and her taste is followed; new colors become available and are experimented with. Innovations in materials and willingness to experiment are admired, within certain bounds, which are perhaps felt rather than set out.

Within any range of possibilities open to women, however, certain constraints apply which make each one's work individual within her village. In Holy Cross, women do not copy each others' patterns. On that part of the river, for instance, skin applique work, often with bead embroidery overlaid, is popular. It appears on the borders of mukluks, or high skin winter boots and parkas, the beautiful fur coats worn on special occasions (fig. 20). Grandma Frances has firm ideas about border patterns. Her old friend Mrs. Margaret Demientieff, works in the same materials, but uses different patterns of elements. The two women each have their own repertoire of patterns and placements which are immediately obvious to anyone who is used to looking

at their work. And because most of the work they produce stays within their families or in the village, no extra signature—a redundancy—is ever necessary. But it takes experience to know whose work is whose. In a small society in which hunting and gathering still condition the organization of knowledge, the ability to make rapid visual identification is carefully encouraged in the education people receive.

I saw this when I realized I sometimes asked silly, or obvious, questions. "How can you tell beadwork from Holy Cross," I asked Harriet Walker, a young woman who works in beads and skins. "Hmmm. It's just the way we do it," she replied. But then she eased me off the hook. "In Shageluk, where I learned from my Mom, they have a way of making a flower there that no one here does. It's in the shape. It just seems like it's a Shageluk flower." She drew out the shape of the flower for me.

I think she was telling me two kinds of things here. One was about how she recognized differences: from the experience of learning from her mother and looking at others women's work, and of course, from doing her own work. The other was another aspect of what Martha had spoken of: how important the identification of people with place is, and how colors, motifs, materials, and arrangements express such an identification ("It's just the way *we* do it"). This is a complex identity. Yet, each woman owns her own patterns and works her own colors and combinations of colors. Martha had said,

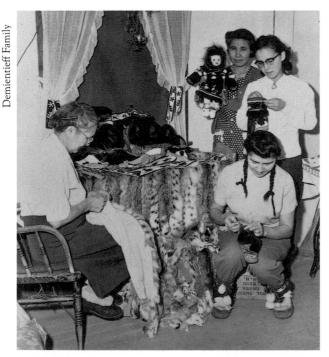

Figure 19. Frances Demientieff supported her family by teaching sewing to the girls from the mission. Geneviere Newman holds a doll dressed in a fancy parka. Alice Demientieff works on a mukluk, and Mary Demientieff sews on a slipper. Holy Cross, 1950.

"We value our personal freedom: no one can tell anyone else what to do. Yet we can only be individuals within the group."

Thus, the social display of beadwork, I assume, can stimulate the range of emotions and comments which any art is capable of exciting in any community. But there is, in Holy Cross and similar communities, a profound difference in attitude toward the work than one ordinarily finds in the contemporary art world. In Holy Cross, it is my sense that women's handiwork (certainly Frances Demientieff's handiwork) is never a commodity. This is true even when an object is produced on commission. It is so despite the economic fact that handiwork has been an important source of personal and family income for some time in rural Alaska. Women are precisely informed of the market value of their work; and they are as interested to sell their work as an artist of any other medium is. But it is my impression that the income resulting from this work is something like an unexpected benefit, though a most desirable one. There is something more important to its makers: the passion which compels any artist to make something.

It was, I think, such passion which drew Frances Demientieff to her work. It is in her voice when she describes how she persuaded Sister Superior to allow her to leave school and take up her needle. It is clear in the excitement with which she still talks about her work; although the words must come a little more slowly now. "So much to tell you!" she said to me, then gestured toward her forehead. "It's all up here, but I cannot say it fast enough!" Her pleasure in being called an artist was clear in her face: the recognition of the *work* that was coming to her.

One clue to the nature of this passion lies in the way she tells how she quit school to sew. "I didn't like fractions and decimals. I didn't like it! and I just liked to sew." In talking with Martha, I learned something noteworthy about this aspect of mathematics. Martha has taught mathematics at home to her twin daughters for years, and she has found school mathematics quite different in assumptions it makes than the mathematics of, say, the trapline. "I laughed when the math books wanted us to measure things," she said. "How long is this line or how big is that angle? For what? On trapline, we know how a long line must be for what kind of snare we are setting. We always look at one thing in connection with another thing; but it is one *thing* compared to another *thing*. We don't like to break things apart into pieces the way you do." This is a way of seeing things whole, of seeing things within the web of their connections with each other.

While Grandma Frances was working at her therapy, before she returned home, I asked everyone I could, what does she say about what she *sees*? I wanted a visual sense of how she sees the world. Some painters I have

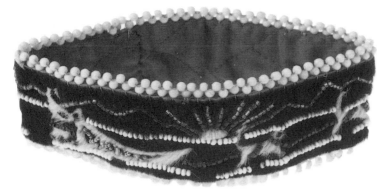

Figure 20. Calfskin border with bead-work.

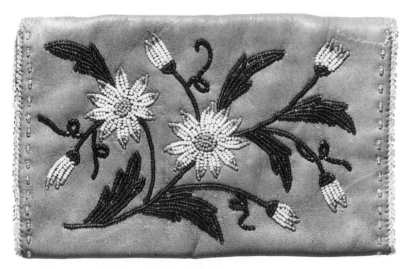

Figure 21. Two moosehide purses beaded by Frances Demientieff. Flowers are a favorite subject for her beadwork designs.

known seem to inhale colors and exhale them onto canvases, painters whose palettes change with location and the light. In Holy Cross, the light is crystalline; and there is a distinct red-yellow in it, different from the blue of southeastern Alaska or the Gulf of Alaska, for instance. I noticed, too, that her house is filled with flowers and colors, the way an artist's studio is filled with visual notes and reminders: plastic flowers before the Virgin's small shrine, big roses in a piece of carpeting, flowered plastic placemats, dainty flowers embroidered on her slippers, pictures of flowers cut from magazines and posted on the refrigerator, flowered curtains, slipcovers. Her kitchen table, which is also her work table is by a window which looks out over the village spilling down the hill to the slough and the river beyond it. She can watch people going about, the weather moving in, airplanes, the way the willows on the bank yellow and then green in spring, watch the water come up in the slough just before breakup.

Helping me to see, Martha remarked that in Holy Cross work, the beaded flowers seem more "real" than those of other places. Grandma Frances has passed much of her life in the woods or by the river. She looks at everything there; she remembers if a stem curves, or how the little bells of a flower hang: "You look and try to copy it," she told me. She does not draw in the woods; she remembers for later. A forget-me-not, for instance, has red stamens, yellow pistils, blue petals. She knows this, but in her beading, she changes colors a little "to make it show up better" and "be pleasant to your eyes."

Roses are another of her favorite flowers. I looked at a pair of slipper tops she had finished. The petals had a dark border, red, and were filled in with a much lighter dusty pink. This is like flowers that have already bloomed and begun to fade, she said. "You watch the flowers as they grow and try to copy them." Leaves have various kinds of shading; some are darker outside, which she can represent with shades of brown and bronze as well as with darker greens; some have noticeable veins, or are shaded inside, or they have peculiar little twists, which she arranges to agree with the shape in which she is working.

Flower colors change with the season; they are bright early in summer and fade as the summer passes. If a flower is all red or all yellow, and darker-hued toward its center, it is a younger flower, just blooming; this she will represent with beads. Daisies are flowers she often uses. They are yellow flowers, she explains, but when she beads them, she will often put white on the tips of the petals; or, she will make white petals with blue or some other bright color on the tips, in order to "show the color." Exactly how she does this depends on what other flowers and colors are worked into the space.

Her passion is visible in the way in which she talks about matching colors. She takes infinite care as she piles up skeins of beads and sorts through them, comparing, searching for the exact shade to match the idea she has found in her head. The women in her family talk fondly of the pleasure of watching her hold the strands of beads in her fingers, placing color next to color, hue next to hue, until she finds the combination that pleases her. "You put the beads down, you look good with your eyes. You know how it's gong to look when it's finished. You match your colors. If it appears nice to you, you take them." She taught them all to look hard at the pansies in her garden. "Then draw and draw till it's perfect." She learned to do pansies from the nuns: this is the lip, these are the whiskers, this is the cheek, then the other cheek. Her daughters and daughters-in-law still recite this little litany. They remember her big flower garden at fish camp.

Figure 22. Frances often works at her kitchen table where she can observe village activities and the changing seasons.

Figure 23. Paper border patterns. The top border pattern was made for a bush pilot in the 1930s. The middle pattern shows a musher and sled dogs. The bottom pattern with a landscape motif is a favorite style in Holy Cross.

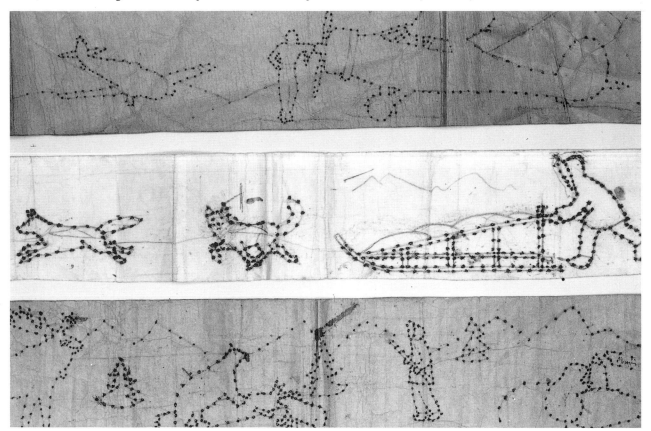

Drawing patterns was a Sunday task; sewing, because it brought in money, was work and so reserved for weekdays. On Sunday she would get out her pencils and cardboard or brown paper and translate her memory into shapes. One day she brought out a cardboard box full of patterns. One by one she held them up. "This I made when my husband was alive." "This I copied from Sister." "This one is for women's slippers, the top." They have been traced and retraced; some are in tatters; most are pierced by tiny pinpricks and ink-stained. They are transfer patterns, for which she uses an old-fashioned dip pen to mark the patterns of pin holes onto the skin or fabric to be beaded. I picked up a long horizontal strip, a parka border (fig. 23). She had made it for a pilot many years ago. "When you make a border, you have to make a good story," she told me. This border pattern was about airplanes taking off, flying, the country below them, landing. She had drawn from memory. "You can make a story out of anything." The next pattern I picked up had the following story: a man coming out of his house, dogs tied up, the man and his team going hunting, the man sees a caribou, a plane lands, a wolf howls. The animals always have little beaded lines under them; these are to represent tracks, because the animals have to be *some place*. The tracks establish context.

These landscape story parka borders seem to be a Holy Cross speciality. They are constructed of dyed (black or white, generally) clipped calfskin, pieced and sewn into place with tiny stitches. Sometimes the pieces are shaped to represent figures and applique; sometimes the skin is merely the ground for the bead embroidery. The latter is probably the most difficult and time consuming work of all, for the embroidery pattern can be pricked only on the back of the piece to be sewn, so that she must constantly turn it over to check that the beads are in place on the right side. Then, too, calfskin is more difficult to sew than moosehide is, although it is easier to obtain. Moosehide, caribou and reindeer skin, elkhide: she has used all of these materials. She buys them from a commercial tanner; but commercially tanned skins are stiffer and less durable than home-tanned skins. Very few women do this work now; Grandma Frances herself has not done it for many years. (Her scraping stone sat on a table in her entry porch.) Very early, the mission introduced imported skins such as calf, elk, lynx, (from the States) and the mission girls worked them for sale, to benefit the mission. Red and green flannel were other materials she used as backing.

Memory holds shapes as well as colors. Holy Cross flowers have their own shape. Shape takes space: how is space to be filled? How are shapes to be arranged? "Long

Figure 24. This dress glove of moosehide and other trim was made by Frances for her son, Luke.

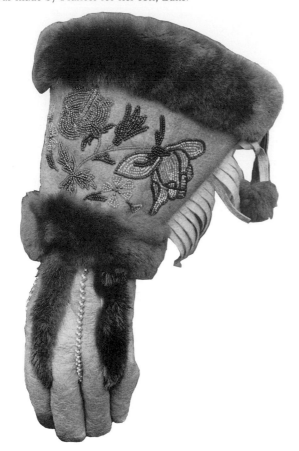

ago those women told us how to do it, we learned by doing it." She practiced until the shape came easily. There was a square pattern, perhaps eighteen by eighteen inches, for a pillow she made for daughter Alice. She made it of moosehide with beaded embroidery; the picture is of an eagle, with stars in the top left and right corners, a shield, crossed flags: a patriotic theme. "I made it years ago, when I was young." I wanted to know why she arranged it as she did, so that all the elements of the picture came close to one another, so that no one thing existed by itself. The eagle sat haughtily in the center, the flags and shield above and below it, the stars forming a border around them. The border had to be there, she explained; "otherwise it would be too empty."

For her sons she made dress gloves of moosehide trimmed with otter and mouton and beaded with flowers and initials on the front and back of the long, fringed cuffs. Her son remarked that there's something "old fashioned" about the way she worked them, strewing flowers around the available space without filling it in with white beads, as is often done now. "Filling in looks better," she admitted, "but it's lots of work to do." She brought out some slipper tops she had finished. These are shaped like an elongated shield, and form the upper part of moccasins. Usually they are filled with beads. This design was a bunch of monkey flowers—she was not sure of the formal name—a flower not native to Holy Cross but a present from one of her daughters (fig. 25). The flowers are yellow and red and puffy; they look as if you can squeeze them. She had made a bouquet of them with forget-me-nots, which she added because there would have been too much of the white beaded background without them. Her opinion is that there

Figure 25. Frances based this monkey flower design from a gift of flowers given to her by one of her daughters. The flowers are not native to the Holy Cross area.

should be just enough of the background so that the flowers show up clearly and brightly. She had drawn out the design to fill the shape on which she was going to work; once the space was properly filled, she knew how it would look and could choose beads.

I turned over small patterns for parkas, mittens, mukluks. These were the patterns for the dolls she makes; she has been making them for years. She does not make the doll itself but buys commercial dolls, rather like the little-girl dolls little girls receive at Christmas. She then makes sumptuous clothes in traditional style for them; they are miniature versions of her memories of old-time dress.

She started making dolls in the mission. One day she was given a new reindeer skin. Reindeer were introduced across the river in the early part of the century by the mission, and Lapp herders were hired to care for them. (There were Lapp children in the mission school, and several women learned how to make Lapp boots, which differ from moose-soled mukluks in their shape, having a pointed toe, and in the way the hair is left on the hide soles, pieced so the nap goes in two directions, for traction.) She tanned the skin and then took her sharp stone and clipped the fur until it lay close to the hide, like calf. With this she made a parka for a doll. She made others after that, which were sold by the mission or given to benefactors. After her marriage, calfskin became available. Now she uses clipped calf for fancy work inlay; but she uses many other skins and trimmings as well.

The clothing for the dolls, the precision and detail of construction, the kinds and arrangements of skins are very beautiful. She knits tiny stockings, makes little undergarments. The dress is a woman's kuspuk, a belted, lightly ruffled anorak-like garment; it is trimmed with piping of rick-rack, as women do on their own kuspuks. The parka is in the old village style, full around the bottom. She makes it of rabbit, often dyed, trimmed with wolverine and wolf tassels and scraped, dyed skin with beaded borders. The tiny boots are made of moose and calfskin with otter trim and applique border. There are little mitts of moose skin embroidered with small flowers and trimmed with mink and otter. The ruff on the parka is beaver, wolverine, and wolf. A most beautiful detail is the little cap of moosehide and beads, which she first saw on the old grandmother from the village across the river. It takes about three months to finish such a doll.

She described making these old-style parkas, not only for dolls, but for her daughters, as well (fig. 26). The Village Across style is different from that which women on the Kuskokwim wore. The latter type was rounded at the hem and cut deeply up the side seams nearly to the arms, "because when they sit, they pull it up and it stays good." That style had no fancy work, just beads and yarn on the border edging.

There is an exquisite Yukon women's style called a snowflake parka (fig. 7); she made one years ago for her daughter Alice. The fancy work is a fringe of weasel fur that sways gracefully as a woman walks, reminding one of dancing snowflakes. The weasel fur is attached to pieces of red tape, which also outline the otter fur which runs down the center of the parka. The snowflakes are

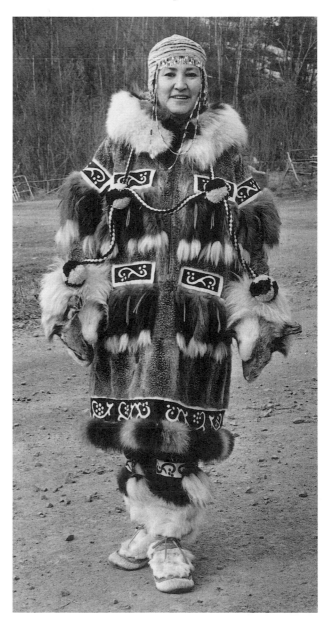

Figure 26. Frances made this fancy parka and mukluks for her daughter, Alice Nerby. Alice had been collecting skins for the parka for about fifteen years. After Frances and Alice tanned the skins in one evening, Frances began sewing them together, completing the parka in ten days. The parka is made from Arctic ground squirrel skins with a wolf and mouton ruff, a cut-out calf border, and fancy trim of calfskin, wolverine, and wolf tips.

arranged in three rows down the front and back and one row on the sleeves, and they are attached to split otter skins. A mother would make it for her daughter for special occasions.

Women's parkas, she told me, used to be very nice: mink, squirrel, muskrat (bellies) were the preferred skins, because only "weaker" skins were used by women. Men wore parkas of muskrat backs; muskrat is a "stronger" animal. Wolf was never used for a woman's parka, only for ruff and tassels, along with wolverines. From her son, I heard an additional catalog of proper use. Bringing out the old-style dress gloves she had recently made him, he pointed out that the otter fur laid out in three lines on the back of the hand was correct; but the mouton trim around the edges of the cuffs should properly have been beaver.

From this, I infer that there is still in effect at least some observance of a formal etiquette of relations to animals—in this case, to the power of animals of which their skins are a relic. "Weaker" and "stronger" have, in this sense, no reference to the capacities of women and men (clearly, strength is not limited to one or the other sex). Rather, it seems to refer to concordance of spiritual attributes with which various animals are endowed, some of which are more powerful than others. These must be treated in specific ways by women and in other ways by men. This is something hinted at in the careful discussion of "luck" and in the discreet way I was told about life in the kashim. When the elaborate funeral of the wife of a medicine man was described—the wolf skins hanging above her coffin—it was clear that the teller, and the women who were listening, considered this significant and unusual, for they nodded and looked grave when the speaker mentioned this.

It seems important, then, to show that evidence of the practice of these old beliefs was given me in connection with my work on this text. What I infer from these statements is not about Frances Demientieff's own beliefs, for I am not privy to those. Rather, it is the presence of signs of a sacred etiquette which seems notable, the strict observance of which may (I do not know) have been altered by time and the exigencies of contemporary life. In such a world, everything is connected, and one may speak of stronger and weaker animals. The anthropologist Richard Nelson has written of the relation of the physical and spiritual world of the people of Huslia (Grandma Frances' relatives, interestingly enough). "In our culture," he says,

> we can easily enough understand the sanctity of physical symbols like the cross or the star of David; we venerate them or empathize with those who do. Here among the Koyukon, a kind of sacredness is an inseparable part of living things. They are not symbols, but rather living objects of veneration and physical manifesta-

> tions of spiritual power. The reality is somewhat different, but the underlying emotions are similar.
>
> (Make Prayers to the Raven,
> A Koyukon View of the Northern Forest.
> Chicago: University of Chicago Press, 1983, p.148)

It is to this way of belief, this sense of the sacred connections of the world, that such statements as "stronger" or "weaker" fur possibly refer. In the observance of such tradition may be seen a manifestation of that sense that the world and its inhabitants are related to and dependent on one another.

Figure 27. Luke Demientieff wears black bear leggings with beaded tops, beaded slippers and gloves, a beaded moosehide ammunition bag, and a wolf fur hat.

There used to be a style of parka for men and boys, with only one tassel on the back; it told a story. "Ask her about it," I was told. Long ago, a man wore a caribou skin parka with a wolverine tassel on the back. He was out hunting; someone shot him in the back with an arrow. Now, when that parka is made, there is a red trim on the tassel. Mrs. Ivan told the story to Frances.

Telling the story prompted a discussion of older materials and methods. Showing me the fancy work of dyed, scraped skin with which she had trimmed the dolls' parkas, she noted, "Long time ago, they used fish skin. You take off the scales and dye it." The color was always

Figure 28. Joe Demientieff is wearing the lighter colored leggings made of wolf skin with beaded tops, moosehide gloves, ammunition bag, and a marten fur hat.

red, and the dye stuff was gotten by scraping the inside of red willow bark. One took bark and a little Fels Naphtha soap and mixed them with a few inches of water in a kettle and left this overnight. Then the skin was added, weighted, and left, again overnight. Sometimes, black edging was used, either with the red or alone. This was made with the skin of swans' feet, which was stretched with pins, allowed to dry, and cut into strips. White sealskin, with the hair scraped off, was cut into thongs for shoes. And crepe paper was sometimes used to dye clipped calf ("any color"—red, green) to use in landscape applique.

She made leggings for Eluska of porcupine bellies, with a band of beadwork around their tops. They were similar to the leggings of black bear and grey wolf she made not long ago for her sons (figs. 27, 28).

I asked about needles and threads. Steel needles have been available since she began sewing; even the women from the Village Across carried steel needles in their noses. She uses a fine needle for beading, and fine thread, but she knows how to make caribou *babiche* and sinew thread. "It makes nice thread," she said. The best sinew is from the caribou's back; it is then split by hand, and split again, and again, as many times as necessary to reduce it to the desired fineness.

Her insistence on perfection is famous in her family. "She made me rip very many times my work," said Mary D. somewhat ruefully. "I always had to rip." Grandma Frances still rips out stitches if they do not look right. When the Pope came to Alaska several years ago, she made a white beaded stole for him; all the women contributed work on it. Martha worked a very small part of the beaded fringe, and Grandma Frances made her do it over again. (Grandma Frances and several other women planned to fly to Anchorage to meet the Pope; on the day they were to leave, the visibility was zero-zero, with little chance of clearing. They prayed; the weather lifted.)

Her masterpiece is the beaded altar cloths adorning Holy Cross church (plates 5 and 6). There are six of these cloths, for the main altar, the missal stand, the tabernacle stand, and the stands for three statues: the Virgin, the Sacred Heart, and St. Joseph (fig. 29). Each is made of dyed white clipped calf backed with cloth and embroidered with flowers and sacred symbols in beadwork. Each bead is individually sewn down. Each cloth is edged across the bottom with a deep fringe of freehand net beading in colors repeated in the embroidery. "Each bead is a prayer."

The method of construction of these cloths is very interesting. The main altarpiece, for instance, is very long and narrow, the same shape as a parka border, though much longer. She explicitly pointed out how it differed in design from a parka border. In the latter, there is a centerpiece design (perhaps a mountain with

the sun peeking over it), just as on the altar cloths. But the *story* around it proceeds from left to right, as if (I infer) it can be read. The story on the border refers to events which unfold over time and in specific space (as do the "tracks" underneath animals, to establish context).

But the altar cloths are constructed differently. The centerpiece is the last element applied to the skin. Spreading out from either side of this space are flowers. These are arranged and applied identically on each side, beginning from this space. Her formal principle here is balance of identical elements radiating in two directions from the center and harmony, or colors (by graduating contrasts) and shapes (intertwining sinuous lines with flower shapes).

All the cloths but one (the missal stand cloth) have this centerpiece: for the Sacred Heart, it is a red heart; the Virgin's cloth has a scrolled M; St. Joseph's is a scrolled J; the tabernacle has a gold chalice and a white host; and the main altar bears a silver salmon and a birch basket of bread, with a cross between and slightly above.

Without wishing to present an elaborate over-interpretation, I point out two things about these cloths

Figure 29. Frances standing by the statue of the Virgin in the Catholic church in Holy Cross. This in one of six beaded altar cloths Frances made for the church.

that seem especially interesting. The first is the lovely symbol on the main altar, the loaves and fishes. In Church iconography, these refer to the miracle which occurred at the Sermon on the Mount, when Christ multiplied the loaves and fishes to feed the hungry faithful. They have been interpreted here in a way that is specific and easily recognized by the congregation, as salmon and as a birch basket. These refer to, and (possibly) evoke, that great reverence for life which is the heart of the subsistence relationship.

The second point is that the sequence in which she works the design on the cloth seems to me to be analogous to the way in which I have noticed that much communication occurs among people there, that is, by a sort of indirection, of circling around the point. It seems to be both an esthetic and an ethical point, in telling an event or a story, for the teller to lead her audience to a conclusion, by introducing or referring to the significant details and linking them in a masterful way. But the conclusion to be drawn, the punchline of the joke, these are left to the audience to infer, perhaps because it is so obvious that no words need be said.

What seems to me formally analogous, in an interesting way, is that a similar process is followed by Frances Demientieff when she sews what is for her the most important of her works. I am guessing that there is a rhythm in the elaboration of the work (because as a poet I tend to work in a similar way). It begins in the flowers flanking each side of the central space, and it grows out from this harmoniously. I suspect that as the flowers appear, they seem to her to grow that way, each one suggesting the next in a play of likeness and contrast: the curve of a petal suggests an answering curve in a tendril of vine, or the bouquet will contain all spring flowers, or a mixture of old and young flowers, according to her feeling about the time of the year these represent, or a slant of light, or any similar emotion in the artist's repertoire. And I think that, as this interplay of feeling and design carry her along, the working of the centerpiece comes to feel more like a culmination than a simple end of work. Because of the particular formality of the altar cloth, I imagine it as a poem (rather than a narrative, perhaps): a story of feeling which the artist has told herself as she made it manifest to her audience.

Along the bottom border is her characteristic net fringe. Perhaps it is only intended as a finishing off; I cannot help remembering the lace trim and the crocheting she learned in the mission as womanly arts. This might have mattered in forming the esthetic which requires this elaborate trim; but then too, there are the fish nets she knits in winter. The fringe on the altar shimmers in the filtered light of the church.

There is still so much that she wants to say about her work. The day of her stroke she was working on a moosehide wall pocket. She was about to pull the thread

through. Something happened. She could not figure out what it was. The right side of her body did not work. Just about six weeks later, she was telling me this. The next day, when I arrived, she said excitedly, "I threaded a needle today!"

Afterward

Early in 1986, Martha Demientieff wrote to tell me how Grandma Frances' life is continuing in Holy Cross.

> Frances will be 91 years old March 4th, 1986. she still lives alone and for the most part takes care of her own home. She still goes to fish camp the first part of June and stays through the end of September. She still gives gifts of smoked fish to relatives and friends. She knits socks for gifts and makes patchwork quilts. She walks to church for Mass and receives Holy Communion.
>
> She will be a great-great-grandmother in April, 1986. Her granddaughter Pamela Vaughn Power will have a child. Betty Johnson (Pam's mother) will escort her to Anchorage for the baby's birth.
>
> She still travels unescorted to visit each of her children.
>
> In spite of a stroke that caused a speech problem, we had the privileges of hearing her lovely soprano voice at midnight Mass as we sang a favorite hymn, O Holy Night.

Figure 30. (L to R) Martha Demientieff and daughters Betty Johnson and Alice Nerby admire Frances' sewing in Holy Cross, 1985.

ENDNOTES

1. In this work, I speak of Frances Demientieff as Grandma Frances. It is an honorific title which I use to show respect. "We call her grandma when we talk about her but not to her face," Martha Demientieff told me when we discussed this. "We do not address her at all, just begin talking. We know she is grandma." But this is not always an appropriate title for Elder women when they are spoken of by outsiders. Of another respected Elder Martha explained, for instance, "This grandma is different and wants to know exactly who calls her grandma and will accept or reject that relationship as she is free to do."

2. Eliza Jones, linguist at the Alaska Native Language Center, has documented these kinships. She herself is the granddaughter of Hadozeelo and daughter of his son Little Peter, and so is a relative of Frances.

3. According to her baptismal certificate, she was born June 5, 1895; but she has always claimed March 4 as her birthday. Also, family members say that she came to the mission about 1903, when she would have been nine; but she says she was six. I have followed her own memories about dates but note the differences for the reader inclined to stricter chronology.

4. Alice Nerby remembered hearing of this, also. "Mrs. Ivan Demientieff told Mom (that) there was a big illness at a large fish camp down river," she wrote. "The tents were blue, some white, or mixed red/white. The people were dying. Some would take their canoes in the woods, lay down in the canoes, and die in them.

"They were dying so fast that they couldn't keep burying them, so people would put the bodies in a tent, and drop the tent on them. Then one year later Father Lucchese went down with some Mission boys to bury them. The boys would dig the graves, and Father would not have the boys touch the bodies, he was the only one who put the bodies in the graves. Then the boys covered them. Then there was the job of cleaning Father's coat later" (Personal communication). Father Lucchese's wool coat had green stains on it from the decomposed bodies.

5. These children had heard the word *Malemuit*, meaning people of a certain place, and thought this meant *Malemute*, a kind of dog.

ACKNOWLEDGEMENTS

In November 1982, I was invited by Dr. William Schneider, of the University of Alaska, to contribute a text and archive to the project, "The Artists Behind the Work." He suggested that, because I had worked and lived for several years in the Interior, I might like to write about an Athabaskan artist. He proposed Frances Demientieff as an artist whose life would be of interest to himself and his sponsors, the Oral History Program of the University, and the Traditional Native Arts Panel of the Alaska State Council on the Arts. I agreed with some enthusiasm, as I have always liked Holy Cross, and one of my close friends, Martha Demientieff, lives there.

At that time I was not living in Alaska, but other work was going to take me there by the following January. I agreed to contact Mrs. Demientieff and Martha Demientieff, to present the idea for the project, and to say that it would be an honor if Frances Demientieff would consider being the subject of this work. After some consultation with her family, she agreed to allow me to visit her in Holy Cross.

I was to arrive for a preliminary visit on March 13, 1983, the earliest date possible because of other commitments. I was eager to begin the work, even feeling some urgency about it. But on the day I was to have arrived, other business interfered; and I called Mrs. Elizabeth Johnson, Mrs. Demientieff's daughter, to ask if I could postpone the visit. She agreed to discuss another date with her mother; and I said I would call back later in the afternoon. But I could not reach her that afternoon. In the evening, Martha called. "Katherine, Grandma Frances had a stroke this afternoon. I knew you would want to know at once." It was sad news for her family, as for me. With some regret, we agreed to put aside the work until more was known about her recovery. (Betty Johnson later told me her mother had become enthusiastic about the project, and, on the day of her stroke had said with, she thought, some prescience, "Why didn't that girl come last week?")

Within a short time, Grandma Frances was in Anchorage in therapy for her blocked speech and useless right arm; and within what seemed liked a surprisingly short time, her speech and movement began to return. By the middle of April, Bill Schneider said, "Well, even if you can't talk with her now, how about going out to Holy Cross and spending time with her family. Just work around her, until she's well enough to participate, if she still wants to do it. See what happens."

And that is what I did. Martha, to my pleasure, invited me to stay with her and her twin daughters, Mary and Mitzi. Even more generously, she spent many hours talking about her memories of Grandma Frances, helping me annotate audio and video tapes which happened to be available, and generally interpreting remarks and events I was not always sure how to make sense of. She arranged visits with Grandma Frances' friends and, in general, made me part of her family. Betty Johnson and Mrs. Mary Demientieff, her sister-in-law, affectionately known as Mary D., spent hours listening to tapes and talking about their lives with her. Luke and Alice Demientieff, Grandma Frances' son and daughter-in-law, offered fine hospitality and hours of stories. Mrs. Axinia Peters kindly gave me insights into the seasonal cycle and shared her own memories. Mr. Joe Demientieff, Grandma Frances' son and Mary D.'s husband, and her son Bergie also offered assistance; Lisa Demientieff, Mary D.'s daughter, sat with her grandmother and, while I was there, made sure I understood her speech.

I stayed in Holy Cross about three weeks. To everyone's happiness, Grandma Frances recovered much of her speech and movement; by early May she was back in Holy Cross. I was able to spend the good part of a week with her, visiting for a few hours each afternoon.

Glen Watson and Paul and Linda Rourke contributed fine photographs to the project; these are in the archival material which accompanies this text. Will Peterson, of station KSKA, McGrath, gave me an audio tape he made with Mrs. Demientieff. Eliza Jones, of the Alaska Native Language Center, kindly read part of the manuscript and gave me important family information to transmit to Frances. In Fairbanks, Howard Van Ness opened his house to me, as Wendy and Peter Esmailka did in Holy Cross. Bill Schneider and Matt Ganley spent patient hours listening to me talk about this project. My brother Brian McNamara has given me good company and a cheerful place to work.

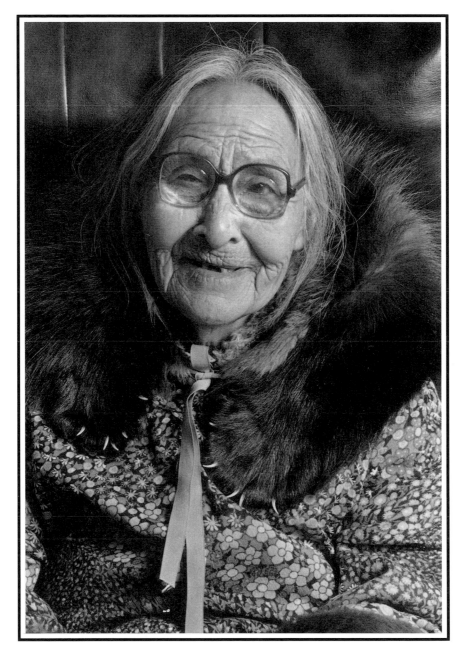

LENA SOURS

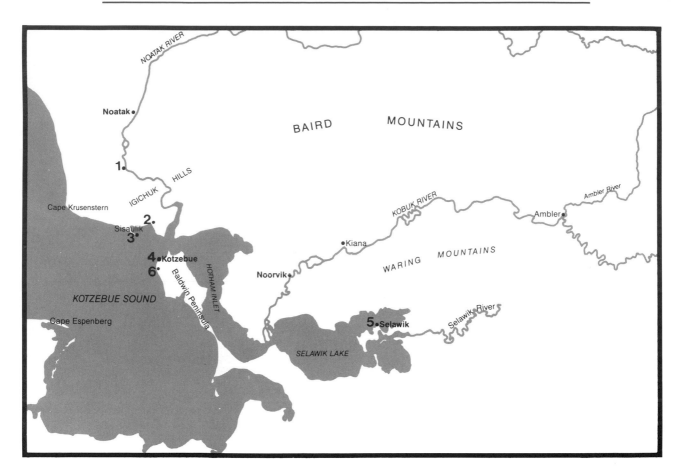

1. Nauyauraq
Lena's birthplace; and the family's winter camp, ca. 1880-1907.

2. Napaaqtuqtuuq
Fall camp, ca. 1880-1907. Site of the *qargi* where Reverend Samms saw Eskimo dancing and shamanism and began preaching against them.

3. Sisaulik (Sheshalik)
Lena's family's spring camp ca. 1880-1907, and where she first saw white people.

4. Qikiqtaqruq (Kotzebue)
Lena's family's summer camp; where Lena attended school (ca. 1902-1907), married Burton Sours (1907), and has lived continuously since 1917.

5. Siilivik (Selawik)
Area where Lena and Burton Sours lived, herding reindeer, and sewing mukluks and parkas, 1907-1917.

6. Saugaliq
Lena and Burton Sours' summer camp.

M A T E R I A L S M A P

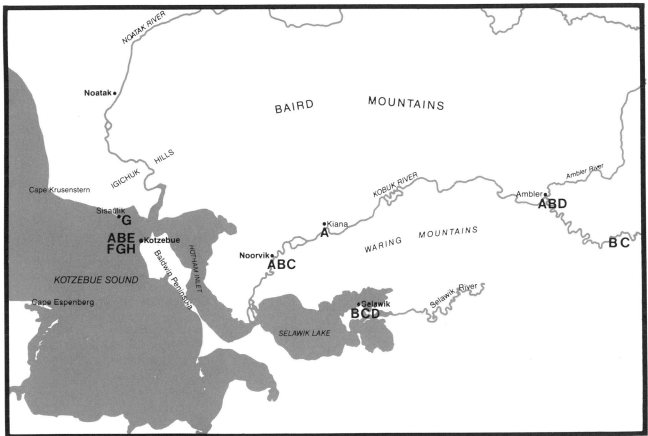

A. Arctic ground squirrel

B. Wolf

C. Wolverine

D. Beaver

E. Blackfish skin

F. Calfskin, zippers, and lining fabrics
Purchased or traded from stores in Kotzebue, commercially imported.

G. Sinew

Page 99: **Figure 1.** Lena Sours, Spring, 1985.

INTRODUCTION

Almost three years have passed since I began working with Lena Sours and Sophie Johnson on "The Artists Behind the Work." Throughout the spring and summer of 1983 Sophie and I visited Lena many times. We rarely found her idle. Lena's hands were always busy—plucking geese, cooking soup, cleaning fish, or tanning squirrel skins. She'd finish whatever task she had started, and we'd take our seats around her kitchen table. Between the sounds of passing snowmobiles and trucks, the telephone ringing, the dogs howling outside, and people coming and going, we'd listen to Lena talk about her life.

We had a small tape recorder, and both Sophie and I took notes when Lena used English. More often she spoke in Inupiaq, her first language. While Sophie's pen raced across the paper, I wished that I could understand more than just a few words.

After Sophie translated and transcribed the tapes, we began trying to write about Lena's life and work. Her stories seemed to fall into a pattern of seasons. When she talked about the first contact with white traders, her family was camped at Sisaulik in springtime. The Kotzebue trade fairs were held in the summer, fall was the time for Eskimo dancing, and winter was the time for sewing.

This project acknowledges the work of a respected Inupiat artist Lena Sours, but that respect and acknowledgement is also shared with many other talented sewers and artists who may never be part of a museum exhibit. They still take the time to stitch bits of fur together, matching texture, shading, fur length, and shape until a beautiful and functional garment is completed.

Fancy parkas are just one example of the adaptability and creativeness of the Inupiat people, but every finished garment is a small tribute to the way of living that has led Lena Sours and others to create their works of art.

SDM

LENA SOURS
Suuyuk

by

Sharon D. Moore and Sophie M. Johnson

Suuyuk was born more than a century ago, be-fore airplanes and electric lights and telephones were introduced in northwest Alaska. She grew up dur-ing the time that her Inupiaq relatives met the first whalers, missionaries, and miners, before outboard mo-tors and television and wooden frame houses. While Suuyuk was yet a young girl, the missionaries began establishing schools and teaching the English language to Natives across the Territory of Alaska. By the time her oldest children were teenagers, they had attended a two-room schoolhouse through the sixth grade. If they wanted to acquire a high school education, they had to travel by airplane to White Mountain or Mt. Edge-cumbe. At least one of Suuyuk's grandchildren attended the Friends Church High School in the late 1950s and early 1960s. Now Lena's grandchildren ride to school on motorbikes or snowmachines, and they can complete their high school education without leaving their fami-lies. Her great-grandchildren and great-great-grandchildren watch television programs seen by children in Atlanta, Chicago, and other cities halfway round the world.

How can we begin to describe the changes that Suuyuk—Lena Bangham Trueblood Sours—has wit-nessed? If one year's events, insights, and accomplish-ments could be condensed into a single page, this entire manuscript would represent only *half* of Lena's life. People outside of northwest Alaska know of Lena Sours because she makes beautiful fancy parkas[1] for women and men. To residents of this region, she is more than a talented seamstress: Suuyuk is respected for her knowl-edge of traditional Inupiaq culture, her strength of char-acter, and faith in God. As an Elder, Suuyuk willingly shares her wisdom with others and is a living example of the adaptability and strength of the Inupiaq people. In

the following pages we will try to explain a little about Lena Sours, her lifestyle and accomplishments, her val-ues and beliefs—to present a glimpse of the artist behind the work.

Kotzebue, 1983

Lena's home is Kotzebue, a coastal community of about 2,500 residents, located on the northern tip of the Baldwin Peninsula, twenty-six miles above the Arctic Circle. Eighty-five percent of Kotzebue's residents are Inupiaq (real people). Kotzebue is surrounded by water on three sides, with Kobuk Lake (also called Hotham Inlet) to the east and Kotzebue Sound to the south and west. Across the inlet towards Sisaulik and Napaaqtuq-tuuq the water is shallow. A boatman who is unfamiliar with the channels will probably end up stuck on a sand-bar; barges have to anchor approximately fourteen miles offshore while tugboats haul their cargo to town.

The Kobuk and Selawik Rivers run into Kobuk and Selawik Lakes, and the Inmachuk, Kugruk, Kiwalik, Buckland, and Noatak Rivers all drain into Kotzebue Sound. Subsistence and commercial fishing is an impor-tant summer activity. During July, August, and Septem-ber, people set nets for chum salmon that usually weigh eight to ten pounds. Very few king salmon are caught this far north, but trout (arctic charr) weighing four to ten pounds are caught in large numbers.

More than half of Kotzebue's residents are employed full-time, but most people still rely on traditional food sources including caribou, fish, seal, walrus, and beluga. Traditional Inupiaq parkas, mukluks, and mittens are still the best protection against the cold winter wind.

The highest recorded temperature in Kotzebue was more than eighty-five degrees in July of 1958. The lowest

Figure 2. Planes and motorized boats have replaced most traditional forms of transportation. Kotzebue, 1985.

was minus fifty-eight degrees in March 1930; yet when the windspeed is considered, the chill factor can reach minus sixty to minus seventy degrees. Average annual snowfall is 46.8 inches. Officially, June 21 is the longest day of the year, but the sun does not really set from early June until mid-July. Northern lights (aurora borealis) can be seen as early as August, and during December and January there are barely two hours of light in a day.

Kotzebue has many modern conveniences (cable television, banks, a hospital, recreational centers, taxis, a radio station, two museums, restaurants, electricity, and running water), but winter blizzards remind us that Western technology has not yet discovered how to control the weather. Last January the windblown snow was so thick that the jets could not land for almost a week; mail was backed up, and the stores began to run out of produce and dairy products.

There are no roads connecting Kotzebue to Anchorage, Nome, Fairbanks, or villages in the region, but in mid-October Kotzebue Sound and Kobuk Lake freeze solid, and residents travel by snow machine, dogteam, or three-wheeler to nearby villages and camps. In February or March, the Department of Transportation and Public Facilities grades an ice road to Kiana, a village sixty miles east of Kotzebue; the trip to Kiana takes about four hours by truck. Trails to all the villages are marked, but travelers can get lost when blizzards cover the trail and visibility is limited to one to two feet. An active volunteer organization, the Northwest Arctic Native Association Regional Search and Rescue, works hard to locate lost or stranded travelers, and people are reminded to be prepared for emergencies.

The Northwest Alaska Native Association (NANA) was organized as a non-profit regional association in 1966 and worked to secure title to Native land. In 1971, when the U.S. Congress signed the Alaska Native Claims Settlement Act, a new profit-making corporation was created: NANA Regional Corporation. The Act also created village corporations in each of the region's eleven villages, but ten of these corporations have since merged with NANA to economize on operating costs and maximize investment opportunities. Kikiktagruk Inupiat Corporation, the Kotzebue village corporation, was the largest of the eleven village corporations

Figure 3. Residential housing, Kotzebue, 1985.

Figure 4. Satellite television and three-wheelers are some of the modern conveniences enjoyed by Kotzebue residents, 1985.

and chose to remain independent.

In addition to maintaining local control of resources, providing employment opportunities, and earning money for stockholders, NANA Regional Corporation is also working to ensure the survival of the Inupiaq culture. NANA sponsored the first Regional Elders Conference and recently has initiated the Inupiat Ilitqusiat Program, also known as the Inupiaq Spirit Movement.

Five years ago NANA also contributed to the revival of the summer trading fairs. The Northwest Native Trade Fair has now become an annual event with people traveling from Savoonga, Barrow, Point Hope, Wainwright, Nome, and Shishmaref to compete in Inupiaq contests of skill and strength. Events include leg wrestling, blanket toss, arm pull, goose plucking, seal skinning, harpoon throwing, doughnut making, Eskimo dance, and fashion competitions. People also bring arts and crafts for sale or barter, and on the last day of the Fair there is a traditional Native feast.

This year's (1983) Northwest Native Trade Fair also featured an exhibit of some of the parkas that Lena has made. She received a standing ovation from the appreciative crowd. Suuyuk also entered one of her parkas in

the traditional fur parka contest and she won first prize.[2]

As part of an out-of-court settlement, the State of Alaska has built high schools in rural communities across the state. Since 1975, Kotzebue children have attended a locally controlled school system. All the members of the locally elected Northwest Arctic School District Regional School Board are Inupiaq. The District's Bilingual Materials Development Center is creating new textbooks, lesson plans, and training Inupiaq teachers so that students can continue to take courses in Inupiaq language and culture. Since the Inupiat Ilitqusiat Program was initiated, they have also been participating in Inupiaq Days when Elders come into the classroom and teach traditional values, customs, and skills.

Rachel Craig explains how long Kotzebue has existed as an Inupiaq community: "Kotzebue is one of the very ancient settlements. It's not a new settlement like some of our villages are. It's an ancient, ancient settlement. Like one of the Elders said, his grandfather told him 'I don't know how old Kotzebue is, but ever since there were people, there was Kotzebue.' They don't know how old it is. She [Lena Sours] comes from a long line of Kotzebue people" (Craig 1983a). Since *naluagmiut* (white people) came to northwest Alaska, Suuyuk has had to adapt to many changes but she has retained her sense of identity as an Inupiaq, a real person. Like Lena, Kotzebue in the 1980s is adapting to the change imposed by Western contact while trying to maintain its identity as an Inupiaq community.

Early Years (1880s—1900)

Suuyuk (Lena Trueblood) was born late in the fall at Nauyauraq, a seasonal camp on the Noatak River about halfway between the current Noatak and Kotzebue village sites. Although they are known as a Kotzebue family, the Truebloods actually stayed in Qikiqtagruq (later named Kotzebue for the German explorer) only during the summers. Like most Inupiaq families, they moved seasonally, following the game and gathering food for use during the long Arctic winter. A healthy family needed forty to fifty sealskin pokes filled with meat, *uqsruq* (seal oil), berries, and greens in addition to dried meat or fish that was not stored in the sealskin pokes. During the springtime the men hunted for *sisuaq* (beluga or white whale) and *ugruk* (bearded seal) at Sisaulik, a gravel spit about ten miles from Kotzebue.

Spring

Lena's family was camped at Sisaulik when she first saw white people. Four sailboats came up and anchored, and there were lots of naluagmiut (white people) on board. The boats had two sails or masts, but they were not very big. The Inupiat were frightened of the men

because they were smelly. Nobody had ever smelled people like that before. The naluagmiut also had lots of whiskey on board (the whiskey was not stored in small bottles like today, but in kegs about 1½ feet high and 1 foot in diameter). Lena's father traded two dogs—one male and one female for a keg of whiskey. Everyone started drinking, both men and women. Lena says that the young kids were "plenty scared because they had never seen anyone drinking before" (Sours 1983b). Mary, Ethel, Lena, and the other young kids were scared to go home. They built a shelter out of grass, behind the willows a short distance from the main camp, and stayed there for several days.

Qavgin was an *umialik* (wealthy man) from Siilivik (Selawik); his nephew served as his assistant. After they had stayed at Sisaulik for a few days, the naluagmiut killed Qavgin's young helper with a gun. Lena did not understand why; maybe they got tired of his going back and forth while Qavgin was trading furs and food. After they had killed him, the naluagmiut became very frightened and did not want to stay at Sisaulik. Perhaps they were afraid that the Inupiat would want to avenge the young man's death. The Eskimo people did not want to stay around after the murder (because corpses were taboo at that time [Craig 1983b]), so they also left a few days later.

These were the first white men that Lena saw. Next came the missionaries, and after they arrived, swarms of naluagmiut, mostly miners with gold fever, started coming to northwest Alaska.

Suuyuk's father, Ayyaiyaq (William), was an excellent carpenter, fisherman, and hunter. Every spring he built a new *umiaq* (skin-covered wooden frame boat) at Sealing Point or Sisaulik. Then the family traveled to Kotzebue in two boats. Ayyaiyaq would sell or trade the boat for beaver, fox, and wolverine fur from the Kobuk River people.

At that time Ayyaiyaq's two unmarried nephews were staying with the Truebloods. The young men helped the family by hunting ugruk (bearded seal). They needed eight to ten ugruk skins to cover one umiaq. The women bleached the ugruk hides and scraped off the hair. After Ayyaiyaq built the frame, Lena would help the older women sew the ugruk hides together with waterproof stitches, using twisted sinew for thread. The skins were moistened and stretched tight across the frame; when the hides dried, they made a sturdy boat cover.

Summer

After leaving spring camp, the Trueblood family traveled across the inlet to Kotzebue by umiaq. At that time the people were staying on the beach about one mile south of the present townsite. People from all over came to Kotzebue during the summertime to fish and to trade.

They traveled by umiaq from Tikigaq (Point Hope), Noatak, Siilivik (Selawik), Buckland, Deering, Shishmaref, Wales, Diomede, and even mainland Siberia. Each group of people brought food or materials that were abundant in their area and traded these items for something that was scarce or unavailable at home.

Siilivingmiut (people from Selawik) brought fresh and dried whitefish and pike; people from Tikigaq (Point Hope) brought uqsruq (seal oil), *mikigaq* (fermented whale meat), and *maktak* (whale skin and blubber, spelled "muktuk" in English). People from Noatak brought caribou and reindeer meat and hides. Everyone coveted parkas made of spotted reindeer skin, and the people from Diomede brought many of these. Buckland people brought dried smelts and sisauq (beluga), and were very well known for the clay pots they traded (Craig 1983b). Even Kobuk people came down and stayed at Kotzebue for more than a month, bringing wolverine, wolf, and reindeer hides to trade for uqsruq (seal oil), umiat (skin boats), seal skins, and rope. They also traded birchbark baskets, cooking pots, and wooden spoons because they lived near forests and had access to wood (Craig 1983b).

Lena said the Siberians brought lots of tobacco, an addictive plant that did not grow here. Because of its rarity, tobacco was very costly and one bundle cost as much as five fox skins. Elwood Hunnicutt, a "Kotzebue man for generations and generations" and also Suuyuk's nephew, explained how the Siberians packed the tobacco: they made a bag out of two reindeer skins and used a piece of walrus hide for the bottom. Walrus intestine was used to line the inside of the bag, just like a plastic liner. Wild tobacco leaves about eighteen inches long were tied into bundles about three to four inches around. The Siberians filled the reindeer hide bag up to the neck until it was so heavy that one man could not handle it. Two men had to work together to carry the bag. During Elwood's lifetime, he can recall two summers when about fourteen Siberians came to Kotzebue to trade tobacco. They traveled in two boats, carrying one bag of tobacco in each boat (Hunnicutt, 1983).

These annual trade fairs attracted lots of people from the outlying areas, and they were festive occasions. The people treated each other with respect and hospitality, even making sure that the guests' dogs were fed (Sours 1983a). People also participated in competitive athletic events like foot races, and Inupiaq games that are still part of the World Eskimo-Indian Olympics and Northwest Trade Fair today. People would trade at Qikiqtagruq in the summertime, and when fall came they returned to their homes.

Fall

Lena's family returned to Napaaqtuqtuup during the falltime. There were usually about ten other families,

mostly people from Point Hope, staying at Napaaqtuq-tuuq at the same time. This was the time for Eskimo dancing. People gathered in the *qargi* (central meeting house or community house) for a feast or celebration. Qargich were of different sizes, depending on the population and wealth of the people (Craig 1983b). Usually qargich were rectangular buildings, but the qargi at Napaaqtuqtuuq was circular. There was a bench or platform about two feet high around the perimeter so that people could have two rows of seating (Hunnicutt 1983). An *uqsrupiaq naniq* (seal oil lamp) provided both light and heat, and the orphans who stayed in the qargi kept the central fire going so everyone stayed warm. The qargi also served as a school house for the boys; the women and girls brought them food to eat (Craig 1983b).

Lena remembers one year they sent for more Point Hope people to join the Eskimo dancing. Robert Samms, the first missionary in northwest Alaska, heard that many people were gathering to dance and decided to visit Napaaqtuqtuuq. He and his wife Carrie went to invite people to join the Friends' Church. They stayed there in the qargi for several days while a feast was being held. This was two or three years after they first came to Kotzebue (they arrived in 1897, so the feast was held in 1899 or 1900).

During the feast, people ate delicacies such as *akutuq* (Eskimo ice cream made of berries and whipped animal fat), *quagaq* (sour dock), *paniqtaq* (dried caribou, reindeer or moose meat), *paniqtuq* (dried fish), *uqsruq* (seal oil), boiled seal meat, *quaq* (frozen meat or fish), and many other foods. They were served water from wooden buckets (at that time nobody had tin buckets).

There were still *angatkut* (shamans) then, and Lena said they healed people by using "devil practice." The Inupiat used to obey the shamans long ago, because the angatkuq could kill them if they got out of line. At this particular feast, there was a shaman named Kuuyuk. Before anyone was allowed to eat, Nasuk Lincoln told Kuuyuk they should feed the *tuungaq*, or devil (long ago this was the shaman's helping spirit). Kuuyuk started throwing food from the plate, and when the food touched the ground it disappeared. Lena said that the young people were terrified, especially the missionaries. After that everyone ate, and the people began Eskimo dancing after the feast, as was their custom.

Robert Samms was learning the Inupiaq language, and he understood what was happening when Kuuyuk practiced shamanism. Samms did not want to stay in the qargi after that, so he asked Lena's father if they could stay in their house. Samms left for Kotzebue the next day and began preaching against Eskimo dancing as soon as he got back. Although they had not discouraged Eskimo dancing, and some people say the Samms even learned how to dance when they first arrived

(Craig 1983b), the Friends Church missionaries have banned Eskimo dancing since that time when the Samms witnessed shamanism at Napaaqtuqtuuq. They did not distinguish between Eskimo dancing for social purposes, and ceremonial dancing for shamanistic purposes (Craig 1983b).

Winter

Lena and her family moved to Nauyauraq and stayed there all winter long because wood was easily available. Small game, including rabbits and ptarmigan, were also plentiful at Nauyauraq, and the fresh meat added variety to their diet of dried, frozen, and preserved meat (Craig 1983b).

Long ago not everyone had enough warm clothes, so only the men with warmest clothes went hunting far from home. The others stayed home and gathered wood from nearby to heat the houses. The houses were designed to stay warm. There was an open fire pit in the center of the house, with a removable window directly overhead so that smoke could escape. Some larger houses even had a separate cook house (Craig 1983b). An *uqsrupiaq naniq* (seal oil lamp) could also be used to provide heat. The lamps were only about fifteen inches long, but the Inupiat knew how to keep the uqsrupiaq naniq flame going to provide heat and light without causing smoky fumes (Hunnicutt 1983).

Long ago the women used wooden buckets for cooking. They did not hang the bucket or pot over the open fire; instead they heated rocks in the fire and then put the hot rocks inside a bucket filled with water and meat or fish. The hot rocks caused the water to boil and the food would cook. Wooden buckets or pots were made from a branchless tree. After chopping it down, the Inupiat split the tree very carefully and soaked the wood in water. When the wood had softened, they bent it to the desired shape and secured another piece of wood onto the bottom. The wood pots or water buckets were very water tight, and the groove on the bottom and the thinly carved wood siding from the tree were made to fit tightly together. Even the seams were water tight (Craig 1983b).

People used *qiku utqusriich* (clay pots), too, long ago. When the qiku is exposed it gets hard like rock and will not crack or break, even if it is on or over a fire. They were handled very carefully. Lena has never seen anyone cook with a qiku pot, but pieces of the clay pots can be found in old campsites and even near Lena's homestead. She said right across from her homestead, kuugaatchiami (rivulet linking a lake to a river), there is qiku. The clay was mixed with ptarmigan or duck feathers, probably so it would hold together better. Once when she and Jennie (Eugene's wife) were putting away *tagiitchiaq* (pickled salmon) under the ground, they found and broke and old qiku pot when it was hit by

her spade. Lena had thought about making a qiku pot while staying in her homestead, but she never got around to it. She said qiku pots would be valuable now.

The Russians later introduced copper pots. Lena remembers Lester Gallahorn's mother bought one when the Russians first came up. Not many people bought copper pots then. Ugruk (bearded seal) and *natchiq* (hair seal) were cooked in those pots.

The *tuqsruq* (hallway or entry tunnel) in an Inupiaq *tupiq* (sod house) did not have a level floor. There was a dip so that cold air was trapped and settled to the bottom without entering the house. The tuqsruq was long and sloped down to the *katak* (drop-off or cold trap). Suuyuk lived in houses that were built this way when she was young. She is not sure if the same style of house was used by the Kobuk River people because winters are colder here, close to salt water. Those *tupqich* (sod houses) were so warm that melted snow would drip from the ceiling and people took off their parkas or upper clothing while they were inside.

This is how the people lived long ago. They had to work hard because there were no stores to provide their food. If the men could not find *ugruich* (bearded seals), *tuttut* (caribou) or *sisurrat* (beluga whales), people went hungry. Women had to know how to prepare and preserve the meat, oil, and hides of the animals and to sew warm clothes for their families (Craig 1983b). Even young children were not lazy and were responsible for doing chores.

Marriage and Reindeer Herding (1907—1917)

Lena did not get married early. Her father Ayyaiyaq (William) did not like men courting her. If a man wanted to get married in those days, he had to ask permission from the woman's father. If the father said no, the man could not chase after that woman. Long ago, even before the missionaries came, the Inupiat obeyed their parents.

Before a young man got married, he had two *putuk* (holes) put in his lower lip. They put sticks or labrets through the holes. When a young girl was ready for marriage they sewed (tattooed) several vertical lines just under the skin of her chin. The Inupiat from this area did not tattoo women on their cheeks, but Lena recalls seeing Diomede people with tattoos all over their faces. Sometimes the young girls also put tattoos or designs on their wrists, but these were only for decoration and did not have any special meaning.

Burton Sours was originally from Shishmaref, but his parents moved to Kotzebue. Lena was not trying to chase him, but Burton wanted to marry her and so he talked to Lena's father. Ayyaiyaq (William) approved of him, and Burton and Lena were allowed to marry. They were married at the Friends Mission in Kotzebue on February 9, 1907 (Alaska Yearly Meeting of the Friends n.d.). In December when the ice was thick, Burton and Lena left for Siilivik (Selawik) to herd reindeer. Lena remembers "since Mr. Sours and I got married, that man [Burton] was busy. Since I got married I was sewing" (Sours 1983c).

Although they stayed fairly close to Selawik, Lena and Burton were out of town a lot watching the reindeer. Burton had accepted a ten-year contract with the government to watch the reindeer in exchange

Window

Tuqsruq

Figure 5. A typical sod house with a *tuqsruq* (entry tunnel) and a window at the top to let light in and smoke out.

Figure 6. Reindeer boys in reindeer skin parkas during a reindeer fair at Shismaref early in the twentieth century. Lena Sours' husband was a reindeer herder in Selawik from 1907-1917. Lena sewed parkas and mukluks for the herders.

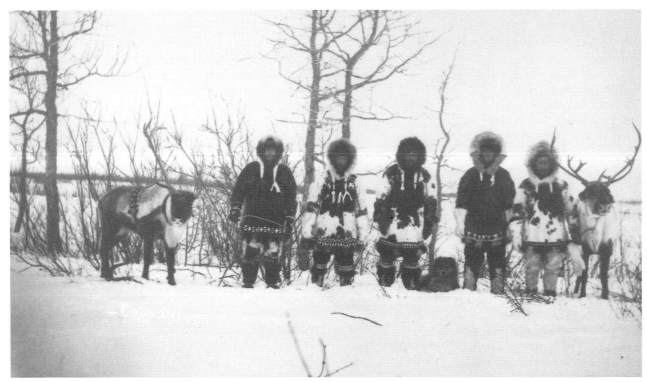

for food and a little money. There were several other "reindeer boys" working with him: Alfred and Jimmy Nilima, Harry Morena, and Richard Jones. Lena was the only young woman among those young men. The men had no boots or tennis shoes—only mukluks. The government paid Lena a little extra to make mukluks for the reindeer boys.

Burton had worked as a reindeer herder for several years before they moved to Selawik. Lila Gregg's father, Alfred Nilima, taught the herders how to take care of the reindeer. Alfred was a Laplander, and Lena says he was a very good chief herder who "knew his business." While he was in charge, the reindeer population grew quickly.

Lena and Burton were happy all the time; they had no worries because there was no drinking and very little smoking. Although neither Burton nor Lena was from Siilivik (Selawik), they became leaders among the new Friends Church members. Burton was considered a leader of the men's meeting group, and Lena and Lulu Young were "leaders of the women's work" (Roberts 1978).

While they were staying in Siilivik, Lena began making parkas. Although her mother had shown Lena how to make mittens, mukluks, and other small items, and how to tan leggings and twist sinew, she had not learned how to make parkas. There were plenty of good reindeer hides available, so Lena tried to make a parka for her

husband. She recalled watching her mother and sister while she was a young girl, and she tried to copy what they had done from memory. Jenny Sheldon showed Lena what she had done right or wrong, and then Lena tried to fix the mistakes. (Jenny was married to Iqik, Siilivik Jim Sheldon, who was Lena's mother's half-brother.) From then on Lena sewed all the time.

Lena's first cousin encouraged her to make parkas for all the reindeer herders. Although she was hesitant, Lena eventually made lots of parkas for the reindeer boys. When the boys married, she also showed their wives how to use reindeer hides to make mukluks and parkas. If she had not moved to Siilivik, Lena says she might not have learned to sew so well. Since she was the only woman among the reindeer herders for two years, she quickly became expert at sewing parkas and other garments.

Although Lena and Burton sometimes got homesick for their families in Kotzebue, they wanted to live up to their ten-year contract. Lena has many good memories of the years she spent in Siilivik. She visited with the wives of the other reindeer herders while they were working, and they often shared their meals outside. Lena got to know the Siilivik people very well, and she still recognizes the grandchildren of some of her old friends.

By the time Lena and Burton returned to Kotzebue there were many more naluagmiut living in town. Some

were storekeepers, teachers, or miners—and there were even new missionaries. The Catholic Church had come to Kotzebue, and unlike the Friends Church, they did not forbid Eskimo dancing. Many Inupiat who were unwilling to give up Eskimo dancing joined the Catholic Church.

Clothing

"Long ago when I was a young girl people have not much clothing—not like us today. They use pants—caribou skin. Woman always have inside fur—call them *aliqsit* (caribou skin pants). Man have pants, some inside hair...when they hunting—outside hair. Call them *nalikaak*" (Sours 1983e). The aliqsit were inside out so that the fur was next to a person's skin. Men wore knee-length fur pants called nalikaak. When they were out hunting they wore the fur on the outside; when men were inside the house they wore nalikaak with fur on the inside. Men also used *attulaaq* (slippers) on their feet inside the house. Wintertime the men used *isiqtuuq* (knee-length mukluks) with hard (ugruk skin) or soft (caribou skin) bottoms.

Women did not wear dresses then, just parkas and caribou pants. Men had pants made from sealskin, squirrel skin, or almost any kind of skin. Our forefathers even wore clothing made from the more durable bird skins—*tatirgaq* (sandhill crane), *kanguq* (snow goose), *malgi* (common loon), *aahaaliq* (old squaw duck), *nauyaq* (seagull), and even *qugruk* (swan) skins. They tanned them in the fall and put them away for winter use, for mittens or anything.

When men and women went in the house they would take off their parkas and just wear pants or mukluks. Women also had capes that they wore when they were working or cooking outside. The capes were made of aahaaliq (old squaw duck), loon, pintail ducks, or nauyaq (seagull) skins.

Before the missionaries came, the Inupiat used everything from the animals they killed. In addition to being used for clothing, the skins were used for blankets and sleeping bags. They would let the hair fall off of natchiq (seal) skin and use the leather for rope, mukluk ties, and fish nets. Strips of seal rawhide were also used for boat lines, towlines for dogsleds, rope, and dog harnesses. Nothing went to waste.

When a man and wife were married they saved all their old clothes—worn out bottoms from mukluks or softened caribou skin, the ones with the fur or hair worn off. They used these for *makkaich* (diapers) for their children. In the fall they gathered sacks of *ivrut* (green moss) from the *nunavik* (undulating tundra), not from the *natignaq* (flat tundra). If they could not get ivrut they twisted grass until it was softened and used this as a liner for caribou skin diapers. It was said children did not grow fast long ago because the diapers were

attached like suspenders, both in front and in back. They were so tight that they restricted movement. As soon as the child did not need diapers, he started growing really fast.

Wolverine was not easily available, and wolf was even more scarce. There were very few caribou around Kotzebue, so wolves were not seen very often. Kobuk River people often brought these furs to trade for uqsruq (seal oil), seal skins, and rope during the summer trade fairs. Noatak people raised baby wolves so that they could sell their pelts to Kotzebue people. One man named Kuuyuk was particularly good at raising the wolves. He would massage their necks to encourage the fur to grow and to keep them tame. The wolves he raised never died. In the middle of winter, when *aagruuk* (two bright stars) appeared, they would kill the wolves. The fur was thickest then.

Wolf pelts were cut into ruffs, and the tails were used for *pamiiksaaq* (belts) that the hunters would use when the weather was especially cold. The men would put the tail around their faces as a windbreak and protection from the cold. Women used short wolverine tails for belts. Many people could not afford to trade for wolverine or wolf pelts, so they used parkas without *isigvik* (ruffs).

The difference between men's and women's parkas used to be more obvious. Women's hoods had *kavrauraq* (a point on top of the head) and *kipminnaq* (a pouch on the back part of the hood, just above the neck), while men's hoods were rounded. The sewing on women's parkas was more elaborate, so making a woman's parka required more time.

The *manuusiniq*, or white fur along the shoulders and chest of both men's and women's parkas, looked like walrus tusks. A woman's parka had a curved hemline with the bottom reaching past her knees. The sides were cut up almost to her hip, and the wolverine trimmings on her hip-length mukluks showed through the parka opening on the sides. Women never sat on the back flaps of their parkas to preserve the fur (Craig 1983b), and because the seams would get too loose. Instead they would lift up the flap as they sat down. Men's parkas were shorter, reaching to mid-thigh, and had a straight hemline.

When the family could afford it, the ruffs on women's parkas were made of wolverine. A young woman from a wealthy family would also have a "sunshine ruff," made of wolf fur pieced together and lined with wolverine so that it made a uniform circle (like the sun) around her face. Usually only men used plain wolf ruffs. Now you can hardly tell the difference between men's and women's parkas because the hemlines are all straight and people use any kind of fur for a ruff. Men no longer wear manuusiniq, and the hoods of some women's fur parkas no longer have kipminnaq (pouch on the back of the

hood) or kavrauraq (point on top). Most calicos (cloth parkas made from calico or flowered cotton fabric) still have the kavrauraq and kipminnaq.

Sewing

Lena was about nineteen when she began making parkas. She started sewing fancy parkas right away, and she soon earned a reputation as an excellent skin sewer (Craig 1983b). Elwood Hunnicutt said that although most Inupiaq women were good with a needle, three women were known for making the prettiest parkas: his mother, Irene Hunnicutt, his aunt Ethel Washington (Lena's half-sister), and Lena Sours. For years and years they were the best of all the skin sewers from Kobuk,

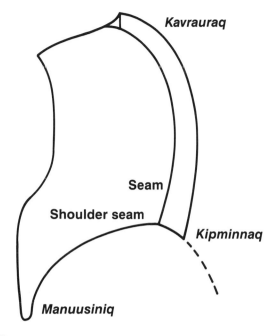

Figure 7. A woman's parka hood showing the *kavrauraq* (point on top) and *kipminnaq* (pouch).

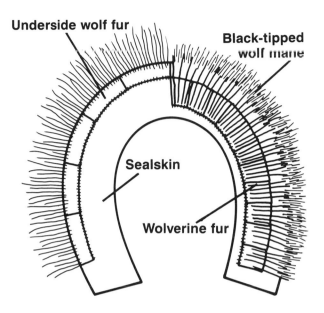

Figure 9. The practical and attractive sunshine ruff is created by sewing together bands of wolverine fur, sealskin, and different colored wolf fur.

Figure 8. Shoulder portion of a parka showing the *manuusiniq* (white fur inlay).

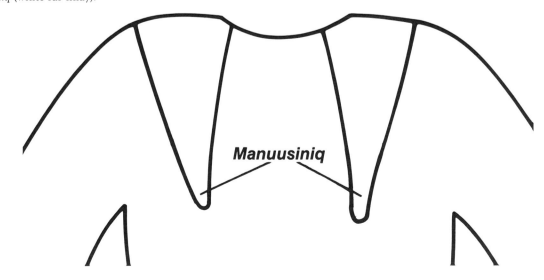

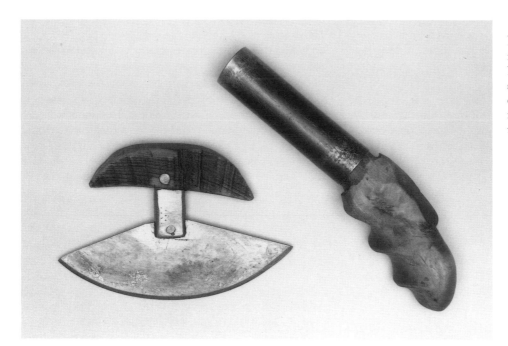

Noatak, Kivalina, Deering, Buckland, and Kotzebue (Hunnicutt 1983). Irene Hunnicutt made a fancy parka for Lena (her niece) shortly after she returned from Siilivik. Lena used that as a pattern when she was making other parkas. Irene made the very traditional style of fancy parkas with a curved hem. Lena has made some parkas in that style, but usually she uses a straight hemline.

Even while she was still a young woman, Lena was an excellent seamstress. The parkas she made were not just beautiful; they fit well and were made to last a long time (Craig 1983a). Lena can not remember how many everyday parkas she has made in her lifetime. Every year she made new inside and outside parkas for just about everybody in the family. They were not fancy, just plain ones for warmth and everyday use.

A fancy parka includes many different kinds of furs, and Lena says that is the hardest kind of garment to make. Everything else is easy compared to a fancy parka (plates 9, 10). Rachel Craig explains some of the differences between everyday and fancy parkas: "Usually if it's dark skin they have white for this part here [over the shoulders and down both sides of the chest, shaped like a triangle], and it looks sort of like walrus tusks right down the front here [*manuusiniq*]. That shapes the head part and makes the size of the head to fit the shoulders and the body, and so when you're turning around the seams don't rip. It's not tight and it fits beautifully. And the same way with the armholes and everything. They're cut in such a way and sewn that it gives you freedom of movement. Those are the plain ones, the functional ones.

"The straight ones are usually what they call the men's style because the women's styles were the curved bottom, what they call the *ipnalik*, like a mountain they say, the literal translation. That was the female style. And usually the women wore long mukluks with them in the wintertime....They were designed for beauty as well as for warmth and function. They didn't just slap some pieces of skin together. They designed them in such a way that they fit the body well without inhibiting your movement. And at the same time the cut was such a way that there was beauty in it. The finished garment was beautiful. It was warm, it was beautiful, and it fit well....Those were the every day clothing.

"Now the fancy ones, where they have the trimmings right on the shoulders and right down the front and right down the back—those were for dress-up times. They didn't wear those every day. Those were worn for special occasions, like when they have certain ceremonies or certain gatherings and when they traveled, too, to keep warm. But they were not an everyday garment. In the olden days the folks said not everybody had beautiful clothing; it was just people who could afford it. Because life in those days was not like today.

"The tassels are usually wolverine, out of the belly part of the wolverine. They always had little bits of red that you sewed on white skins for trimmings on the hood. That's what they call *qaugrisik*, when they say the little red pieces. In those days it usually was little pieces of leather that had been dyed with alder bark. She [Lena] said they had a thumb guard made out of ivory and they would sew these qaugrisik in and then they would cut those little pieces on their thumb guard with an *ulu* [fig. 10]. It was really fine work, and they had to really be careful because it was cut very small and it had to be sewn just right to give it uniformity, and not sloppiness.

"They did the same kind of work on the men's fancy

mukluks, their fancy go-to-meeting mukluks, their dancing mukluks [atukulautchiaq]. And they did them on the shoulder trimmings and the hood [of the parkas]" (Craig 1983a).

One of the main differences between fancy and everyday parkas was the *qupak* (trimmings)(fig. 11). Long ago they did not have fancy trimmings on the everyday parkas; instead they used a little bit of reindeer or trout skin that had been dyed red with willow or alder bark. The women were too busy to cut and sew trimmings. They also traded with Unalakleet people for a real blackfish skin without scales. When that blackfish skin was not available, Lena used charcoal to dye trout skin black after the scales were removed. Lena has tried commercial dyes, but burnt wood works best. Even if the charcoal-blackened skins get wet or are rubbed against something, the color does not come off or fade away (Craig 1983a).

When Suuyuk is making a parka she starts on the hood, body part, and then the sleeves. After that she works on the qupak. At the fur stores in Anchorage you can see parkas that are machine-sewn with designs stamped (in ink) on leather for trimming. Lena does not make parkas like that. Every stitch is sewn by hand, and any holes in the fur are patched with matching pieces. When Suuyuk makes a qupak she does not applique small pieces on top of another fur; small squares, diamonds, or triangles are cut out and pieced together just like a puzzle to create the design of the trimmings.

The first time Lena made a parka for sale she was paid sixty dollars. Everything was cheap then, so that was a lot of money. People brought her all the furs and materials needed for the parkas, and Lena was paid for designing, cutting, sewing, and fitting them. The last time Suuyuk sold parkas she charged four hundred dollars for a lady's muskrat parka and three hundred dollars for a man's muskrat jacket. That is the highest ever charged. Lena made those parkas for Mr. and Mrs. Savok from Selawik, and their grandchildren modeled the parkas during the 1983 Northwest Native Trade Fair.

Every Fourth of July more than half of the Miss Arctic Circle contestants wear fancy parkas made by Lena

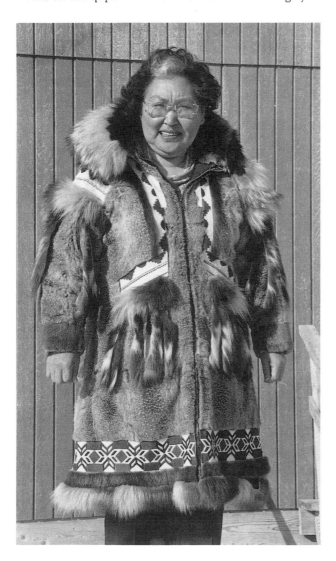

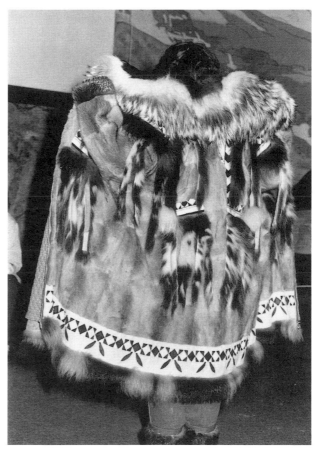

Figure 11 (Left). The *qupak* or pieced calfskin trim which decorates the hem of a fancy parka.
Figure 12 (Right). The pieced calfskin trim on the hem of a fancy parka.

Figure 13. Close-up of the qupak made by Lena Sours using commercial black and white calfskin. Small squares, diamonds or triangles are cut and sewed to create a symmetrical design.

Sours (Craig 1983a; Lowe 1983), and several of the parkas entered in the Northwest Native Trade Fair fashion competition are made by Lena. When Lena tried to remember all the fancy parkas she has made the list totalled more than fifty![3]

The women used *ivalu* (twisted sinew) for sewing. Caribou tendons are best for sinew because they are so long, but they even used sinew from the *sitquq* (knee of flipper joint) of ugruk (bearded seal) or from *sisauk* (beluga). They saved every scrap of ivalu (sinew), fur, or leather. Suuyuk explained why ivalu is still better than commercial thread or dental floss: "When caribou sinew is used on the mukluks, their seams remain a long time. They are made to last....Today they use dental floss as a substitute for their sinew. They aren't long-wearing and sturdy seams. They tend to open. When they get wet they also get out of shape....mukluks that are sewn with sinew are very well made to wear. Last long time. Seams stay intact instead of opening" (Sours n.d.,a).

Lena learned to make parkas using reindeer skins.

They are best in the springtime because the hair is shorter. Men like parkas made of reindeer skin or even dog skin. The hunters especially liked dog skin ruffs because the frost or moisture could easily be shaken off.

The Inupiat also made parkas from walrus or ugruk *ingaluaq* (intestines) for raincoats. That was the only kind of raincoat they had long ago. Although the ingaluaq was easy to tear when dry, it made very warm waterproof parkas. Ugruk ingaluaq could be used, but walrus intestines were stronger. The outer muscle covering of the intestine was removed for food, and the remaining intestinal membrane was scraped with a spoon to remove residue from the intestinal tract. The membrane was then soaked in water to remove any blood (Craig 1983b). After the intestines were cleaned they were blown up like balloons and dried. When they were completely dried, the intestines were clean and opaque and could be cut and pieced together to make a raincoat. Ingaluat were also used to make drums for Eskimo dancing and for windows in the houses.

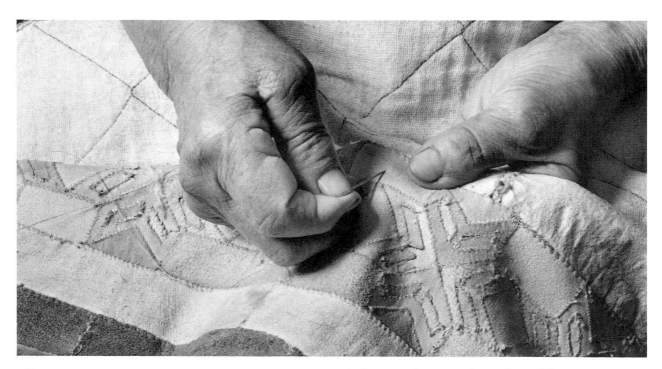

Figure 14. Lena sews on a pieced calfskin border. The piecework design can be seen in the stitching of the seams.

Once Lena Sours made two pairs of atukulautchiaq (dress mukluks) just before Christmas as presents for Fletcher Gregg, Sr. and Elwood Hunnicutt, Sr. After that everyone wanted Lena to make atukulautchiaq for them. She made some for James Norton, Sr., Oliver Henry, Enoch Sherman, Eugene Sours, and Paul Green. She made two pairs for her son, Marian Sours. Atuku-lautchiaq mukluks are very fancy knee-length mukluks with wolverine tassels for trimming (fig. 15).

One of Eugene Sours' classmates at White Mountain later became a school teacher. Emily Ivanoff Brown was the first Eskimo teacher in Kotzebue. She taught school here after all of Lena and Burton's children were out of school. Emily Brown also started a Mothers Club while she was in Kotzebue. The women got together one afternoon a week and sewed, making mukluks, yo-yos, and other items for sale so they could earn money for the Mothers Club. Lena says that Emily "taught them how to start something and build up money" (Sours 1983f). When Emily returned to school, the women kept working by themselves. They even owned a little house that they used for the meetings. Maggie Swanson had the legal papers showing the government had deeded the property to the Mothers Club, but when she became sick and died, nobody could find the papers. After about five years some people used the building as a library, and the Mothers Club could not prove they already owned it. They even started a fund for lawyers' fees, but the women gradually became less interested.

Some time later they started a Womens Club; Lila Gregg and Annie Mills were selected as leaders. They sewed only in the evenings, but when they sold the items they made over six hundred dollars. The women donated five hundred dollars to the Friends Church and to charity; they did not keep it for themselves. Besides mittens, mukluks, yo-yos, and slippers, the women made quilts from old clothing donated by churches in the Lower Forty-eight. Now the women no longer raise money that way. Lena tried to get it started again a few years ago, but she did not want to be the leader and nobody else volunteered.

Lena's daughter, Margaret Russell, explained how Lena lost part of her finger. Sometime during the 1940s, about the same time that she was teaching skin-sewing at school, Lena had a freak accident while cutting meat. She hit a cupboard while holding an ulu (women's knife) in her hand and cut the middle finger of her right hand near the middle joint. The wound became so infected that the doctor wanted to amputate her entire hand. Suuyuk would not hear of this, but the doctor had to amputate her middle finger when the infection got worse (Russell 1983). Dick Curtis, Jr. remembers hearing about Lena's accident. Lena was worried that she might not be able to sew anymore, and she was so upset she even cried. That is how much Suuyuk loved sewing (Curtis 1983).

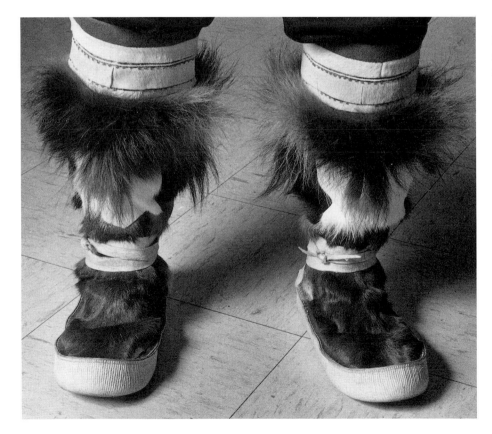

Figure 15. Fletcher Gregg, Sr., models a pair of dress mukluks made by Lena Sours.

Since that time Lena has made many parkas. Suuyuk has always loved sewing and takes pleasure in making things for sale. She encourages young women to learn how to sew, because store-bought clothing is very expensive and a woman can earn good money from sewing. During the summer Lena is still too busy to sew; she preserves ugruk and other game caught by her son Freddie, picks berries, and dries fish. Wintertime is when she is busy "sewing, sewing, sewing." Lena still makes Eskimo dolls for sale. She told students at the Kotzebue Elementary School, "I work on these [pair of Eskimo dolls, male and female] myself, although I can't see good. In fact I cannot recognize you students....Arthritis make me slow. Slow to push the needle....No more make parka. No more make mittens. Except Eskimo doll making and mitten harnesses made of yarn....I'm never idle. That's how we were raised. We had to sew" (Sours n.d.,a).

Family

Suuyuk (Lena Trueblood) was born late in the fall at Nauyauraq, a seasonal camp on the Noatak River about halfway between the current Noatak and Kotzebue village sites. Friends Church records list her birthdate as

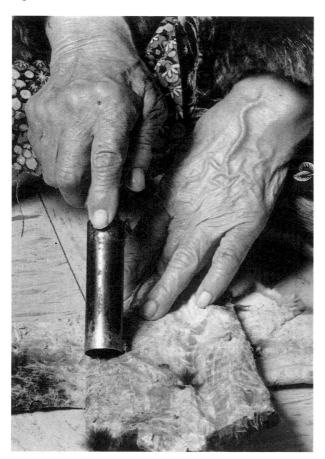

Figure 16. Lena Sours uses a scraper to clean and soften a skin for sewing.

November 2, 1894, and NANA Regional shareholder records show her birthdate as November 25, 1892 (NANA Regional Corporation 1982). On November 28, 1982, family and friends celebrated Suuyuk's 101st birthday; so she could have been born as early as 1881. Suuyuk was about nineteen when she married Burton Sours in 1907, so she might have been born in 1888. There were no agencies present to issue a birth certificate when Lena was born, and whether she is 91 or 101, Suuyuk is one of Kotzebue's oldest and most respected Elders.

Suuyuk was named after one of her ancestors, a woman from Point Hope. In those long-ago days there were continual wars between tribes. One of her forefathers decided to marry a Point Hope woman for political reasons, like European royalty was known to do, to bring peace among people (Craig 1983b).

Lena was next to the youngest of Qallayauq (Clara Arnold Trueblood) and Ayyaiyaq's (William Trueblood) four children (Russell 1983). Her oldest brother was Uvigaq (Benjamin Arnold), and her two sisters were Qimatchuq (Ruth Trueblood Henry) and Aullaqsrauq (Mary Trueblood Curtis). Suuyuk's younger brother was Nauyaq, who died when he was only in his early twenties (Russell 1983). Lena also had a half sister, Ethel Washington, who later became "one of the most renowned doll makers in Alaska history" (The Alaska Geographic Society 1981). Lena's grandparents were known only by their Eskimo names. Her paternal grandmother was Ilguq, and her paternal grandfather was Nauyaq. Clara Arnold Trueblood was the only daughter of Panikpiraq, Lena's maternal grandfather, and Aapangaaq, Lena's maternal grandmother. She had a half brother, Siilvik Jim Sheldon.

William, Lena's father, was the first born and only male in the family. His sisters were Aakuuq, Aalgahn, Ilguk (Jessie Brown's mother) and Suuyuk, for whom Lena was named. Joshua was named after his maternal grandmother, Ilguq (Jessie Brown's mother).

Lena and Burton had twelve children and also adopted one boy and raised him as their own. Lena's cross-cousin, Jessie Brown, died in childbirth. Lena and Burton adopted her baby, Joshua, because Jessie's other sister had tuberculosis, and they did not want to expose him to that disease. The whole family never even considered Joshua as "adopted" and the children were offended if someone told Joshua that he came from another family.

Uvigaq (Benjamin Arnold), Lena's oldest brother, and his wife had no children of their own, so they adopted children. They adopted Dwight, Lena and Burton's son, and raised him as their own (Russell 1983).

Six of Lena and Burton's thirteen children are still living. Aurora (Aiyaaqi), the oldest, died when she was only three years old. Eugene (Sakik), the oldest of Lena's

Figure 17. Lena Sours and her daughter wearing a parka made by Lena.

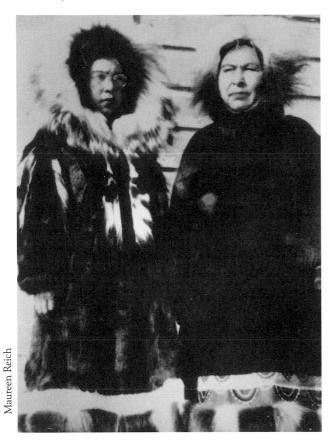

living children, is married to Jennie; Jennie has a daughter, Helen Kagoona, but Eugene and Jennie have no children together. Marian (Kuukpuk), the next oldest son, died leaving his wife Belle and three daughters, one of whom was adopted. There are several grandchildren. Peter (Siiqhak) John Sours was known as P.J.; he died in 1947, while serving in the U.S. Army (Russell 1983). Thomas (Mannaq) and his first wife, Rose, have ten children and many grandchildren. He is now married to Susie, and they also have several children.

Lottie (Aiyaaqi) was named after Aurora, who died at a young age. She was married to John Stein. They had one son who died when he was young. Elizabeth (Uyauyuk) was married twice, but had no children. Her first husband was Frank Davidovics, Sr.; after they were divorced she married Wally Brys in Anchorage. Elizabeth died from pneumonia about ten years ago while she was young. Charlie (Pakik) married Daphne Sheldon, and they have eight children and several grandchildren. Margaret (Sigvautchiag) married Homer Russell, and they have eleven children. Freddie (Sikkuvran) is the youngest, and he lives with Lena.

During the summers, Lena and Burton raised their children at Saugaliq, a beach site south of Kotzebue, just below the present Air Force Site. They spent the sum-

mers fishing for salmon, berry picking, and gathering greens. After staying at the same campsite for more than twenty years, they had to abandon their camp when the U.S. government decided to build the Air Force Site. That was a good fishing and berry picking spot, and Lena did not want to give it up. Burton was a law-abiding person, though, and he would not stand in the way of the government, even though it meant leaving his campsite (Russell 1983).

After that, the Sours moved around every summer looking for a suitable place to build a camp. They had to keep moving because one place did not have any berries, or was a poor fishing spot, or was unsuitable for some other reason. There was no compensation for losing their campsite; the government just came in and built over it. The young men even wrecked the Sours' cold storage cache, drying racks, and radio poles (Russell 1983).

Lena and Burton later got a homestead at Kipmik, on the Noatak River. It is a real big lot up there, and there are lots of blueberries on the hill behind their house. Lena has not been up to her homestead for the last couple of years. Lots of moose move around in that area, and Lena and Jennie Sours (Eugene's wife) shot two moose while they were staying at her camp on the Little Noatak River.

Education

Suuyuk attended school in Kotzebue at the mission school established by the Friends Church. She was received into membership of the Friends Church in November 1902 (Alaska Yearly Meeting of the Friends n.d.), and she probably started school that same year. After the ice froze in the inlet, she came to Kotzebue from Napaaqtuqtuuq. Suuyuk stayed with her aunt while she was attending school. Her aunt took good care of her. In those days the mothers and aunts watched the young girls closely, and they never had *aapailak* (illegitimate children).

The missionary's wife taught school. Suuyuk started school when she was about twelve, and she stayed in school for three to four years. She did not stay in school all winter long; every December she went back across to Napaaqtuqtuuq. Most of the children who went to school with Lena were living in Kotzebue all winter long. Their parents had settled in Kotzebue after the missionaries came. Those schoolmates were good translators and spoke English well, but they have all died now.

Families from the other villages (Point Hope, Deering, Buckland) did not send their children to school in Kotzebue because the distance was too great. There were no planes or snowmachines then, and it was too far to travel by dogteam. There was no high school, but the students learned reading, writing, spelling, and

arithmetic. They used story books in school just like the young children use now. Lena used to read while her eyes were good, but now her eyesight is bad.

The first missionaries sent by the Friends Church had some disagreements about how to bring the Inupiat into the Friends Church. According to Arthur O. Roberts in *Tomorrow is Growing Old*, "Robert and Carrie Samms learned the Eskimo language, [but] Martha Hadley dutifully refrained because she felt that it was the responsibility of the Eskimo in the school to learn English" (Roberts 1978).

After they returned from Selawik, Lena and Burton stayed in Kotzebue so that their children could attend school. Life would have been easier if they had stayed at Napaaqtuqtuuq, or some other place where small game was plentiful, but they wanted their children to get a good education.

Paul Green came to Kotzebue and started teaching Eskimo dancing in school. Lena did not approve of this, partly because the Friends Church had banned Eskimo dancing and partly because she did not think the school should be teaching her kids something they already knew. The Eskimo people already knew how to dance—they sent their kids to school to learn how to read, write, and speak English. Lena and several other mothers went to the principal and told him to stop the Eskimo dancing. The principal gave in and they quit teaching Eskimo dancing in school.[4]

Lena and Burton's children attended territorial schools and also schools that were run by the Bureau of Indian Affairs. The older children attended school through the sixth grade without leaving home, and by the time the younger children were attending school, they could complete the eighth grade in Koztebue. Only recently have students in Kotzebue been able to attend high school at home. Although only three of Lena's children have attended high school, they all read and write well and are fluent in both English and Inupiaq. Lena and Burton sent three of their children to high school at White Mountain and Mt. Edgecumbe: Eugene, Peter, and Margaret (Russell 1983).

Eugene and Peter attended school together, and while they were away at school, they sent many letters explaining how they wanted to return home. Peter was especially homesick. There were not many airplanes then, and airfare was too expensive for Eugene and Peter to come home during Thanksgiving, Christmas, or even for summer vacation. Even though they did not have much money, Lena and Burton paid their airfare. Lena wanted them to stay at school and graduate, but Burton missed his children so much that he could not say no when they wanted to come home. Both Peter and Eugene had completed a couple years of schooling beyond the eighth grade before they came home.

Lottie was younger than Eugene and older than Elizabeth. She attended school through the eighth grade,

Figure 18. Lena Sours and two friends dressed in parkas made by Lena. Lena's parka has a sunshine ruff.

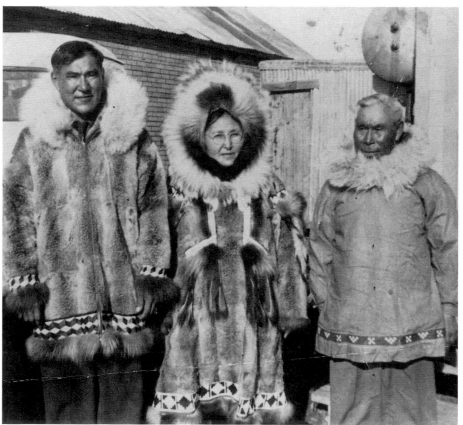

Maureen Reich

and Suuyuk wanted her to continue her education but she did not want to go away to school. Elizabeth went to Anchorage for vocational training and became a beautician (Russell 1983). Suuyuk was willing to send all her children to school, even though it was expensive, but the boys were most interested in hunting. Long ago there were few jobs, and Suuyuk wanted her children to have an education so that they would be able to get good jobs. She said, "We want to learn it—how to live, have more jobs" (Sours 1983f).

Margaret, the youngest daughter, also went away to school. She stayed away from home for four years while she was attending school. Even though she was very homesick, Lena and Burton were not able to afford Margaret's ticket when she wanted to quit school and come home. Margaret is the only high school graduate of Lena and Burton's children. She learned shorthand while she was away at school, and Lena says that people were awed at her ability to write in that way. Margaret started working as soon as she came home and she has not quit working since then.

Margaret Russell is now Executive Vice President for Maniilaq Association, a non-profit regional corporation providing health, human, and social services to villages in the NANA Region. Maniilaq also operates the Kotzebue Senior Citizen Cultural Center and administers the Regional Planning, Coastal Management, Housing Improvement, Agriculture, Employment and Education, Tribal Operations, and Media programs. Maniilaq Association also works with NANA Regional Corporation, the Regional Elders Council, village Elders' Councils, the Northwest Arctic School District, and other local agencies to promote the goals of the Inupiat Ilitqusiat (Inupiaq Spirit) program.

Lena taught sewing at the Kotzebue school for many years during the early 1940s. She taught young (ages twelve to sixteen) girls how to tan skins and how to sew mukluks, parkas, mittens, and other clothing. Her daughter Margaret was one of her students. The girls used reindeer skin while they were learning because it was cheaper than muskrat or squirrel. Lena never scolded them when they made a mistake. She would just smile, let them rip the seams, and try again. They learned well that way, and they are able to make fancy parkas now. Sewing classes were held all afternoon, two days a week, during the whole school year.

Inupiat Ilitqusiat (1980s)

Since the Alaska Native Claims Settlement Act was passed in 1971, Native Regional corporations have been searching for ways to integrate their corporate and cultural responsibilities. In northwest Alaska, the NANA Regional Corporation has relied on the Elders to help ensure the continued survival of the Inupiaq people. With their cooperation, NANA has initiated the region-wide Inupiat Ilitqusiat Program.

Regional Elders and leaders were concerned that "while the corporations might survive [after 1991], the people may not survive as Native People" (NANA Museum of the Arctic 1982). The Elders identified seventeen critical values that contributed to the survival of Inupiat people in the Arctic: knowledge of language, sharing, respect for others, cooperation, respect for Elders, love for children, hard work, knowledge of family tree, avoiding conflict, respect for nature, spirituality, humor, family roles, hunter success, domestic skills, humility, and responsibility to tribe. They also approved the goals and basic principles of the Inupiat Ilitqusiat Program and outlined a plan for individuals and regional agencies to follow.

The goals of the Inupiat Ilitqusiat Program are: to teach the Inupiaq (human) values listed above, develop individual identity and self-esteem, develop incentive

Figure 19. Lena Sours holds a jade plaque presented to her for her leadership in the Inupiat Ilitqusiat Movement. This program, developed by the Elders in the NANA region, promotes traditional Inupiaq values: knowledge of language, sharing, respect for others, cooperation, respect for Elders, love for children, hard work, knowledge of family tree, avoiding conflict, respect for nature, spirituality, humor, family roles, hunter success, domestic skills, humility, and responsibility to tribe.

and motivations, develop use of Inupiaq language, preserve Inupiaq cultural heritage, and to teach traditional job skills. One of the basic principles of the Inupiat Ilitqusiat Program is that *Elders are responsible for cultural survival and transmission of traditional values and skills.*[6]

Lena Trueblood Sours has been a leader in establishing and implementing these goals. She has volunteered many hours explaining traditional Inupiaq culture and values to local school children and administrators. She has encouraged other Elders to participate in Inupiaq Day activities and planning sessions. Suuyuk has also participated in the Regional Elders Conference, has served as a board member of the Kotzebue Ilitqusiat Elders Council, contributed to the planning of the first Inupiaq Days, and has participated in all the Inupiaq Days held in Kotzebue.

The Kotzebue Ilitqusiat Elders Council decided that alcoholism was the first problem they should address. In January 1982, Lena and several other Elders met with Maniilaq's Alcoholism Program staff and commented on how alcholism is affecting our community. Lena said: "I have discovered how disturbing the effects of alcohol are—losing a lot of our young people—separation of families, suicides, accidents, murders" (Sours n.d.,b). She also noted that while the surrounding villages have banned the importation of alcohol, Kotzebue has increasingly become a place where people go to drink.

In the early 1960s Kotzebue residents succeeded in banning the use of alcohol. Suuyuk recalls gathering to pray for people who abused alcohol. Later, when more and more naluagmiut came to Kotzebue, people who wanted a dry town were outvoted. Since then Kotzebue has become a "major source of dispensing liquor" (Sours n.d.,b). Suuyuk is willing to try to circulate another petition to ban alcohol, but she says that other people are not enthusiastic.

Bertha Lowe, Kotzebue Inupiat Ilitqusiat Specialist (Maniilaq Association), said that without Lena's support for the Kotzebue Spirit Movement it would have been hard to implement the programs (Lowe 1983). Suuyuk has made numerous suggestions while planning the Inupiaq Day activities and has taught classes on skin sewing and on traditional taboos.

Rachel Craig, Director of the Inupiaq Materials Development Center (Northwest Arctic School District), has worked with the Elders since 1975 when she was researching historic sites for NANA Regional Corporation. She comments on Lena's contributions to the Elders Conferences: "She's been very supportive and helpful all along the way in all of our Elders Conferences and whenever I need help....Even the Elders look to her in an Elders Conference. Like after all the younger ones have given their input, then they depend on her to fill in the holes because they feel that she knows the culture so well and has lived so long, and her memory is goodThey really look up to her and the things that she says" (Craig 1983a).

The Elders of the NANA Region have been instrumental in retaining, teaching, and living our Inupiaq culture. Suuyuk has been one of many Elders who are teaching the traditional skills which help to promote the survival of our Inupiaq culture and spirit. At 101, Suuyuk embodies the knowledge and training of Inupiaq womanhood. Her knowledge of the Inupiaq culture is extensive, and she is willing to share that wisdom with others. She is a strong spiritual leader in the Friends Church, and Lena is also an artist who has created many beautiful and varied fancy fur parkas. She has encouraged the continuation of Inupiaq skin sewing as an art form. Perhaps Suuyuk's greatest contribution is the lesson that adapting to modern life does not require us to sacrifice our identity as Inupiaq.

Figure 20. Lena visits Effie Ramoth and her daughter-in-law, Belle Sours at the Kotzebue Senior Citizens Center.

Figure 21. Lena Sours received the 1983 Governor's Award for the Arts from Governor Bill Sheffield. Other recipients were Polly Lee, Molly Smith, Bill McKay, Elvira Voth.

Rob Stapleton

ENDNOTES

1. Fancy parkas are dress-up parkas, worn only on special occasions. "Fancy" can also mean the strip of trimming (*qupak*), around the hem of a parka. A local variation of the word parka is "parkie" or "parkee."

2. During the Lena Sours parka exhibit, Maniilaq NUNA editor photographed some of the parkas made by Suuyuk.

3. **Fancy Parkas Made by Lena Sours**
Squirrel Parkas
Cora Cleveland, Ambler
Ella Armstrong, Buckland
Bessie Henry, Kiana
Christina Westlake, Kiana
Helen Wells, Noorvik
Mrs. Aiken, Unalakleet
Daphne Sours, Kotzebue
Jennie Sours, Kotzebue
Margaret Russell, Kotzebue (2)
Carrie Gallahorn, Kotzebue
Myra Walker, Kotzebue
Ruth Harris, Kotzebue
Judith Allen, Kotzebue
Emily Monroe, Kotzebue
Lena Sours, Kotzebue (5)
Dora Johnson, Ambler
Amelia Blastervold, Kiana
Ella Sheldon, Kiana
Stella Adams, Noatak
Grace Graves, Fairbanks

Belle Sours, Kotzebue (3)
Lottie Ferreira, Kotzebue
Dolly Sours, Kotzebue
Rose Sours, Kotzebue
Susie Hunnicutt, Kotzebue
Mabel Henry, Kotzebue
Lottie Sours, Kotzebue
Fannie Mendenhall, Kotzebue
Maureen McCarthy, Kotzebue

Muskrat Parkas
Gertrude Sherman, Noatak
Irene Schene, Noorvik
Annie Savok, Selawik
Daphne Sours, Kotzebue
Carrie Gallahorn, Kotzebue
Vernita Ray, Noorvik
Lucille Kolhuk, Selawik
Johnny Sours, Kotzebue
Margaret Russell, Kotzebue

Muskrat Jackets
Tommy Sheldon, Kiana
Mary Arnold, Noatak
Marian Sours, Kotzebue (2)
Thomas Sours, Kotzebue (2)
Allen Dahl, Kotzebue
Enoch Sherman, Noatak
James Savok, Jr., Selawik
Aurora Krammer, Kotzebue
Aloysius Ferreira, Kotzebue
Burton Sours, Kotzebue (2)

4. Lena Sours, interview, April 26, 1983. Eskimo dancing has recently become more popular, and students at the Kotzebue Elementary School now learn how to Eskimo dance (with parental permission) as part of the physical education program. Lena says that she does not try to stop it now because her children are no longer in school.

5. For twenty years after the passage of the Alaska Native Claims Settlement Act shareholders are not allowed to sell their stock. In 1991 those restrictions on the sale of stock will be lifted. Many Native leaders are worried that large oil companies, mining companies, or foreign investors will buy the stock to gain control of the corporations' land and resources.

6. A copy of the Inupiat Ilitqusiat Goals and Basic Principles has been deposited with "The Artists Behind the Work": Lena Sours Collection in the Oral History Program, Alaska and Polar Regions Collection, Elmer E. Rasmuson Library, University of Alaska, Fairbanks.

BIBLIOGRAPHY

Alaska Geographic Society. 1981. *The Kotzebue Basin.* AK Geog. 8(3): 160.

Alaska Yearly Meeting of the Friends.n.d. Church Records. Kotzebue, Alaska.

Craig, Rachel. August 3, 1983a. Taped interviews with Sharon Moore and Sophie Johnson, 3 August 1983. "The Artists Behind the Work." Oral Histroy Program, Alaska and Polar Regions, Rasmuson Library, University of Alaska, Fairbanks, Alaska.

—. 1983b. Written comments to author, 11 August 1983.

Curtis, Dick, Jr. 1983. Oral Communication to authors, 11 August 1983.

Hunnicutt, Elwood. 1983. Personal interview with the authors. 4 August 1983..

Lowe, Bertha. 1983. Taped interview with the authors. 3 August 1983. "The Artists Behind the Work." Oral History Program, Alaska and Polar Regions, Rasmuson Library, University of Alaska, Fairbanks, Alaska.

NANA Museum of the Arctic. 1982. "Traditional Chief's Retreat." *NANA Museum of the Arctic Newsletter* 1, no. 2 (December).

NANA Regional Corporation. 1982. "Alphabetic Shareholders List." Run date October 30, 1982. Kotzebue, Alaska.

Roberts, Arthur O. 1978. *Tomorrow is Growing Old.* Newburg, Oregon: Barclay Press.

Russell, Margaret. 1983. Written comments to authors reviewing preliminary draft of this biography. 12 August 1983.

Sours, Lena. 1983a. *Suuyuk Remembers Trade Fair Long Ago.* Northwest Native Trade Fair booklet, based on a taped interview translated and transcribed by Bertha Lowe.

—. 1983b. Taped interview with authors. 24 March 1983. "The Artists Behind the Work." Oral History Program, Alaska and Polar Regions. Rasmuson Library, University of Alaska, Fairbanks, Alaska.

—. 1983c. Taped interview with authors. 26 March 1983. ibid.

—. 1983d. Taped interview with authors. 26 April 1983. ibid.

—. 1983e. Taped interview with authors. 30 June 1983. ibid.

—. 1983f. Taped interview with authors. 1 July 1983. ibid.

—. n.d.,a. "The Elder Speaks." Taped interview with Lena Sours, KOTZ Broadcasting with permission from the Kotzebue Ilitqusiat Elders Council. Translated and transcribed by Bertha Lowe.

—. n.d.,b. From transcript of Elders comments to Maniilaq Alcoholism Program staff, quoted by Bertha Lowe in 3 August 1983 interview.

ACKNOWLEDGEMENTS

Earlier this year Bill Schneider from the Elmer Rasmuson Library (Program for Preservation of Oral History and Traditions of the Alaska and Polar Regions) contacted us to see if we would be willing to work on "The Artists Behind the Work" life history series with Lena Sours. Although neither of us are trained in anthropology, oral history, or even photography, and the required length of the final report was pretty scary, we decided to accept the contract. We were looking forward to working with Lena and learning about our Inupiaq heritage from a respected expert.

The project turned out to be even more work than we expected, but we also learned more than we anticipated. Lena was always willing to make time to talk with us and never lost patience when we got events or people confused. Her contributions to the survival of Inupiaq culture will be invaluable for generations to come.

We owe thanks to Rachel Craig for her detailed comments, proofreading our draft, and correcting our Inupiaq spelling and translations. We are also grateful for Margaret Russell's help—finding the errors in our first draft and answering all the last-minute questions while Lena was at camp. Elwood Hunnicutt shared detailed information on the Napaaqtuqtuuq qargi, tobacco trading and Kotzebue history. Like Lena, he had more fascinating stories than we were able to record in such a short time.

Bertha Lowe provided information on Lena's involvement in the Inupiat Ilitqusiat Program; she also helped translate and transcribe some of the audio tapes. We would like to thank Robert Rawls and Dick Curtis, Jr. for taking pictures during the Northwest Native Trade Fair and to Gretchen Jessup for helping to write the section on Kotzebue.

Bill Schneider planned the project, gave us a deadline, provided suggestions and moral support, and convinced us that we could handle all the work. We owe him our thanks for giving us the opportunity to work with Lena Sours for "The Artists Behind the Work" se- -ries.

Most of all we owe our thanks to Suuyuk for spending so much time with us and being so generous with her wisdom. Suuyuk has worked hard to guarantee the survival of the Inupiaq culture; we hope this project will help her reach that goal.

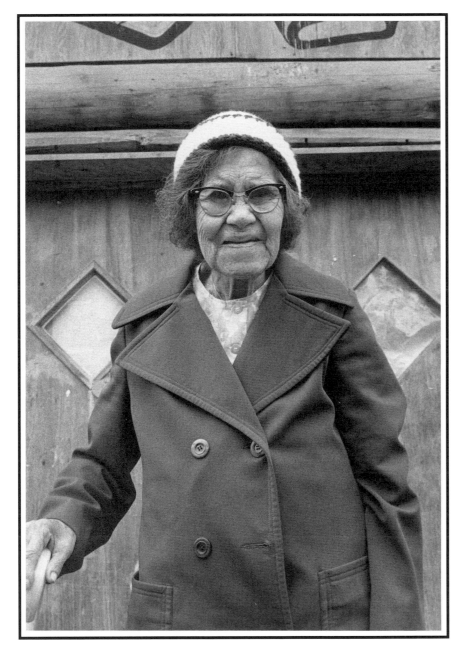

JENNIE THLUNAUT

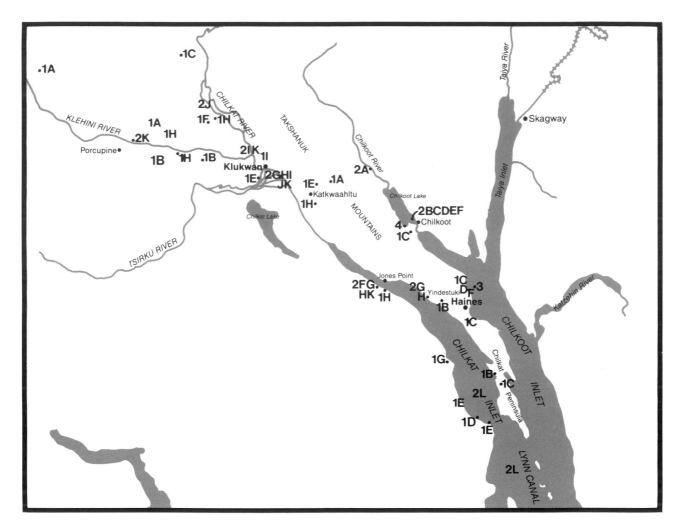

Klukwan
Jennie lives here.

Yindestuki

Katkwaahltu

Chilkoot

Jones Point
Jennie spent the early years of her first marriage here.

Porcupine
The mining camp where Jennie and John James lived in the summers, 1908-1909.

Haines
Jennie lived in the Raven House when she was married to John Mark Thlunaut.

Berry picking places:

1A. Mountain blueberries
1B. Highbush cranberries
1C. Blueberries
1D. Strawberries
1E. Soapberries
1F. Raspberries
1G. Grey currants
1H. Salmonberries
1I. Serviceberries

Fishing areas for the Chilkoot Tlingit.

2A. Sockeye salmon or "goonk," spawned-out salmon
2B. Sockeye salmon

2C. Pink salmon
2D. Dolly Varden trout
2E. Silver salmon
2F. Eulachon ("hooligan")

Fishing areas for the Chilkat Tlingit.

2G. Chum salmon
2H. Silver salmon
2I. Sockeye salmon
2J. Trout
2K. King salmon
2L. King salmon trolling area

3. Areas for gathering seaweed.

4. Areas for picking Hudson Bay tea.

Page 123:
Figure 1. Jennie Thlunaut at age 93, Klukwan, 1985.

MATERIALS MAP

1. **Klukwan**
 Jennie's village.

2. **Mountain goat hunting area**
 Their wool was used in Chilkat blankets and spun with yellow cedar bark acquired from Sitka and Hoonah (both south of this map).

3. **Spruce roots**
 used in basketry were often gathered on Katzaheen Flats.

4. **The best grass**
 for decorating baskets came from Chilkoot.

5. **Skagway**
 Jennie's early baskets and moccasins were sold here to tourists who came on steamships.

6. **Seal hunting areas**
 Seal skins were used in sewing.

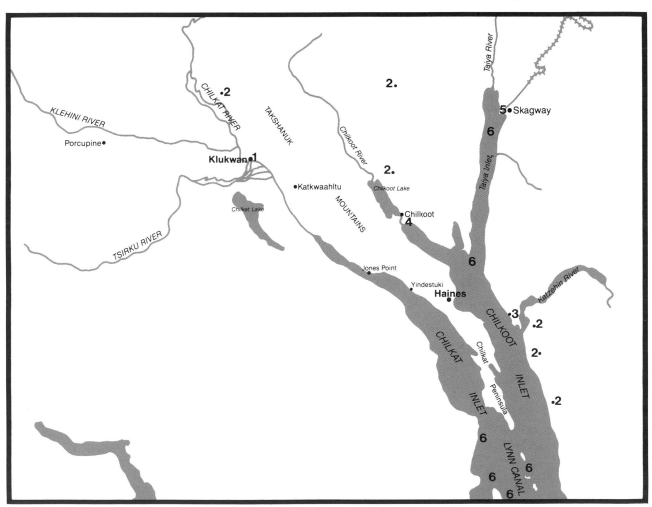

Jennie Thlunaut
1892-1986

Two months before the completion of the exhibition and catalog, Jennie died at the age of 94. We are thankful that many aspects of her early and later years as a Tlingit artist have been described in her biography. She will be remembered as one of the most eminent and celebrated weavers of Tlingit ceremonial robes. Because of her adherence to traditional art forms, designs, and materials in a changing society, Jennie will continue to be a role model for other artists, especially those Tlingit weavers of the Shax ' saani Keek' Guild who were fortunate enough to have watched and learned from her.

INTRODUCTION

My first recollection of my grandmother Jennie Thlunaut goes back to the period when she was living in the Raven House. I recall the happy moments as a little girl picking blueberries and playing on the beach on the beautiful, sunshining days. My grandfather, John Thlunaut, was still alive then. After his death, Jennie left Raven House, according to Tlingit custom, since she was no longer married to a member of the Raven Lukwaax.adi clan. She returned to Klukwan, and it was there that I began to work with her as a colleague. She encouraged me and supported my work in collecting oral traditions and songs, but she could not understand why I was more interested in this rather than in learning how to weave Chilkat blankets and spruce root baskets.

Through the years, Grandma Jennie continued to help me. When I went back East for my graduate studies, she made me a vest with "Alaska" beaded on the back because she wanted people to know I was from Alaska. Later she came back to participate in the "Tlingit Aanee" exhibit which I developed at the Harvard Peabody Museum. When I returned to Alaska, she worked with me and my colleague, Dr. Charles Smythe, on a project on Tlingit property law.

It seemed fitting that I should also be able to collaborate with her on her biography. She was already in her early nineties when we began to discuss her life history. Her hearing had begun to fail and it was necessary for me to speak directly into her ear. She also tired easily, and we found that it was best for her if we worked in short intervals. She seemed to be quite eager to work with us if it proceeded more as an informal discussion.

My familiarity with Jennie was an asset, but it became apparent during our initial work that it was sometimes a disadvantage. Dr. Smythe, who was present during our discussions, began to ask her questions that I had overlooked because I assumed I already knew much about her life. We decided that it would be best if he continued to play a formal role in the work on her life history. She would also occasionally lapse into Tlingit, and Johnny Marks, another relative of both Grandma Jennie's and mine, assisted in the translations.

After we finished writing Grandma Jennie's life history, we sent copies of it to members of her family. John Marks also reviewed and commented on the biography. In the years after we finished the biography, Grandma Jennie would often recount incidents in her life, and I was always so amazed that it seemed to be a verbatim account that she had given to us earlier. It indeed has been a pleasure to us to know that when her life history was read to Grandma Jennie, she smiled and seemed to be satisfied with the work.

R.W.

JENNIE THLUNAUT
Master Chilkat Blanket Artist

by
Rosita Worl and Charles Smythe

Shax'saani K̄eek' (Younger Sister of the Girls) was born during the spring run of the eulachon in 1892. Her birthplace, Laxacht'aak, was within the Jilk̄aat K̄wāan (Chilkat Territory) of the northern Tlingit in Southeast Alaska. Her mother, Kaakwdagāan (Ester) belonged to the Eagle clan Kaagwaantaan and the G̱ooch Hīt (Wolf House) in Angoon and is a Deisheetaan Yadi. Her father, Yaandakinyēil (Matthew Johnson), was a member of the Raven G̱aanax̱teidi clan and the Xīxch'i Hīt Frog House in Klukwan and is a Kaagwaantaan Yadi.

The all too brief years of Shax'saani K̄eek's early childhood were like any other Tlingit child. She played on the beach, picked berries, gathered wild celery, and threw rocks into the river. She accompanied her parents on their cyclical subsistence round. She traveled with her family in the Tlingit war canoes to visit relatives in other communities and to attend potlatches. Shax'saani K̄eek's listened to the great stories of Tlingit history told during the lavish potlatches, stories which told of clan migrations and feasts which were still held in her childhood era.

Shax'saani K̄eek's also received her first box of mountain goat yarn from her mother when she was yet a child. She had no idea that she was destined to become one of the most renowned weavers in the nation of *naaxein*, Tlingit ceremonial robes, known to the world as Chilkat blankets. Neither could she have know that she, Jennie Thlunaut, as she would become known to the art world, would be one of the last traditional Tlingit Chilkat blanket weavers.

The Chilkat Environment

The Chilkat territory—the home of Jennie Thlunaut and the Chilkat blanket weavers—encompasses the northern regions around Lynn Canal and its tributaries. It extends northward through the Chilkat and Chilkoot passes into the Interior.

The Chilkat Tlingit controlled the passes into the Interior where they traded with two Tlingit inland groups—the Atlin and Tagis—and an Athabaskan group, the Southern Tutchone. They were bordered to the south by the Auk Tlingit and to the southeast by the Hoonah Tlingit. The Chilkat Tlingit controlled the trade between the interior and coastal groups until the gold rush period in the late 1800s.

The Chilkat region is surrounded by rugged, mountainous terrain. The mountains rise 2,500 to 5,000 feet above sea level. The topography shows the effects of glacial action, and the glaciers to the north, east, and west are the origins of the rivers in the area. To the north and west lie the St. Elias Mountains, the third largest glaciated area in the world.

The lower elevations are comprised largely of coastal western hemlock and Sitka spruce forests. Above four thousand to five thousand feet, the land becomes alpine tundra, barren ground, and exposed bedrock. This system, composed of barren rocks interspersed with herbaceous and shrubby plants, provides a home for the mountain goat. The goat is used for food, and its hair is one of the primary materials in the Chilkat blankets.

The Chilkat and Chilkoot Rivers and the southward-extending fjord (Lynn Canal) provided the Chilkat Tlingit with a steady and abundant resource base. The beaches and rivers are bordered by black cottonwood and red alder. The vegetation also includes a variety of berries, Sitka alder, devil's club, and fern plants. The coastal area also contains red ribbon seaweed, which is a Tlingit delicacy. The vegetation provides an important dietary supplement. In former times, the vegetation was also important for materials used in the construction of many tools and equipment.

Figure 2. Klukwan, 1895.

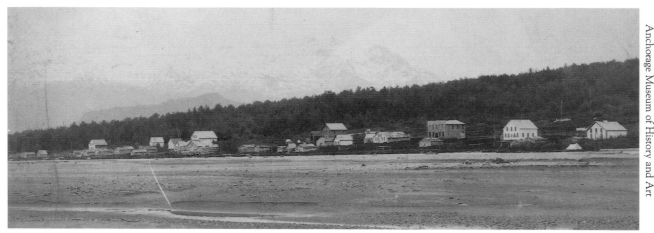

Klukwan is located some twenty miles up the Chilkat River, away from the sea and closer to the larger mountain range. This area has considerably less rainfall than other southeast communities. Average annual precipitation is lower at Klukwan, and a larger proportion is snowfall as compared with Haines, which is located on Lynn Canal near the mouth of the Chilkat River. Winter temperatures average about ten to fifteen degrees cooler, while summer temperatures are comparable to those at Haines.

The Chilkat Tlingit begin their spring resource harvest with fishing for trout in the rivers. Cod, halibut, clams, and mussels are obtained from the shore and Lynn Canal. Klukwan residents can obtain a plentiful supply of Dolly Varden and lesser quantities of rainbow and cutthroat trout from the Chilkat River directly in front of the village. Mammals hunted or trapped in the spring include wolf, fox, mink, land otter, sea otter, muskrat, marten, rabbit, porcupine, and brown bear. Ducks, geese, and grouse are hunted, and different seaweeds are collected later in the spring. The bald eagles and ravens which populate the region in large numbers have significant cultural value to the Tlingit.

The herring and eulachon runs begin in early May and provide an important source of oil as well as meat and the much-prized roe. Naturally-occurring vegetable foods, including celery, potatoes, rhubarb, and clover, are gathered. The women also begin to gather spruce roots. Berries, roots, and herbs are gathered as summer approaches.

Salmon fishing for king, silver, red, and dog salmon begins in July and continues through September. The

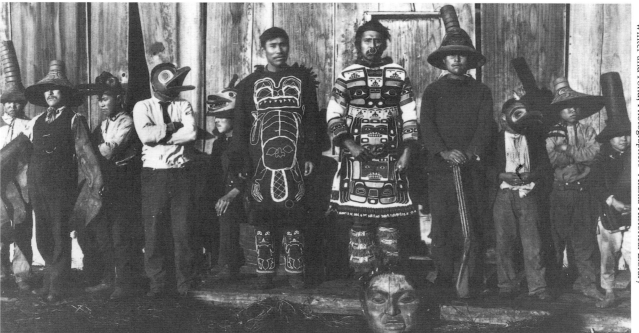

Figure 3. Chilkat people in ceremonial dress, 1895.

128

Figure 4. Klukwan, 1985.

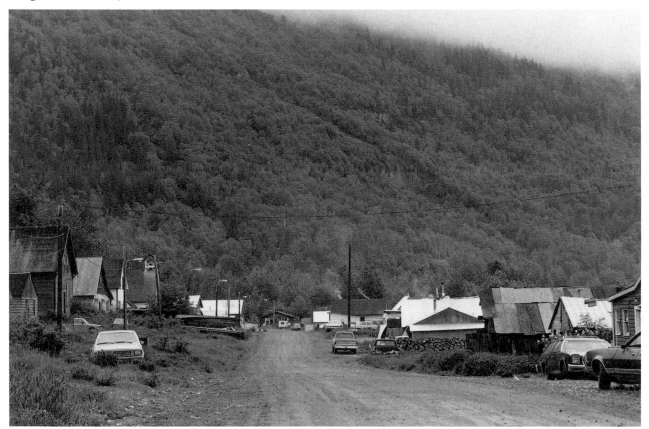

fish and eggs not immediately consumed are dried and smoked. Today salmon is also canned and frozen. Blueberries, cranberries, soapberries, and salmonberries are picked alongside the streams in the late summer. Small mammals such as gophers and ground hogs are also available.

Deer, mountain goat, lynx, wolverine, and black bear are hunted or trapped in the fall. Klukwan hunters climb the steep slopes to hunt these animals.

During the winter months, the people utilize the resources they have gathered and stored during the spring, summer, and fall. Women traditionally work on the raw material and prepare cedar bark, spruce roots, porcupine quills, mountain goat wool, furs, and hides for making clothing, baskets, Chilkat blankets, and mats.

The Chilkat Tlingit utilized both land and marine resources. Resources that were not available locally were obtained through trade. The abundance of resources allowed them to amass a surplus which they could trade, and their control over the inland coastal trade was an additional source of wealth. Up until the early 1900s, they lived in four major settlements named Klukwan, Yindestuki, Katkwaltu, and Chilkoot. Smaller villages and campsites were scattered throughout the region. Today the Chilkat Tlingit are concentrated in Klukwan and Haines.

The Community of Klukwan

Klukwan is located twenty-two miles up the Chilkat River from Haines. It is situated on the north side of the river, opposite the outflow from Chilkat Lake and the point at which the Klehini River flows into the Chilkat. The village rests on the narrow outwash belt along the river; the steep wooded hill in back of the village rises over five thousand feet. The Haines highway passes along the foot of the hill within several hundred yards of the village.

Chilkat people from Klukwan traveled downriver to Lynn Canal for hunting, fishing, trading, and ceremonial activities. They also journeyed into the Chilkat Pass for hunting, trapping, and trading with the Interior Indians. The Chilkat people were known for their ferocity and controlled the trade routes, enforcing their monopoly on commerce with northern groups. For many years after white contact, Klukwan was accessible by canoe only, and the village remained apart from the large-scale influx of outsiders moving through the area to the Klondike.

Although situated close to the Haines highway, Klukwan is a small, isolated community whose residents tend to prefer to keep apart from impinging social and economic forces. The entrance to the village is posted

with signs to discourage tourists from stopping off on their travels. There is no store or gas station in the town, and not more than half a dozen jobs are available. People drive to Haines for shopping and a few commute for work. People who have worked in Haines said they quit because the commute was a strain on their financial resources and family life or because they encountered some form of racism or discrimination.

English is the primary language in the community, but Tlingit is spoken by most of the adult population and is used exclusively in potlatch ceremonies. Until a year ago, grade school children attended the village Bureau of Indian Affairs School, which has now been transferred to state jurisdiction. There is no local high school, and students are bussed to Haines or attend the boarding school in Mt. Edgecumbe. People go to church in Haines. Klukwan has active camps (chapters) of the Alaska Native Brotherhood and Alaska Native Sisterhood. The weekly bingo game at the ANB hall is a popular community activity.

Traditional foods are a large part of the diet in Klukwan. The different species of salmon and trout discussed above are important, as are the small mammals, birds, and seals. Herring eggs, seal and eulachon oil, berries, seaweed, and larger game such as deer and moose are also significant. These food items are distributed by relatives to those who are too elderly to provide for themselves.

Klukwan has been the principal village of the Chilkat Tlingit at least since the time of American occupation of the region. In the 1880 census, the population of Klukwan was 565, more than three times the size of the three other Chilkat villages reported at the time. John R. Swanton, an early ethnographer, lists three other villages as belonging to the Chilkat tribe. Aurel Krause, who spent the winter of 1880-81 with the Chilkat people, reported a similar population figure for Klukwan, and counted sixty-five houses. He recorded six clans represented at Klukwan, and ten in all for the Chilkat people as a whole (Krause 1956:66-68, 78; Goldschmidt and Haas 1946:39).

By the time Oberg visited the area in 1931-32, the Chilkat people were divided between two communities: Klukwan, up the Chilkat River from Haines, and Haines itself on the Lynn Canal. This pattern has remained to the present day. Although formerly they were a single unit, they now consider themselves separate tribes (Goldschmidt and Haas 1946:39). Krause (1956:66-67), Oberg (1973:xii), and Goldschmidt and Haas (1946:39, 43) provide evidence that the Klukwan Chilkats have throughout the years protected themselves from incursions by whites and were regarded as the least influenced by the foreign culture.

Based on his work in Klukwan, Oberg (1973:58) reported the presence of four clans and twenty houses.

Only ten of the houses were occupied at that time (1931-32). The houses were located side by side in a row, facing the Chilkat River. About eight to ten of these houses are still standing today, although none of them are inhabited. The road in front of these houses has been extended to loop back parallel to and behind it further up the hillside. In the late 1970s, federal Housing and Urban Development housing was built which forms the core of the present village. There are four active tribal houses in the village (Gaanaxteidí, Kaagwaantaan, Dakl'aweidi, and Shangukeidí), which are the same clans reported by Oberg (op. cit.).

The 1980 census reported a population of 135, with a median age of twenty-five years. There are seventy-one males and sixty-four females represented in the census. Of the sixty-four housing units, forty are occupied on a permanent basis. Thirty-five of these are Chilkat households.

Jennie's Childhood

Jennie's recollections of her early childhood are happy memories. She has a smile on her face and a far-away look in her eyes as she says "my mommy" and "my daddy." As she talks about the stories of her early life some eighty years ago, it is as if they occurred only yesterday. She recounts early childhood events with exact detail and with the same exuberance and happiness she must have felt then.

She grew up in Klukwan in her father's tribal house, the Frog House, which is one of the old wooden houses still standing in Klukwan. The Frog House is a shell of its former grandeur. Great and lavish potlatches were once held in this tribal house. The Frog totem pole was sold long ago and, according to Jennie was taken to Juneau.

Her parents' love for her was demonstrated not only through their affection and care, but also through their efforts to ensure that Jennie received the best possible training for a Tlingit girl of her era. Her mother was opposed to Jennie attending the Western school at Sheldon Jackson in Sitka, but she did learn to read up to the "third reader" from the minister, Mr. Faulkner. A few years ago, Jennie addressed the Alaska Federation of Natives convention in Anchorage and told the audience, "I didn't go to school, but I think I'm all right!"

Jennie Learns Her Skills

Jennie recalls that her auntie named Saantaas' "knew how to make things." Her father gave the auntie fifty dollars to teach Jennie's mother how to make Chilkat blankets. Later her mother would teach her. Jennie cites this as one of the reasons her mother was good. Jennie learned about making baskets, moccasins, beadwork, and blankets from her, as well as skin-sewing. In her words:

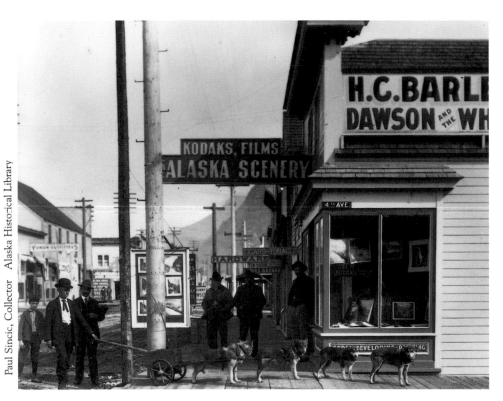

Figure 5. Skagway, Alaska, where Jennie's father took her baskets to sell.

My mama's good mama. When I was a kid and they gonna leave me alone, any place they go; you go with me; you put my dress on! He carry me on his hands all the time. And they learn me how to do something, how to do something inside the house. You know, that's why I live longer, see. And here we are, we watchin' this time: they never take care of the kids; they don't care where they go. Go to show nighttime, everyplace; get mixed-up. But I'm glad—say that I have a good mama. He never leave me behind someplace; he just carry me and tell me get married.

Her mother began teaching her to weave blankets and baskets and sew moccasins with beadwork when Jennie was about ten years old. Jennie played at weaving baskets and blankets, and her mother noticed her toy-like products and showed her how to make them properly. She tells of playing with spruce roots with her playmates when she made something "like a spider net." After her mother learned from the children who had made the net, she began to show Jennie how to work the materials.

She gave Jennie good roots (that is, already split) to work with. "Then I learn it good." Jennie used to finish about seven baskets in a year. Her father would take them to the store in Skagway and sell them. In springtime, about April, her father would travel to Skagway by canoe. He would make totem poles, and her mother made baskets and moccasins. At that time, moccasins sold for one dollar a pair, and baskets brought from five to seven dollars, depending on the size. That was considered a good price for the baskets: "I made lots of money from the baskets." Later on, she learned to make baskets with tops by herself. (She still makes this type of basket, which sells for three hundred to four hundred dollars to the store in Haines.)

When a German baker opened a store in Haines, Jennie used to take her baskets there to trade or sell. She traded for bread and dry goods. She laughed as she told about trading a little basket for a big sack with "everything in it." She bought cloth to make dresses, silk, and stockings with her baskets.

Making baskets was easy to her. One does not need to spend money and "you just pick the roots yourself. You buy some dye—black, red, different colors. Then dye the grass. That's all you do." She learned to split roots after trying to do it with the girl next door. They tried to split the roots themselves, and when her mother found out she was playing this way she showed Jennie how it was done properly.

Jennie learned to weave blankets in a similar fashion, her mother providing her with materials and instruction after Jennie was observed playing at weaving. As a young girl, she took some yarn from her mother's supply and, using the can she used to store her dolls in, positioned a stick across the top and hung yarn on it—"all different colors." Then they started weaving. She and her playmates were going to make a doll's rug. It was halfway finished when her mama saw it and asked, "Who makes this?" When Jennie responded, her mother said, "How come you put the stick inside? How you

gonna pull it out? You should use a string [referring to the methods of attaching the headings cord to the loom beam with strings]." Her mother took the children over to her loom and showed them how to do it.

Afterwards, Jennie helped her make the black and yellow border on the blanket, which is how a blanket is started. Later on, in 1902, Jennie was shown how to weave her first design. She helped her mother make a frog blanket for her father. After 1905, when she was married, her auntie Mrs. Benson (Saantaas') taught her how to count the yarn strands for the designs: "how wide the black, how long the green and yellow." She learned to use the "design board" to measure the dimensions of design elements.

Jennie lived in Jones Point after her marriage. It was there that another auntie lived, who was married to her husband's brother. She taught Jennie how to sew porcupine quills on skin for moccasins. "We learned it from the (Interior) Indian people; they dye it different colors. It is just like beadwork—it's good, the quills never come out for a long time. You twist it around the thread and sew it on." Her sister-in-law taught her to knit. "I know how to knit, and the crochet, and the embroidery."

Jennie's Isolation Period

Jennie, like all Tlingit girls of her status, received spe-

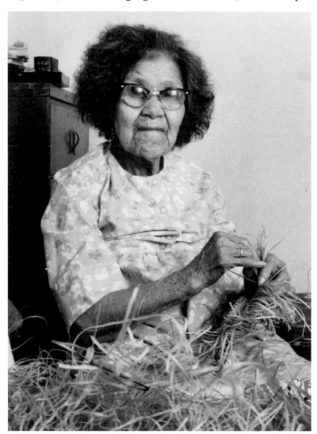

Figure 6. Jennie still makes several spruce root baskets each year. Klukwan, 1985.

cial training. The Tlingits believe that life-long habits and attributes are shaped during early adolescence. Young girls are awakened early in the morning so they will not be late-morning sleepers in later life. They are required to walk wearing a hat with a wide brim without shaking the hat. This is to teach girls to walk in a stately manner.

During their first menstruation they are isolated in the back room of the tribal house. Jennie recalls that she was isolated for a period of seven to ten days. She explains that she does not to this day have gray hair because during the isolation period her mother and her mother's oldest sister, Kinjee, washed her hair with a special shampoo. Other Tlingits have suggested that the special shampoo was blueberry juice. Jennie recalls the event:

> They bring water in my room, basin and he's [they] got something in it. Crazy, I don't find out what it is. And she says, "You grandma used to use this shampoo, you going to use it. You not going to get gray hair right away." My grandma, my mama's mother, still black just like mine. They didn't get no gray hair. But I'm sorry I don't ask what it is, that Indian shampoo.

Jennie Reaches Adulthood

According to Tlingit tradition, marriages are arranged. So it was for Jennie that her parents told her of her impending marriage: "We are poor people, but that guy is a high class. Be a good girl!"

Her first husband was a member of Tlingit nobility whose mother came from the Shakes family of Wrangell. At the age of thirteen, in October of 1905, she left her parents and married a Gaanaxteidí man, John James. Jennie recalls that her husband's mother and sister came. Her mother brought money. It was an "Indian marriage." Jennie tells that her mother and father also gave her husband the Chilkat blanket with a Frog crest that she and her mother had made in 1902. Later her husband would go to Juneau and sell the blanket to buy a war canoe.

Her husband was an industrious man. He worked hard in both wage labor and subsistence fishing. He used the war canoe to haul freight from Haines to the gold mine up the Chilkat River to the Porcupine gold fields. He transported "all kinds of tools and groceries to use at the gold mine." Since there was no road at the time, he was busy all through the summer of 1906 hauling freight. In 1908 or 1909, he worked in the gold mine at Porcupine during the summer months. They lived together at the mining camp.

Jennie recalls with particular delight and in vivid detail her trip to Klawock in 1910. Her husband was out trolling when she saw the Klawock women returning with sacks filled with black seaweed. She asked them

where they had picked the seaweed. They told her out on the island. Young Jennie ran to her husband and said, "You better pick some for me, I want to dry some!" "No, he don't listen, he like trolling." Jennie then pleaded with her sister-in-law (Henry Phillip's wife), "Maggie, let's go out to the beach, see how it looks." Maggie responded, "You don't know how to do." Jennie pleaded again, "No, let's go. The older women pick lots of seaweed."

Her sister-in-law relented and off they went with two sacks and a rope. They tied the rope around Jennie who climbed down the rocks to gather seaweed. Maggie was to watch the waves and pull Jennie up before they reached her. They came back to camp ever so happy with their two bags full of seaweed. They cleaned the rocks where they would spread their seaweed out to dry. Jennie laughs, "I see the women folks go down. Oh, I feel good. I got it!"

Jennie recalls the women began examining her black seaweed and then they started laughing, "Look at that Chilkat People, they pick some different kind of black seaweed." Jennie remembers, "I hear it good. And then I run to Maggie—'Maggie, we pick some wrong one, not black seaweed. The women folk was laughing down there!' The women folk was laughing down there. And I watch and they go home, two of them. I go down there. I throw away in water." They had gathered what the Tlingit call "rock fat."

Jennie then returned to Maggie and said, "I not going to cook for your brother!" Jennie recalls that she returned to her tent and climbed in bed. She even refused to build a fire. Around four or five o'clock, her husband returned home. He asked Jennie, "What's wrong, you sick?" She refused to answer. He asked again, "What's wrong?" It all comes tumbling out: "You don't want to pick the black seaweed for me, that's why I don't cook for you. I pick the different one; the women folk was laughing!" Jennie recalls her husband's words, "Oh, no, come on get up." Maggie had cooked for both her husband and brother. Maggie's husband, Harry, also came over to persuade Jennie to join them for dinner, "Come on and eat with us." Jennie relented and joined them.

The following day, Jennie's husband did not go trolling but rather went out to pick her seaweed and returned with three sacks full. Jennie continues with her story, telling that the Klawock women, even though they had laughed at her, taught her how to make seaweed (kat'at'xi) with halibut-head juice, which acts like glue, and pack it in boxes.

Jennie's memories are filled with these happy times in her carefree youth. She remembers that she bought a "handmade" short canoe from her brother, Tom. Her husband asked her why she bought it when she did not know how to use it. She responded that "we young girls, if we can fish, people will come and buy it from me.

Pretty soon, I learn how to do it. I have a lot of fun. I had no kids at that time."

Jennie's first two sons did not survive. Her husband's family believed that her sons did not live because she was married to a noble and she was not equal to his status. When Jennie was pregnant with her third child, she went to Juneau to see a man whom Jennie called a "fortune teller" (shaman) to fix her up. She was given a flask and was instructed to put a drop of the medicine it contained wherever she stepped. The medicine person promised that her children would live but she would have to give her first-born to the person who gave her the medicine. The child lived, and the medicine person kept asking for the child, but Jennie refused to give her up.

Jennie and her husband, John James, had three daughters—Kathryn, Edith, and Edna.

In 1920, her husband became ill, which Jennie describes as "funny sick." His gums were swollen, he had a sore throat, he could not eat, and he stayed in the hospital in Haines for two months. One day Jennie heard him laughing in his sleep. When he awoke he called Jennie to his side and told her, "I got a good dream. Don't worry if I go away, I see my son."

He told Jennie that he was going away. He told her that in his dream their son had brought a sack and told him not to worry. The sack contained "green backs" (dollars). The dream was a prediction that Jennie would be able to take care of herself and her daughters with the money she would earn. Her husband died that year, confident that Jennie would be able to take care of herself. After his death, she went to work in a laundry and cannery.

In 1922, Jennie married John Mark Thlunaut. John Mark's mother and sister came to her and told her she should marry John. John had adopted the English surname of Mark. Jennie and John used Mark as their last name. After his death, Jennie dropped the name Mark and used the Tlingit name Thlunaut. They lived in Haines and moved into the Yéil Hít (Raven House) of the Lukwaax.adi Clan. They had a daughter who died in her crib. Jennie says the baby was frightened by a barking dog. Another daughter, Agnes, survived.

Her second husband died in 1952. According to Tlingit law, her husband's property, including the tribal house, would not be inherited by herself but rather would revert to someone in the clan who ascended to John's position. If Jennie did not marry anyone else in her husband's clan, she would have to move out of the Raven House. Jennie never remarried and she returned to Klukwan. She bought a small red house near the river where she could clean and smoke her fish.

In about 1973, she moved to a new house which was constructed by the Tlingit and Haida Housing Authority under the HUD program. Although the house was

larger, it was inconvenient because it was on a hill away from the river. She would live in the new house throughout the winter but return each summer to her house by the river. She recently gave her small house to a grandson.

Throughout her life, Jennie has been active in many church and civic affairs. She has been a faithful member of the Alaska Native Sisterhood and made some of the first ANS and ANB banners. She has been recognized for her life-long dedication to her home, family, people, and culture.

Her participation in the traditional Tlingit ceremonies and potlatches has been as faithful and extensive. She has been given many names, and the following two stories tell of the love and regard her people have for her. Tlingit names are like titles and they are owned by particular clans. They also tell the stories of clan histories.

Jennie Gets the Name "Strong Coffee"

The name "Strong Coffee" was formally bestowed on Jennie when she was young, during a potlatch in Hoonah. The name originated with John Benson and Henry Phillips.

John and Henry returned to Klukwan after attending school at Sheldon Jackson. Jennie said, "They don't know how to do hard work." This statement is often made about students who have not had the opportunity and time to learn adequately the technical skills necessary for hunting and fishing.

Jennie recalls that the price of a river fish had jumped from ten cents to twenty-five cents. Jennie said that "Hoonah People" and "Juneau People" had come to fish at Haines. They would put their fish nets in the river at Ten Mile (up the river) and drift down to Jones Point, which is between seven and eight miles upriver from Haines. She said that their nets would be full of dog salmon even before they reached Jones Point.

Fishing in October is cold. Jennie recounted that Henry and John had built a fire under a cottonwood tree and "put lots of coffee on." The fishermen would gather at Henry and John's big fire and drink coffee. It was not too long before people started calling Henry and John "Strong Coffee." Jennie says that anytime she sees the big cottonwood tree by the road as she passes by, "I think about it...good idea they build a fire."

Later in the year, Jennie's husband's uncle, Ḵudéi Nahaa, invited the people from Haines to attend a "big party." According to Jennie, he had "put up lots of money" which would be distributed to the guests. Ḵudéi Nahaa had approached Henry and told him, "It's not good for you that name, that 'Strong Coffee', you better give it to your son's wife." (Because Henry had the same name as Jennie's father-in-law, he was also considered to be her father-in-law). Jennie does not know how many thousands of dollars were "put up" in that potlatch for

her to receive the name "Strong Coffee" but she recalls with much pride: "I honor that name because my father-in-law give [it to] me...that's the way we get [I got] the name but I honor the name, costs lots of money." In Tlingit custom only good daughters-in-law receive gifts from their fathers-in-law.

Jennie Is "The Captain"

This story involves a historical dispute between sailors, who are remembered as being Dutch, and the Tlingit. The sailors killed some Tlingit people in Klukwan. The were pursued in the war canoes by the Kaagwaantaan clan down to the Kaagwaantaan fort, Kax' Nóowu (Ground Hog Bay), near Hoonah. The Kaagwaantaan captured the sailors. They also took the uniforms and hats. The Kaagwaantaan shaa (women) now claim the rights to sailor uniforms. Jennie was appointed to serve as the Captain. She claims she was selected because she was the oldest woman in her clan. She says she is too old now, so Daisy Phillips is next in line to succeed her.

The First Blankets

In 1908, Jennie's mother died, and she had left behind a chest containing materials necessary to make a blanket (yarn and such). The chest also contained a blanket that her mother had started, with "the black and yellow on." Her father gave the chest and its contents to Jennie and

Rosita Worl

Figure 7. Jennie Thlunaut in her ceremonial role as *The Captain.*

Figure 8. Jennie Thlunaut with a completed blanket, ca. 1930.

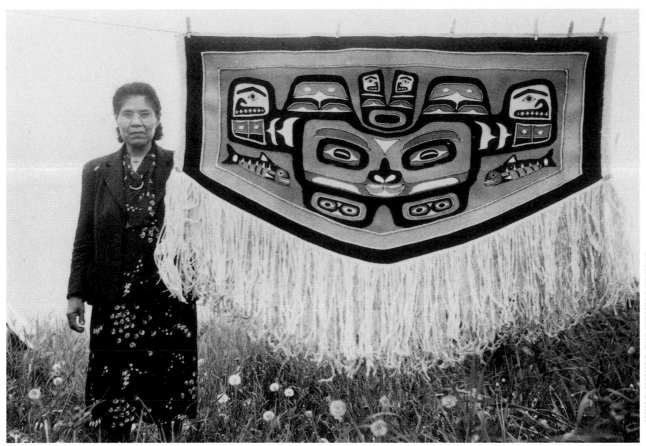

she took it with her when she went to the mining camp with her first husband. She "worked steady up there in Porcupine from May to September" and "finished that blanket up there." This was the first blanket she finished. Jennie's definition of "steady" means working continuously through the daylight hours of the long summer day and stopping only a few moments to eat.

Her husband's sister, Noow Teiyí, married a man from Ketchikan. Jennie and her husband used to go there during the summer for the fishing, starting in 1910. In the first summer she was there she made a blanket while living "in a little tent." The white ladies would come in to watch her work on the blanket. She worked steady and completed it in two months. It was "a little one." She traded it for a gold watch "for her old man." This was the first blanket she made by herself from start to finish.

The next blanket she made was also woven in Ketchikan during the summertime. Someone had ordered it and she sold it for fifty dollars. Her husband used the money to buy a sailing boat which they used to return to Klukwan at the summer's end.

A man from Klukwan, Kawushgaa, ordered an ANB flag so he could give it as a present to the Sitka ANB Camp. Jennie wove the letters ANB and the year

on a plain white background. She thinks it is in Sitka now but does not know who has it.

When she was first married, she made baskets, beadwork, moccasins, porcupine quill work, and blankets (fig. 8). She also knitted, crocheted, and did embroidery. During this time, it was evident she had difficulties with male children. She had six boys in all with her first husband, but "they did not grow up." After a while, her husband did not want her to work and make things; he told her to take care of the kids. When telling her to stop sewing with porcupine quills, he had said, "Don't do that job. It's too dangerous. The kids are going to get into it, that sharp thing." "That's why I quit. It's nice job, that." So she did not make any more blankets or other items until after he died.

Working and Learning

After her first husband died, Jennie began to devote most her time to weaving. She notes, "I started good. Steady." Her aunt and other weavers would work only when "they got the time to sit down." They would usually take two years to finish a blanket. Jennie would work continuously until she finished a blanket. She recalls that her auntie was "surprised I finished two months."

Figure 9 (Top). Jennie does beadwork as well as weaving. She made this vest with a beaded Eagle crest design for her granddaughter, Rosita Worl, in the 1970s.

Figure 10 (Bottom). Beaded deerskin dance slippers made by Jennie in the 1970s.

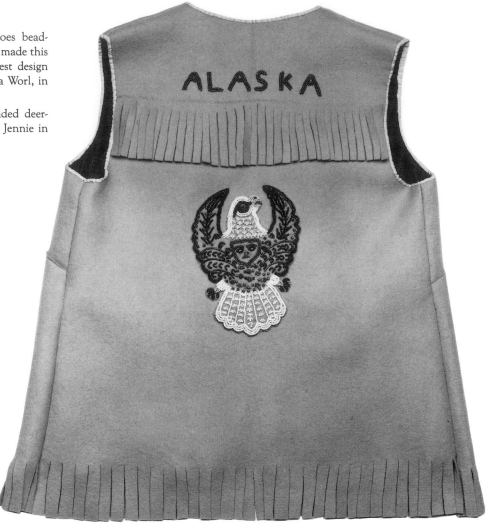

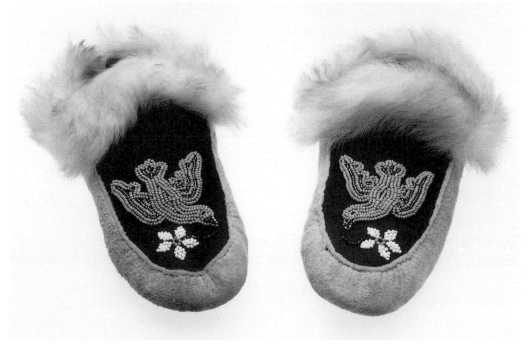

She expresses gratitude towards her mother for her ability to work "steady" until her task is completed. She credits her mother for teaching her to make things properly, which includes taking initiative and working diligently until a task is completed.

When Jennie spoke about her father taking items to sell in Skagway, she comments on the work of her mother that, "not many people do that job; just like that [today] they don't care nothing. But only my mama makes something."

Jennie believes, "if you're willing to do it you'll learn it, but if you don't care you can't do it." When asked about teaching her skills to others, she said she would like to teach, without charge, but "nobody likes to learn. I feel funny about it.... Just the same, they always say too much work. They don't like to do the spinning the yarn and the bark. I'm willing to do it—just my own people, not white people—but nobody like it. Funny. It's big money."

Materials

Jennie spins the wool for the Chilkat blanket from mountain goat hair (fig. 11). In the fall time, the hunters would get the mountain goats, and she would buy the skins from them. Her most recent blankets are a combination of mountain goat and commercially made yarn.

Four skins in all are needed for a blanket. The entire skin is not used, but only a strip along the back which is thicker. She uses two skins for the inner part of the blanket (the warp), and the outer yarn (the weft) takes two additional skins.

She always prepared the wool and made the yarn herself by spinning it on her leg by hand (fig. 12). She says that the hardest is the inner part (warp) in which the goat wool and cedar bark are spun together. Jennie recalls at one time she almost purchased a spinning wheel to make her yarn, but no one knew how to use it. She cooked the bark herself, to prepare it for spinning. Cedar bark is not available locally in Klukwan. She would purchase the bark from her sister, Margaret Shatter, who lived in Hoonah. Margaret's husband picked the cedar bark, and they would send it to Jennie in a box used to ship eggs. Each box held about fifteen pieces; the first box cost her twenty-five dollars. Subsequently, the boxes were higher priced.

The Chilkat Blanket

Jennie related the following as her understanding of the origin of the Chilkat blanket: there was a Gaanax̱teidí man who had two wives. One wife was a

Figure 11 (L to R). Mountain goat wool; mountain goat wool spun into weft yarn; mountain goat wool spun with cedar bark into warp yarn; cedar bark.

Tsimshian named Ha yu was tlaa (I was not able to hear her pronounce this name well, and Johnny Marks was not familiar with the name. It may be a Tsimshian name, but it is also certain that if she were married to a Tlingit she would have been adopted and would have had a Tlingit name). This Tsimshian woman knew how to weave Chilkat blankets. Jennie said that the women of the Gaanaxteidí tribal house in Klukwan "rip it back [that is, took a blanket apart]; the whole house people [all of the women in the Gaanaxteidí tribal house], they learn first, but they have different designs—Killer-whale, Eagle, and Raven design. The Kaagwaantaan [women] used the Eagle, Killerwhale, Wolf, and Bear [designs]." Jennie said that the first blanket made by the Gaanaxteidí women, which Martha Willard has, is "too old" and that it has a "beaver on it."

The Gaanaxteidí shaa (women of the Gaanaxteidí clan) claim the Chilkat blanket. Jennie said, "My daddy pay my auntie [a Gaanaxteidí] to learn my momma [a Kaagwaantaan], my momma's sister, Saant'ass, my auntie, my momma's auntie." Jennie's father has thus paid a Raven woman to teach the Eagle women. Jennie added, "Mrs. Benson, she's a Raven, she a good blanket weaver. I married her son, she learned me."

Johnny Marks related the following about the origin of the Chilkat blanket, saying that it was told him several times by his auntie Jessie: A young Tsimshian woman fell asleep and dreamed. In her dream, she learned how to do the Chilkat weave. When she awoke, she said, "They've been teaching me something." She told her family what she needed and then made leggings. Chief Daakw Tank from Chilkat, who was a Kaagwaantaan from the Bear House, heard about this weaving. His daughter was coming out of her puberty seclusion and he wanted to commemorate it with something significant so that people would remember it. He bought the leggings. His wife or daughter took them apart and studied them and from this made the Chilkat blanket. They practiced it for years before they perfected it. (The hardest to weave is a shirt.) Johnny has the impression that this was a fairly recent occurrence, five hundred to six hundred years ago, or maybe more.

The Tsimshians were the first group to start weaving ceremonial garments. They were known for making dancing aprons, leggings, and blankets. Through intermarriage, the Tlingit learned this craft. By the time of the incursions of European traders into the area in the late 1800s, women of the Chilkat villages were regarded as the greatest producers of the largest of the ceremonial garments, the dancing blanket. The European traders coined the name "Chilkat blanket" in recognition of the weaving skills of the Chilkat women.

Specific designs are woven into the blankets. These designs are crests of family or clan groups which serve as property markers and emblems of the group (plates 12, 13, 14). The crests are stylized animal figures which are symmetrical and are comprised of conventionalized, colored design elements. Blankets are identified by the central figure, although the design may include additional elements or other figures which fill in the available spaces. More rare are blankets in which a single design is repeated in checkerboard fashion in the design space. The design is bounded by three bands of solid color: yellow, black, and white. The white band is narrower than the others and forms the outer edge; braids flow out from it on the bottom and two sides of the blanket. These braids produce evocative effects during dances, often flowing from side to side or shaking violently.

Carving and blanket designs were similar in style. Weavers were provided with pattern boards fashioned and painted by a male artist (fig. 13). The designs on the boards were transformed into wool, each portion being measured by a cord or a piece of cedar bark which would be marked with the thumbnail. Weavers would count the number of stitches in design elements so measured, in order to replicate the design elements with the conventional symmetry (fig. 14).

Women made the yarn from mountain goat wool obtained from skins provided by male hunters. They spun the wool into yarn by hand on their thighs, (although Cheryl Samuels [1982:62] reports an alternative method involving the use of spindles and whorls.) Black and

Figure 12. Jennie Thlunaut spinning wool at the Festival of American Folklife, Washington, D.C., 1984.

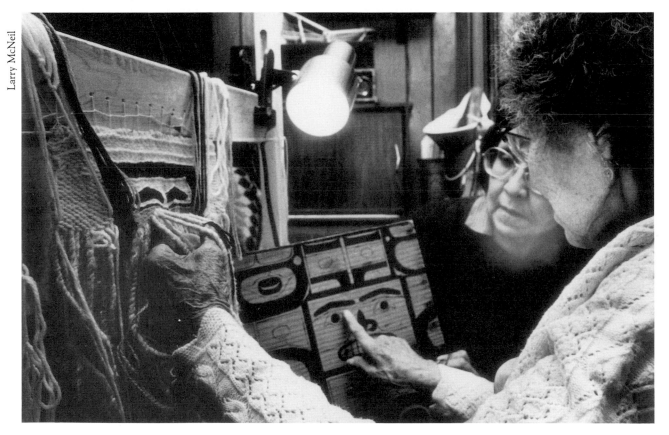

Larry McNeil

Figure 14. Jennie shows a weaver how the design on the pattern board is woven into the blanket.

yellow colors were obtained from dyes made from hemlock bark, copper, and a specific lichen which, combined with urine, would produce the desired colors in the yarn. Women also gathered the inner bark from cedar trees which they prepared and spun together with the mountain goat yarn, making the stronger yarn used for the warp of the blanket.

The loom consisted of two upright posts to which a cross-piece was attached at the top. Another beam was situated just below the cross-piece to which the heading cord was attached by strings that were laced through holes placed in the beam. The warp cords hung down by gravity, and the weaving began. Several different stitches were used for various sections, including the heading, sidebraids, borders, and the design field. In addition to straight stitches, Chilkat weavers were capable of a variety of curvilinear shapes, including circles, ovals, and arcs used frequently in the design elements.

Shirts

Jennie made six Chilkat woven shirts in her life. There was only one lady in Klukwan who knew how to make shirts, but she did not want to teach Jennie how to make them, so Jennie tried it and figured out how to make shirts on her own.

The shirt she made for Jack David is a spirit shirt. It has the name Naa Tuxgaayi. Austin Hammond has this shirt now (fig. 16). She also made a shirt for Tom Jimmie and for her second husband John Mark (Thlunaut). Her husband sold the shirt Jennie made for him while she was in the hospital. He sold it to someone aboard the missionary boat *Sheldon Jackson*, which at the time traveled to all southeastern communities. She felt so bad about it that she made him another one just like it. Austin Hammond inherited this shirt as part of the Lukwaax.adi Clan property. Jennie also indicates she made a shirt for Peter Dick of Angoon.

Cultural Significance of Chilkat Blankets

The ceremonial regalia of the Tlingit nobility includes the Chilkat blanket. They are worn in potlatches and other ceremonies. Weavers were often commissioned to make Chilkat blankets to commemorate events recorded in a clan's oral traditions. Chilkat blankets were also given away in potlatches. Sometimes they were even cut up and the pieces distributed among the guests. The blanket is used in dancing and is quite spectacular when it is swirling in motion as the dancers spin around. Today the blankets are the prize of museum collections around the world. Chilkat blankets are important to the

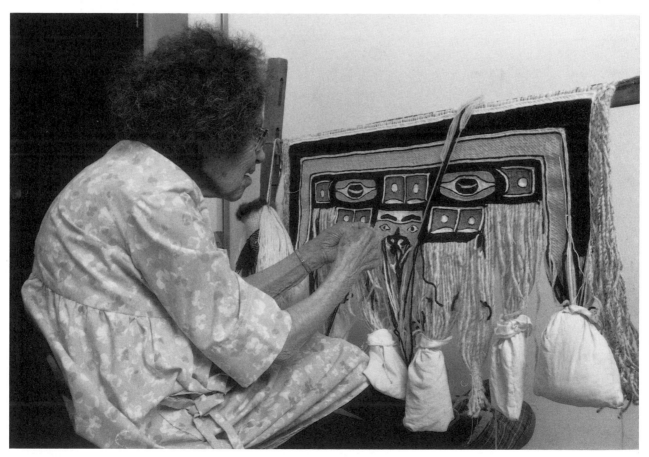

Figure 15. Jennie Thlunaut weaving a blanket at her home in Klukwan, 1985.

Tlingit both in life and death. Tlingit nobles were cremated in their ceremonial regalia. After the practice of burying the dead was adopted, the Tlingit would either wear their blankets or drape them over their burial sites. When they found that whites were taking them from the graveyard sites, the Tlingit began cutting the blankets into strips. They found that even this did not discourage the grave robbers, who continued to remove them.

Jennie made a number of Chilkat blankets for outright commercial sales to non-Tlingits. She was also commissioned by other Tlingits to make them Chilkat blankets and shirts. Jennie also made and gave away Chilkat blankets and shirts to her family members. Many of these Chilkat blankets and shirts remain the property of the clans. Clans also own rights to specific crests. Jennie is always careful to ensure that she weaves only those crests on the blankets and shirts to which the Tlingit recipients of the blankets or shirts have property rights. For instance, she would never weave a Raven crest for a Tlingit who is a member of an Eagle clan.

The following stories which Jennie related reveal the importance of the Chilkat blankets to the Tlingit.

Jennie was invited to a potlatch in Hoonah. During the potlatch Jimmy Marks put money on the table (which would be distributed to validate her right to the name), called Jennie out and said, "Excuse me, sister, I am going to adopt you, I going to give you my sister's name, Alice Sutton's name." Jennie felt so honored to be given the name L'eex'eendu.oo, (Keeping the Broken Pieces), and to become the adopted sister of Jimmy Marks, who was the Chief of the Chookaneidi Clan.

When Jimmy Marks became ill, Jennie was so worried that she would not have any money to give in his honor when he died. She recalls the distress she felt: "What we [I] going to do when he died. I got nothing...I got no money." At that point, she decided to make him a Chilkat shirt. When she finished the shirt she went down to Juneau to visit him. He had recently been released from the hospital. She approached him, "I just came to see you. I worry about [you]. I thinking about you all the time. I got no brother, that's why I'm glad you adopt me for your sister...what we going to do when you go away? That's why I make something for you." Jennie recalls, she opened her suitcase and gave him the Chilkat shirt she had woven with his Bear crest (fig. 17). She told him he could do whatever he wanted: "somebody keep it or you use when you died." Jennie recounted his response: "How do you know my thoughts? Thank you. That's the way we think about it when we know we're going to pass away. Somebody going to put the bear ear, you know, dancing, they use it, they put it on my head and then we died with it. Now this time you make that bear, thank you very much!" (Gangoosh [head band with bear ears] was put on the nobility just prior to their death.) Jennie returned to Klukwan

Figure 16. NaaTúxgaayi, the Spirit Shirt, was woven for Jack David. It is being worn by George Davis in a 1981 potlatch given by Austin Hammond. Hammond and Walter Soboleff are standing by George Davis on the platform.

Joe Kawaky

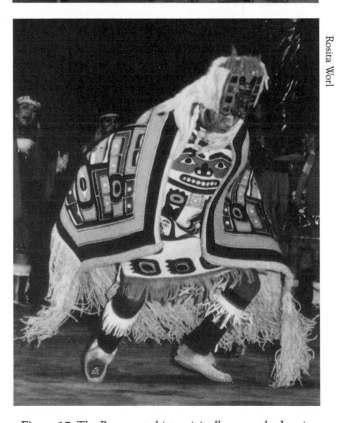

Rosita Worl

Figure 17. The Bear crest shirt, originally woven by Jennie Thlunaut for Jimmie Marks, here worn by a young dancer during a potlatch.

Figure 18. Raven crest blanket, Sheldon Museum and Cultural Center collection.

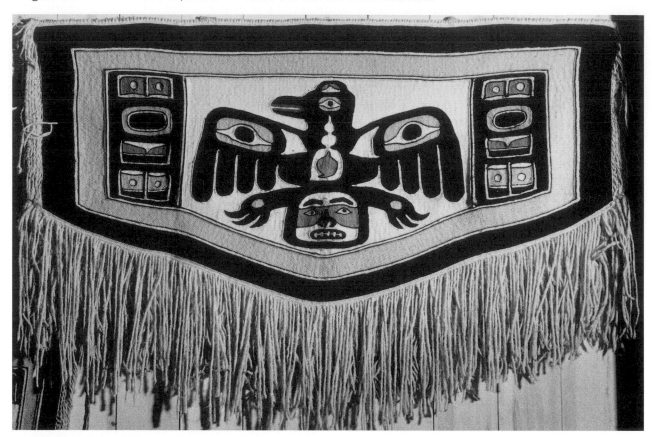

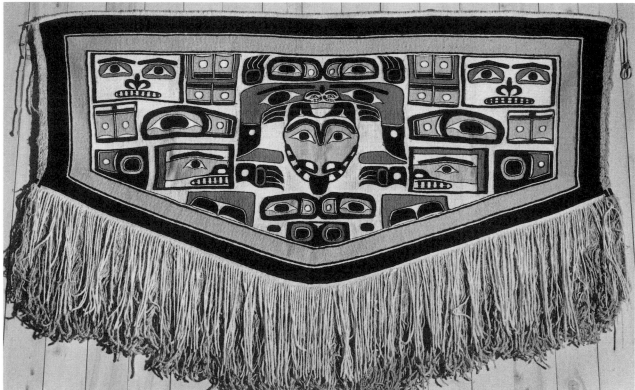

Figure 19. Chilkat blanket with wolf design, ca. 1910. This blanket is owned by Klukwan, Inc., the profit village corporation, and is on exhibit at the Sheldon Museum and Cultural Center.

pleased that she had made something special for her adopted brother.

Jennie occasionally stayed with her daughter, Edna Land. Edna lived in Haines next to the Raven House in which Jennie had once lived with her husband John Mark (Thlunaut). Austin Hammond is now the recognized Chief of the Lukwaax.adi and lives in the Raven House.

Jennie recalls that one day in July when she was staying with Edna, she looked out the window and was surprised to see her adopted brother and his wife going into Austin's house. She recalled thinking, "Oh, my auntie coming and her husband too!" It was not too long before someone came to get her to go to Austin's house, and soon the purpose of the visit was made evident. Jennie recalled her brother's words to her: "We come back from Hoonah. I show the one you give me, the shirt. I show my family, and my family says they don't want to bury with me." Jimmy explained that his family wanted to keep the shirt rather than having it buried with him. His family felt that the shirt would remind them of both Jimmy and Jennie. Jimmy told Jennie the purpose of his visit was to explain his family's wishes to her. Jennie simply replied, "Thank you."

After his death, Jennie went to Hoonah to participate

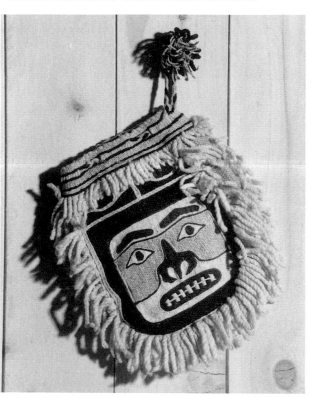

Figure 21. Chilkat blanket clutch purse woven by Jennie. Sheldon Museum and Cultural Center collection.

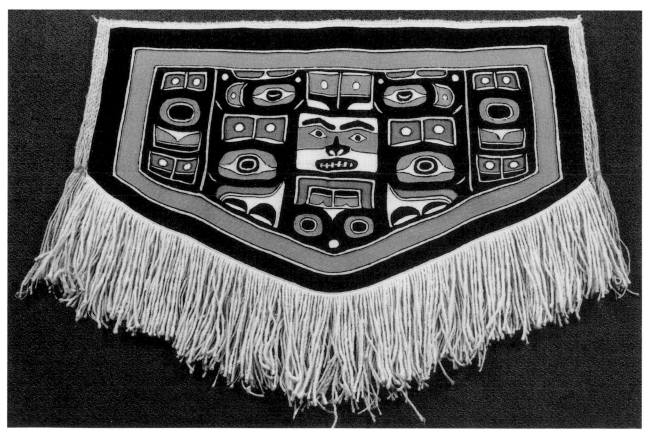

Figure 20. A "classic" Chilkat blanket made by Jennie. Sheldon Museum and Cultural Center collection.

in his potlatch. The evening before the big potlatch, all his personal possessions, "his tools, everything" were given to members of his clan. Jennie was approached by one of her adopted brother's clan members, "Sister, your brother was talking about you lots, about the blanket shirt. It costs too much money....He feels bad he go away before you. He [was] talking about he was going to buy your casket when he go away. Now this time he go ahead of you. That's why he told me to give you this money." Jennie was handed an envelope which she opened and found one thousand dollars. The clan member continued, "your brother was talking about it, when you go away you buy some casket." Jennie explained that this is why her family and friends need not worry, "I'm all right, everything is okay." Jennie has put the money she received from her brother in the bank to pay for her coffin when she "goes away too."

The Chilkat Bear shirt which Jennie had made for her adopted brother, Jimmy Marks, became part of the Chookaneidi Clan property. Willie Marks, who succeeded his brother Jimmy, inherited the shirt. Jennie's niece, Mary Johnson, who is also a Chookaneidi, became the caretaker of the clan's possessions. Jennie points out that she is often given money by those who have her Chilkat blankets or shirts. She tells that once she was at a potlatch and a man came and embraced

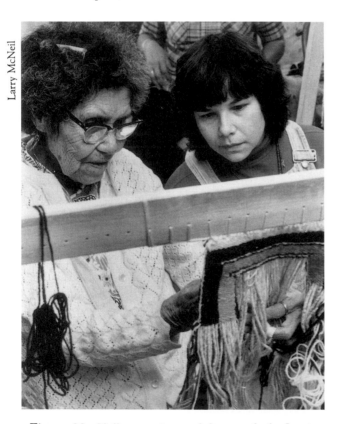

Figure 22. Chilkat weaving workshop taught by Jennie Thlunaut at Raven House in Haines. The workshop was sponsored by the Institute of Alaska Native Arts.

her, he said, "I'm glad I got it your job. Thank you very much." He pressed fifty dollars into Jennie's hand and said, "That's my thanks; don't say no." She also tells that Willie Marks would give her twenty dollars or fifty dollars just to go to the restaurant.

Jimmy Martin's Blanket

Jimmy Martin had ordered a Chilkat blanket from Jennie. He told her he wanted to be buried with it because he had been given the name Yaakwaan, which is the name of a noble, a "big name."

Before Jimmy was able to get the blanket from Jennie, he drowned. As soon as she learned of his death she went to his home and told his son, "You daddy order some blanket. He wants to use it when he died. He put on his casket in the graveyard. I got it one at home. He order that, that's why I tell you." Jennie returned home, packed the blanket, and mailed it to his family. Jennie later received a picture of the blanket which had been cut into four pieces. The blanket pieces had been attached to an anchor and thrown into the water where Jimmy Martin was presumed to have drowned. Jennie said, "That's all right, that's my brother." Jimmy was a member of the Kaagwaantaan Clan, which is also the clan to which Jennie belongs.

Jennie Thlunaut has continued to make Chilkat blankets and shirts up until a few short years ago when her eyesight failed. Many of her blankets and shirts are still seen and used in the traditional potlatches. Some remain the property of clans and others are individually owned by Tlingits. Others have been sold by the Tlingits who had originally ordered them from Jennie. Jennie also indicates that some of the blankets she made were made for commercial sale to non-Tlingits.[1]

Jennie is best known for her Chilkat blanket weaving. However, she is an accomplished spruce root basket weaver as well (plate 11). She made baskets primarily for commercial sale and sometimes for gifts. In addition, Jennie designs and sews her own beadwork. She continues even to this day to sew moccasins. She has made beaded vests for her family members (fig. 9, 10).

Jennie Thlunaut is ninety-two years old (March 1984). Jennie has said she feels strong in her mind, but her body will not do what she wants it to do. At one of her low points, when her eyes began to fail, she was so disheartened that she said she might as well have her hands cut off since she could no longer work. The depression was only momentary since she did continue to work. She remains active and alert. Today she continues to travel, visiting friends and relatives in the northern Tlingit communities. She never misses participating in a potlatch or attending Alaska Native Brotherhood and Sisterhood conventions. She is a devout Christian and a devoted mother, grandmother, and great-grandmother. She is loved and admired by all.

Figure 23. Jennie Thlunaut demonstrates weaving Chilkat blankets at the Festival of American Folklife, 1984. Anna Ehlers, Juneau, has been learning weaving techniques from Jennie.

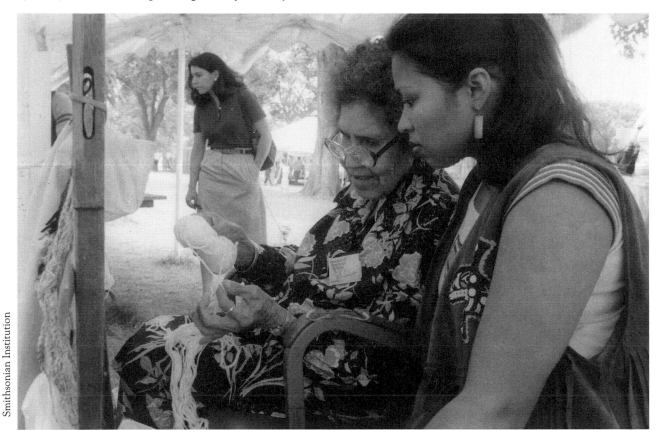

ENDNOTES

The following is a list of the blankets and shirts Jennie recalls making. The listed amount represents the price she received or the money she received during a potlatch:

Chilkat Shirts

1. John Mark (Thlunaut), Haines
She made a shirt for her husband who sold it someone who worked on the *Sheldon Jackson* vessel.

2. John Mark (Thlunaut), Haines
She made a duplicate shirt after he sold the first one. Austin Hammond, who succeeded John Marks, inherited this shirt.

3. Jack David, Haines
Spirit Naa Tuxgaayi. Austin Hammond also inherited this shirt. $300.00

4. Peter Dick, Angoon $300.00

5. Tom Jimmie, Haines $400.00

6. Jimmie Marks, Hoonah
Gift to Jimmy, who had adopted Jennie. Shirt woven with bear crest.

Chilkat Blankets

1. First blanket $50.00

2. Second blanket made in Ketchikan ca. 1910, traded for a gold watch.

3. Third blanket made in Ketchikan ca. 1910, sold for a sailing boat.

4. Wrangell $50.00

5. Juneau $50.00

6. Sitka—Frog design $50.00

7. Mrs. Charlie Benson, Sitka $300.00

8. Annie Sauaton, Angoon $300.00

9. Mr. Johnson, Angoon $300.00

10. John Smith, Hoonah $300.00

11. Joseph Pratt, Hoonah $300.00

12. Mrs. Jimmy Martin $300.00

13. Mrs. Hakkinen, Haines $300.00

14. Mrs. Schnable, Haines $300.00

15. Alaska Native Arts and Crafts Cache, Juneau $300.00

16. Alaska Native Arts and Crafts Cache, Juneau $300.00

17. Alaska Native Arts and Crafts Cache, Juneau $300.00

18. Alaska Native Arts and Cache Cooperative, Juneau $1000.00

19. Carl Heinmiller, Haines $500.00

20. Jenny Marks, Juneau
Lukwaax.adi Clan (wife of Jimmie Marks) $600.00

21. Jenny Marks, Juneau $600.00

22. K'alaxeitl' (Sam Hopkins) $600.00

23. X'alaxeitl (Sam Hopkins) $600.00

24. Joe White, Hoonah $600.00

25. Joe White, Hoonah
Chief of the Shangukeidi. Design with Ga-
gaan Yatx'i (Children of the Sun). Brought out at the dedication of the new Shangukeidi tribal house in Klukwan in 1971, named Kawdliyaayi Hit X'oow. $600.00

26. Mary Hamilton, Fairbanks $1000.00

27. Rosita Worl, Shangukeidi, Anchorage
Jennie and John Mark Thlunaut's granddaughter. Eagle crest (fig. 22) $2000.00

28. Dan Katzeek's daughter in Skagway. Design: Kutkataa Ch'aak' (nesting eagle) This was designed by Johnny Marks. $10,000.00

29. Josephine Winders. Wolf.

30. Agnes Bellinger, Juneau. Wolf.

31. Jimmie Martin. Kaagwaantaan. Chilkat blanket put into water after he drowned.

32. Johnny Marks. Lukwaax.adi. Chookaneidi Yaidi. Jennie gave this to him as a gift. Design: "Two-door house" (formerly named Raven House)

33. Sheldon Jackson Museum. Small Chilkat blanket with a frog emerging from its winter hibernation (plate 12). Jennie gave this to pay for one of her daughter's tuition at Sheldon Jackson. Les Yaw donated it to the museum two years ago.

BIBLIOGRAPHY

Goldschmidt, Walter R., and Theodore H. Haas. 1946. *Possessory Rights of the Natives of Southeast Alaska.* A Report to the Commissioner of Indian Affairs. "N.p."

Krause, Aurel. 1956. *The Tlingit Indians.* Translated by Erna Gunther. Seattle: University of Washington Press.

Oberg, Kalervo. 1973. *The Social Economy of the Tlingit Indians.* The American Ethnological Society Monograph No. 55. Seattle: University of Washington Press.

Samuels, Cheryl. 1982. *The Chilkat Dancing Blanket.* Seattle: Pacific Search Press.

Thlunaut, Jennie. 1983. Taped interviews and transcripts with Rosita Worl and Charles Smythe with the assistance of Johnny Marks. "The Artists Behind the Work": Oral History Program, Alaska Polar Regions Collections, Rasmuson Library, University of Alaska, Fairbanks.

ACKNOWLEDGEMENTS

We would like to acknowledge the graciousness and willingness of Jennie Thlunaut to work with us. We realize we have only been able to capture some of the highlights of her life. Although she is remarkably strong for her years, she was only able to work with us for short periods during the limited time we had with her. We are also especially grateful to John Marks who assisted us in the interviews and subsequently clarified many issues for us. Special thanks also to Austin Hammond who took good care of us when we stayed in the Yéil Hít.

MUSEUM STAFF

Basil C. Hedrick
Director

COORDINATORS

Wanda W. Chin
Exhibits and Exhibits Designer

Terry P. Dickey
Education and Public Service

Barry J. McWayne
Photography Department

PRODUCTION

Steve Bouta
Mary Beth Harder

ASSISTANCE

Sheila J. Carlson
Carol E. Choy
Hazel E. Daro
Nancy L. Ford
Verla J. Gilbertson
Andrea P. Krumhardt
Sharon A. Olive

PHOTOGRAPH CREDITS

Illustrations by Stephanie Harlan

Photographs, unless otherwise indicated, are by Barry J. McWayne

Elizabeth Ali
Alaska Historical Library
Anchorage Museum of History and Art
James H. Barker
Charles Family
Demientieff Family
Ann Fienup-Riordan
Suzi Jones
Joe Kawaky
Larry McNeil
Oral History Program,
Alaska and Polar Regions Department,
Rasmuson Library, University of Alaska, Fairbanks
Smithsonian Institution
Sours Family
Rob Stapleton
Rosita Worl